Moerner

A
Parting of the
Ways

A Parting of the Ways

Carnap, Cassirer, and Heidegger

MICHAEL FRIEDMAN

OPEN COURT
Chicago and La Salle, Illinois

This book has been reproduced in a print-on-demand format from the 2000 Open Court printing.

To order books from Open Court, call toll free 1-800-815-2280

The photograph of Rudolf Carnap on the front cover comes from the Rudolf Carnap collection of the Archive for Scientific Philosophy at the University of Pittsburgh and is used by courtesy of the University of Pittsburgh libraries.

Open Court Publishing Company is a division of Carus Publishing Company.

Printed and bound in the United States of America

Library of Congress Cataloging-in-Publication Data

Friedman, Michael, 1947–
 A parting of the ways : Carnap, Cassirer, and Heidegger / Michael Friedman.
 p. cm.
 Includes bibliographical references and index.
 ISBN 0-8126-9424-4 (alk. paper).
 1. Analysis (Philosophy) 2. Philosophy, European—20th century. 3. Carnap, Rudolf, 1891–1970. 4. Cassirer, Ernst, 1874–1945. 5. Heidegger, Martin, 1889–1976. I. Title.
 B808.5 .F76 2000
 193—dc21 00-06058

In memory of my friend
David Burton (1945–1975)

Contents

Auch wir haben „Bedürfnisse des Gemuts" in der Philosophie; aber die gehen auf Klarheit der Begriffe, Sauberkeit der Methoden, Verantwortlichkeit der Thesen, Leistung durch Zusammenarbeit, in die das Invidividuum sich einordnet.

Rudolf Carnap
Der logische Aufbau der Welt

Die Logik erfüllt die Welt; die Grenzen der Welt sind auch ihre Grenzen.

Die Logik ist keine Lehre, sondern ein Spiegelbild der Welt. Die Logik ist transzendental.

Ludwig Wittgenstein
Tractatus Logico-Philosophicus

Preface

One of the central facts of twentieth-century intellectual life has been a fundamental divergence or split between the "analytic" philosophical tradition that has dominated the English-speaking world and the "continental" philosophical tradition that has dominated the European scene. The former tradition, in the eyes of many, appears to withdraw from the large spiritual problems that are the concern of every thinking person—the meaning of life, the nature of humanity, the character of a good society—in favor of an obsession with specific technical problems in the logical or linguistic analysis of language. Here philosophy has taken on the trappings of a scientific discipline, characterized by clarity of method and cooperative cumulative progress in the formulation and assimilation of "results," but at the expense of all contact with the central philosophical problems that are of truly general concern beyond a small circle of narrow specialists. An engagement with the traditionally central problems of philosophy has thus been left to the continental thinkers, but the works of these thinkers, in the eyes of the more analytically inclined, appear to throw off all concern with clarity of method and cooperative cumulative progress in favor of a deliberate and almost willful obscurity more characteristic of a poetic use of language than of ostensibly logical argumentative discourse. The divergence between the analytic and continental traditions has therefore been an expression within the world of professional philosophy of the much more general split C.P. Snow famously identified between his opposing (and mutually uncomprehending) "two cultures"—that of the scientifically minded and that of the "literary intellectuals."

In the early 1930s this fundamental intellectual divergence crystallized for a moment in a notorious polemical attack directed at "metaphysical pseudo-sentences" authored by

Rudolf Carnap, a leader of the Vienna Circle of logical empiricists and one of the most militant advocates of a new scientific approach to philosophy explicitly intended as a quite radical break with the great metaphysical tradition. In his paper "Overcoming Metaphysics through the Logical Analysis of Language [*Überwindung der Metaphysik durch logische Analyse der Sprache*]," Carnap specifically singles out Martin Heidegger as a representative of contemporary metaphysics, and then concentrates on Heidegger's notorious proposition, "Nothingness itself nothings [*Das Nichts selbst nichtet*]," taken as paradigmatic of a metaphysical pseudo-sentence. For Carnap, this typically Heideggerian proposition is cognitively meaningless precisely because it violates the correctly understood logical structure of language. From Heidegger's own point of view, by contrast, such a diagnosis, arising from the misplaced obsession with logic characteristic of what will later become known as the analytic tradition, of course misses precisely his point.

The collision between Carnap and Heidegger over "Nothingness itself nothings" may now strike us as more than slightly absurd: one party ponderously formulates deep sounding but barely intelligible pronouncements, the other pedantically subjects such pronouncements to what appears to be entirely inappropriate logical scrutiny. It is very hard to see, therefore, how anything of importance could possibly hang on it. When I began work on the present essay in the early 1990s, however, I was surprised and fascinated to learn that Carnap's polemical attack on Heidegger was intimately connected with a well-known defining episode in early twentieth-century philosophical thought, the famous Davos disputation between Heidegger and Ernst Cassirer in 1929. For, as it turns out, Carnap had attended the disputation between Heidegger and Cassirer, had met and talked with Heidegger at Davos, and had taken a very serious interest in Heidegger's philosophy when he returned to Vienna. Carnap then wrote, and delivered, earlier drafts of "Overcoming Metaphysics" directly in the wake of this experience, as he himself struggled to find a professorship in Europe in the extraordinarily uneasy political climate of the early 1930s. It also turns out, perhaps not so surprisingly, that the issues at stake in Carnap's criticism (for

both him and Heidegger) were charged with social and political significance, reflecting the deep and pervasive cultural struggles of the late Weimar period. Indeed, shortly after the Nazi seizure of power in 1933 (during which, as is well known, Heidegger assumed the rectorship at Freiburg while publicly embracing the new National Socialist regime) both Carnap and Cassirer emigrated to the English-speaking world, and Heidegger was the only active philosopher of the first rank to remain on the Continent.

What I hope to show in this essay, then, is that the Davos encounter between Carnap, Cassirer, and Heidegger has particular importance for our understanding of the ensuing split between what we now call the analytic and continental philosophical traditions. Before this encounter there was no such split, at least within the German-speaking intellectual world. Logical empiricism, Husserlian phenomenology, neo-Kantianism, and Heidegger's new "existential-hermeneutical" variant of phenomenology were rather engaged in a fascinating series of philosophical exchanges and struggles, all addressed to the revolutionary changes that were then sweeping both the *Naturwissenschaften* and the *Geisteswissenschaften*. The differing philosophical movements of course disagreed with and opposed one another about the interpretation and significance of these revolutionary changes, but they still spoke the same philosophical language, and they actively engaged one another on a common set of philosophical problems. Moreover, since the Davos disputation itself concerned the fate of neo-Kantianism and the proper interpretation of the philosophy of Kant (with Heidegger taking as his main target the Marburg School of neo-Kantianism with which Cassirer was closely associated), I further hope to show that carefully attending to the very different ways in which the thought of all three philosophers evolved in sharply diverging directions from a common neo-Kantian heritage can greatly illuminate the nature and sources of the analytic/continental divide.

The present essay thus presents the pervasive twentieth-century split between analytic and continental philosophical traditions refracted through the lens of one particularly important defining episode. By looking at the Davos encounter from the

varying perspectives of all three of our protagonists we can, I hope, obtain an especially enlightening perspective for ourselves. We shall see, in particular, how the relatively less familiar philosophical position gradually articulated by Cassirer during this period can be seen as an heroic attempt to bridge the ever widening gulf between the scientifically oriented approach to philosophy championed by Carnap and the decisive attempt to move philosophy in a quite contrary direction represented by Heidegger. Situating Cassirer's attempt at integration against the much more radically polarized positions of Carnap and Heidegger can thus provide us with new possibilities and renewed motivation for making a similarly heroic effort for ourselves. Although, as I shall argue, we might not be able to rest content with the materials that Cassirer has left us, it is still hard to imagine making progress without increased appreciation for both the strengths and the weaknesses of his wide-ranging and deeply synthetic style of philosophical thought.

By focussing on three particular philosophers and one particular episode in this way I do not, of course, pretend to give a complete and comprehensive account of either the historical background or the philosophical significance of the analytic/continental divide. A full account of the historical background would clearly have to pay much more attention to the development of post-Kantian idealism, together with important nineteenth-century reactions to it in the thought of Nietzsche and Kierkegaard, for example. A full account of the philosophical significance of our split would clearly have to involve a considerably larger number of twentieth-century philosophers. Indeed, even with regard to the three philosophers I do consider in some detail, there is still much of importance that is left out. In the case of Carnap, for example, I deliberately emphasize the neo-Kantian influences on his thought at the expense of a wide variety of other influences coming from Wittgenstein, Russell, the empiricist tradition, and even Leibniz. In the case of Heidegger, I similarly emphasize the Kantian and "transcendental" dimensions of his thought at the expense of the genuinely ontological preoccupations ("the question of Being") derived from his reading of the ancient Greeks. By emphasizing the Kantian and neo-

Kantian influences on both Carnap and Heidegger I facilitate their comparison with Cassirer.

For the encounter at Davos between Carnap, Cassirer, and Heidegger concentrated philosophical attention, at least for a moment, on the fate of neo-Kantianism in the early twentieth century, the proper interpretation of Kant, and the relationship, in particular, between Kant's logical faculty of understanding and sensible faculty of imagination. My own aim, accordingly, is to shed as much light as possible on the analytic/continental divide from the point of view of this one particular cluster of philosophical problems. We shall see, at the same time, how these seemingly arcane philosophical problems were closely bound up with the wider social and political struggles of the period that finally resulted in the great intellectual migration that followed upon 1933 and thus contributed decisively to the eventual isolation, both linguistic and geographical, of our two philosophical traditions.

As noted above, I began work on this project in the early 1990s, after learning (from Thomas Uebel) of Carnap's participation at Davos. I produced a manuscript containing preliminary versions of approximately half of the material presented here, which I then circulated to friends and colleagues. At the same time, I presented lectures based on this manuscript at a number of universities, including the University of Illinois at Chicago, the University of Western Ontario, Northern Illinois University, and the University of Notre Dame. I received valuable comments from audiences on all of these occasions, especially from Sandra Bartky, Susan Cunningham, Theodore Kisiel, and Lynn Joy. I also received very valuable written comments on the entire manuscript from Peter Gordon. In 1996 a shortened version of this manuscript, entitled "Overcoming Metaphysics: Carnap and Heidegger," was published in R. Giere and A. Richardson, eds., *Origins of Logical Empiricism* (Minneapolis: University of Minnesota Press). I am indebted to the University of Minnesota Press for permission to reproduce large parts of the earlier paper in the present volume. Also in the mid-1990s, I presented lecture versions of this earlier paper at Haverford College, Northwestern University, the University

of Pittsburgh, and Stanford University. I am indebted to comments on these occasions as well, especially from Kathleen Wright, Kenneth Seeskin, James Conant, John Haugeland, Hans Sluga, and Richard Rorty.

In connection with Cassirer, in particular, I am especially indebted to John Michael Krois, whose acquaintance I made in 1994. I have learned much from his own work on Cassirer and on the Davos disputation, and I am grateful for his comments on the penultimate version of the present volume. I have benefited throughout from his generous encouragement of this project (including copies of as yet unpublished manuscripts where Cassirer deals specifically with logical empiricism).

A debt of a special kind is owed to André Carus, not only for encouraging me to publish the present volume with Open Court Publishing Company, but also for providing me with extremely detailed and careful comments on the penultimate version covering a wide variety of philosophical, organizational, stylistic, and linguistic questions. I believe that I have substantially improved the essay in response to these comments; and I of course bear sole responsibility for all problems in any of these areas that remain—especially where I have occasionally disregarded his advice.

I am variously indebted to comments, advice, and technical assistance from Frederick Beiser, Graciela De Pierris, Gottfried Gabriel, Alison Laywine, Alan Richardson, Thomas Ricketts, Werner Sauer, and Brigitte Uhlemann. And I would like to acknowledge Scott Tanona for his work in preparing the index.

A Note on Texts and Translations

All translations from the German are my own. In references, I cite first the page numbers in the German original, and then, in parentheses, the corresponding pages of the English translation given in the Bibliography. In some cases (in Heidegger's *Being and Time*, for example), the page numbers of the German original are found in the margins of the English translation. In such cases I cite only the German original. In referring to Kant's writings (which are not specifically listed in the Bibliography), I typically cite only the title of the relevant work (perhaps together with chapter or other sub-title). Some few references to the *Critique of Pure Reason* cite the standard pagination of the first (A) and/or second (B) editions.

1

Encounter at Davos

Davos, Switzerland; March 17–April 6, 1929. An intensive
"International University Course," having the express purpose
of effecting a reconciliation between French-speaking and
German-speaking intellectuals, was sponsored by the Swiss,
French, and German governments. The high point of the occa-
sion was a series of lectures presented by Ernst Cassirer and
Martin Heidegger, followed by a disputation between the two
men.

Cassirer and Heidegger were at the time arguably the two
leading philosophers in Germany. Cassirer was the most emi-
nent active Kant scholar and editor of the then standard edition
of Kant's works, and he had just completed his own magnum
opus, *The Philosophy of Symbolic Forms*. Heidegger had recently
published *Being and Time* and was in the process of taking
Edmund Husserl's place as the leader of the phenomenological
movement. And, in the lectures and the ensuing disputation,
Heidegger first made public a radical phenomenological-meta-
physical interpretation of the *Critique of Pure Reason* devel-
oped in explicit opposition to the Marburg School of
neo-Kantianism with which Cassirer was closely associated. It is
no wonder that the event attracted a large and excited interna-
tional audience including both students and professors. Among
them was a representative of the Vienna Circle of logical posi-
tivists or logical empiricists, Rudolf Carnap.[1]

1. I am indebted to Thomas Uebel for first calling my attention to the fact that
Carnap attended the Cassirer-Heidegger lectures and debate at Davos. Carnap reports
on the occasion in his diary [ASP RC 025-73-03, entries from March 18 to April 5,
1929].

Heidegger's interpretation of Kant aimed to show that the *Critique of Pure Reason* does not present a theory of knowledge and, in particular, that it does not present a theory of mathematical natural scientific knowledge. The real contribution of the *Critique* is rather to work out, for the first time, the problem of the laying of the ground for metaphysics—to articulate, that is, the conditions of the possibility of metaphysics. On this reading, Kant argues (in remarkable agreement with the main argument of *Being and Time*) that metaphysics can only be grounded in a prior analysis of the nature of *finite* human reason. As finite, the human intellect (unlike the divine intellect) is necessarily dependent on sensible intuition. Moreover, and here is where the true radicalism of Heidegger's interpretation emerges, Kant's introduction of the so-called transcendental schematism of the understanding has the effect of dissolving both sensibility and the intellect (the understanding) in a "common root," namely, the transcendental imagination, whose ultimate basis (again in remarkable agreement with the argument of *Being and Time*) is temporality. And this implies, finally, that the traditional basis of Western metaphysics in logos, *Geist*, or reason is definitively destroyed.[2]

In the ensuing disputation Cassirer begins by announcing his agreement with Heidegger concerning the fundamental importance of the transcendental imagination—interpreted, however, in accordance with Cassirer's own philosophy of symbolic forms, as pointing to the fact that the (finite) human being is to be defined as the "symbolic animal." But Cassirer strongly objects to the idea that we as "symbolic animals" are thereby limited to the "arational" sphere of finitude. For Kant himself has shown how the finite human creature can nevertheless break free from finitude into the realm of objectively valid, necessary and eternal truths both in moral experience and in mathematical natural science. On this basis, Cassirer asks

2. Heidegger published this interpretation in *Kant und das Problem der Metaphysik* [Heidegger, 1929a], which he wrote up in a few short weeks immediately following the Davos University Course. In [Heidegger, 1991] this work appears together with appendices containing Heidegger's notes for his Davos lectures and a protocol of the Cassirer-Heidegger debate prepared by O. Bollnow and J. Ritter. Translations of these materials can be found in [Heidegger, 1990].

Heidegger whether he really wants to renounce such objectivity and to maintain instead that all truth is relative to Dasein (the concrete finite human being). Heidegger, for his part, acknowledges the importance of this question, but he continues to reject the idea of any "breakthrough" into an essentially non-finite realm. On the contrary, philosophy's true mission—and our true freedom—consists precisely in renouncing such traditional illusions and holding fast to our essential finitude (our "hard fate").

For Heidegger, the Davos exchange with Cassirer was thus a tremendous opportunity. In a direct encounter with the most eminent contemporary representative of neo-Kantian "rationalism," he was able to stake out his own claim to be the author of a fundamentally new kind of philosophy destined to replace the hegemony of the neo-Kantian tradition and to supplant the remaining "rationalist" tendencies in Husserlian phenomenology as well.[3] Heidegger was able to do this, moreover, by presenting a radically "anti-rationalist" reading of the *Critique of Pure Reason* itself. Finally, given the differences in age and career stage of the two men (Cassirer was fifty-five, Heidegger not quite forty; Cassirer had held the chair in philosophy at Hamburg since 1919, Heidegger was just that year taking over Husserl's chair in Freiburg), the encounter involved all the drama of a generational transition. Indeed, it appears that Heidegger in fact won over the young students at Davos,[4] and, in any case, there is no doubt that Heidegger's revolt against the "rationalism" of the neo-Kantian tradition was to be brilliantly successful throughout the European continent and beyond.

With hindsight, it is possible to read back a social and political dimension into the encounter at Davos as well. For Cassirer was not only one of the most eminent contemporary representatives of the classical liberal intellectual tradition in Germany,

3. Compare Heidegger's "Zur Geschichte des philosophischen Lehrstuhles seit 1866," reprinted as Appendix VI to [Heidegger, 1991].

4. For eyewitness accounts see L. Englert's report, reprinted in [Schneeberger, 1962, pp. 1–6]; [Pos, 1949)], and [T. Cassirer, 1981], relevant parts of which are reprinted in [Schneeberger, 1962, pp. 7–9]. See also [Krois, 1992], [Aubenque, *et. al.*, 1992], and [Kaegi and Rudolph, 2000].

he was also a leading representative of modern political republicanism. Born into a wealthy and cosmopolitan Jewish family, he received his dissertation under Hermann Cohen—the founder of the Marburg School, the first Jew to hold a professorship in Germany, and a well-known progressive-socialist political advocate. From 1906 to 1919 Cassirer lectured as *Privatdozent* at the University of Berlin, during which years, despite his truly prodigious output (including his [1906], [1907a], and [1910], as well as editions of both Leibniz's and Kant's works), he was unable to obtain a regular faculty position. In a very real sense, then, Cassirer owed his academic career to the Weimar Republic, when he was finally offered professorships at the newly founded universities at Frankfurt and Hamburg in the spring of 1919. After working productively at Hamburg for ten years (where, in particular, he brought to completion *The Philosophy of Symbolic Forms*), Cassirer presented a defense of Weimar at the University's celebration of the tenth anniversary of the Republic in August 1928. Countering the popular view that the Weimar Republic was somehow "un-German," Cassirer argues [1929a] that the idea of a republican constitution in fact has its origin in the German philosophical tradition. Cassirer then served as rector of the University from November 1929 to November 1930, as the first Jew to hold such a position in Germany. In 1933 all this changed, of course, and Cassirer was forced to emigrate. He spent two years in England at Oxford, six years in Sweden at the University of Göteburg, and the remaining years until his death in 1945 in the United States at Yale and Columbia.[5]

Heidegger's social and political trajectory is almost the mirror image of Cassirer's. Born into a lower-middle-class family in a small town in the Catholic southwest, he had first intended to study theology and enter the priesthood. During his studies at Freiburg, however, Heidegger came under the influence of

5. See [Krois, 1987], which, in addition to biographical and intellectual-historical material, presents an extraordinarily clear and helpful analysis of Cassirer's philosophy. [Paetzold, 1995] also provides a very clear and readable account of Cassirer's intellectual biography. [Schwemmer, 1997] is an excellent treatment of Cassirer's philosophy in its cultural and historical context. The primary sources for Cassirer's biography are [Gawronsky, 1949], [Pos, 1949], and [T. Cassirer, 1981].

Heinrich Rickert's version of neo-Kantianism (that of the so-called Southwest School) and, increasingly, the phenomenology of Edmund Husserl. From the first he impressed both his teachers and fellow students with his philosophical brilliance, and, after taking his doctorate and habilitation (under Rickert), he remained in Freiburg as Husserl's assistant when the latter arrived from Göttingen in 1916. After spending the years 1923–28 as associate professor at Marburg, Heidegger then triumphantly returned to Freiburg as Husserl's successor. Heidegger, of course, was no friend of the Weimar Republic. When Hitler came to power in 1933, Heidegger was appointed rector at Freiburg, officially joined the Nazi party, and greeted the victory of the new political movement with his notorious rectoral address, "The Self-Assertion of the German University" [Heidegger, 1933], in May of that year. Although Heidegger left the rectorship after ten months, and in fact appears to have grown increasingly disenchanted with the Nazi regime, he was nonetheless still able, in his well-known lectures, *Introduction to Metaphysics,* presented in 1935 and published in 1953, to depict Germany as the West's last best hope for salvation from Russian communism on the one side and American technological democracy on the other, and to speak, in ringing and famous words, of "the inner truth and greatness" of the National Socialist movement.[6]

It would be a mistake, however, to read back a dramatic political conflict into the encounter at Davos in 1929, or into the relationship between Heidegger and Cassirer more generally. For, in the first place, it appears that the Davos encounter itself took place in an atmosphere of extraordinarily friendly collegiality.[7] And, in the second place, Cassirer and Heidegger

6. For biographical material see [Ott, 1988] and [Safranski, 1994]. [Farias, 1987], which started the recent wave of interest in Heidegger's political involvement, is a much less balanced account. The famous "inner truth and greatness" remark occurs in [Heidegger, 1953, p. 152 (p. 166)]. A particularly interesting discussion of Heidegger's politics is [Sluga, 1993], which locates Heidegger's involvement in the context of that of the other German philosophers of the time.

7. See the contribution of P. Aubenque in [Aubenque, *et. al.,* 1992] and, especially, the report of L. Englert in [Schneeberger, 1962]. [T. Cassirer, 1981] and [Pos, 1949] depict the disputation between Cassirer and Heidegger as much less friendly and collegial, the former going so far as to suggest evidence of anti-Semitism on Heidegger's part. Since these reports were written with hindsight in the post-war

enjoyed a relationship of friendship and mutual respect both before and after Davos, almost until Heidegger's assumption of the rectorate in 1933. Thus, a well-known footnote to *Being and Time* [Heidegger, 1927, p. 51] comments briefly on the second volume of *The Philosophy of Symbolic Forms* and alludes to a meeting of Heidegger and Cassirer at a lecture of Heidegger's at Hamburg in 1923, where, according to Heidegger, the two came to an agreement about the importance of the kind of "existential analytic of Dasein" that Heidegger had sketched there. Similarly, Cassirer, for his part, includes five favorable footnotes to Heidegger in the third volume of *The Philosophy of Symbolic Forms* [Cassirer, 1929b, pp. 173n, 189n, 193n, 200n, 218n (pp. 149n, 163n, 167n, 173n, 188n)]. Moreover, the two men wrote respectful, albeit critical reviews of one another's works: Heidegger [1928] reviewed [Cassirer 1925]; Cassirer [1931] reviewed [Heidegger, 1929a]. Finally, Cassirer delivered a lecture at Freiburg and visited with Heidegger there after the meeting at Davos. Cassirer reports that this lecture (to which he was invited by Heidegger) was unusually well attended and that, on the next morning, he found Heidegger "very open and directly friendly."[8] Thus, although the two never really came to terms in detail with their obviously very large philosophical differences in print,[9] it is

period, however, it seems to me (particularly in view of the friendly relations between Cassirer and Heidegger both before and after Davos) that they carry less weight. Englert's report, written at the conclusion of the Davos International Course in 1929, speaks of the "wonderful collegiality" and "attunement [*Abgestimmtsein*]" between Heidegger and Cassirer, and how, when the latter was briefly ill, Heidegger read his lectures only reluctantly and then reported to Cassirer personally about the contents [Schneeberger, 1962, p. 3]. Nevertheless, recent work by John Michael Krois suggests that there may have been a darker (but unexpressed) undertone to the meeting after all, due to a very well publicized anti-Semitic attack on the Kant interpretation of both Cohen and Cassirer perpetrated by the right-wing ideologue Orthmar Spann at the University of Munich (in an explicitly National Socialist context with Adolf Hitler in attendance!) just three weeks before the Davos University Course: see [Krois 2000].

8. Letter from Cassirer to his wife, quoted in [T. Cassirer, 1981, p. 184] (also in [Schneeberger, 1962, p. 9]). No date is given for this letter. However, [T. Cassirer, 1981, pp. 181–89] consistently (and mistakenly) locates the Davos disputation in 1931, so we know that Cassirer's Freiburg lecture occurred between then and early 1933. Since Cassirer speaks, in the letter, of "the wild rumors buzzing around [Heidegger]," it appears that his visit to Freiburg took place rather late in this period.

9. Heidegger was planning to review [Cassirer, 1929b], but this review was never finished. In the letter to T. Cassirer cited in note 8 above Cassirer reports that "[Heidegger] admitted to me that for some time he has been struggling with a review

clear (at least before 1933) that no social or political differences interfered with the equally obvious admiration and respect with which they regarded one another.[10]

Carnap, in the audience at Davos, appears to have been also caught up in the collegial yet intense philosophical atmosphere. It is clear, in particular, that Carnap was very impressed with Heidegger. His first report runs [ASP RC 025-73-03, March 18, 1929]: "University Course. Cassirer speaks well, but somewhat pastorally. . . . Heidegger, serious and objective [*sachlich*], as a person very attractive." Carnap then reports that he and Heidegger went for a walk together [Ibid., March 30, 1929]: "With H. walking. Discussion. His position: against idealism, especially in popular education. The new 'question of existence'. The need for a solution." Finally, Carnap reports a rather interesting conversation with Heidegger in a cafe [April 3, 1929]: "With [a professor from Bonn] and H . . . about the possibility of expressing everything, even questions of purpose and meaning, in physical terms. H . . . essentially concedes [this] to me." Carnap also found Cassirer to be especially friendly, and he reports, in particular, how Cassirer gave him extremely supportive and open advice concerning his prospects for finding a permanent position—a problem with which Carnap was understandably very much concerned at the time.[11]

of my third volume, but for the moment does not know how to go about getting a grip on it." Cassirer never developed a criticism of *Being and Time* in his published writings. In 1928, however, he discusses it in drafts intended for a fourth volume of *The Philosophy of Symbolic Forms,* which was to locate Cassirer's thought in terms of the contemporary philosophical scene. This volume, too, never appeared, and Cassirer published instead "'Geist' und 'Leben' in der Philosophie der Gegenwart" [Cassirer, 1930a]. The 1928 manuscript criticizing *Being and Time* was evidently closely associated with the "'Geist' und 'Leben'" project. It first appeared, together with an English translation, in [Krois, 1983]; see also [Krois, 1995], [Krois and Verene, 1996]. (I will briefly return to this manuscript in note 191 below.)

10. Cassirer knew about Heidegger's national-socialist activities as rector in 1933: see [T. Cassirer, 1981, p. 183] (reprinted in [Schneeberger, 1962, p. 8]). [Cassirer, 1946, p. 292–93] refrains from mentioning this, however, and is content to name Heidegger (along with the historian Oswald Spengler) as the author of a philosophy that "did enfeeble and slowly undermine the forces that could have resisted the modern political myths [i.e., fascism]."

11. [Ibid., March 27, 1929]. Carnap finally received an offer from the German University at Prague in June 1930. He held a newly created chair for Natural Philosophy in the Division of the Natural Sciences from 1931 until the end of 1935, when he emigrated to the United States.

Thus, despite the circumstance that he himself was not yet well established, and despite his obvious philosophical differences with both Heidegger and Cassirer (especially with the former), Carnap was nonetheless able to take full advantage of the friendly collegiality of the occasion. The thirty-eight-year-old author of the just-published *Der logische Aufbau der Welt* [Carnap, 1928a] was clearly treated with respect by the two much more eminent men.[12]

In the years immediately following the encounter at Davos Carnap appears to have been especially interested in Heidegger. It seems, in particular, that Carnap studied *Being and Time* rather closely. In the summer of 1930 he participated in a discussion group led by Heinrich Gomperz and Karl Bühler in Vienna where Heidegger's book was intensively examined. Carnap reports [ASP RC 025-73-03, May 24, 1930]: "Lively attempts at interpretation, in which I mostly agree with Bühler, Gomperz, Hahn. I tell [them] about Davos: Heidegger-Cassirer."[13] Moreover, after a second meeting of this discussion group, Carnap (rather proudly) reports [Ibid., June 14, 1930] that "Kraft tells me that Gomperz, Bühler, etc. were astonished that I was capable of interpreting Heidegger."[14] It appears, therefore, that Carnap's interest in, and knowledge of

12. Cassirer knew Moritz Schlick (the founder and leader of the Vienna Circle) rather well, and Schlick had written to him in 1927 asking for help in publishing the manuscript of the *Aufbau*. Cassirer replied that he had indeed mentioned Carnap's book to Bruno Cassirer and told the latter that "on the basis of the earlier works of Carnap's with which I am acquainted, I am not for a moment in doubt that his book involves very interesting and valuable work" [WKS, letter of April 3, 1927]. The earlier works with which Cassirer was acquainted include at least [Carnap, 1922], for [Cassirer, 1929b, pp. 491–94 (pp. 422–24)] models his own account of the transition from the space of intuitive perception to that of theoretical physics explicitly on Carnap's account (and [Cassirer, 1929b] was essentially completed in 1927). Cassirer most likely already knew [Carnap, 1923] as well. He refers to it explicitly in print in [Cassirer, 1936, p. 88 (p. 70)].

13. Heinrich Gomperz, the son of the famous historian of Greek philosophy Theodore Gomperz, was a professor of philosophy at the University of Vienna and the author of *Weltanschauungslehre* (1905) (to which Carnap refers in [1928a, §§ 64, 65, 67, 159]). Karl Bühler was an important psychologist and psycho-linguist; he founded the Psychological Institute at the University of Vienna in 1922. Hans Hahn was a leading member of the Vienna Circle and, in particular, a co-author—along with Carnap and Otto Neurath—of the famous manifesto *Wissenschaftliche Weltauffassung: der Wiener Kreis* [Carnap, et. al., 1929].

14. Viktor Kraft was another important member of the Vienna Circle, who published a well-known book about their philosophical activities [Kraft, 1950].

Heidegger was serious indeed. So it is no wonder that, when Carnap completed the first version of his well-known paper "Überwindung der Metaphysik durch logische Analyse der Sprache" in November 1930, he chose examples precisely from Heidegger as illustrations of "metaphysical pseudo-sentences." Carnap presented this paper in lectures at Warsaw (November 1930), Zürich (January 1931), Prague (at the Kant-Society: November 1931), and then (in a revised version) at Berlin (July 1932) and Brünn (December 1932).[15] The published version appeared in *Erkenntnis* as [Carnap, 1932a].

15. The two lectures, including reports on the discussions, are documents [ASP RC 110-07-21] and [ASP RC 110-07-19]. I am indebted to Dr. Brigitte Uhlemann of the University of Konstanz for providing me with transcriptions from Carnap's shorthand. The examples Carnap chooses from Heidegger are taken from [Heidegger, 1929b], which was presented as Heidegger's Inaugural Address when he assumed the chair in philosophy at Freiburg in July 1929.

2

Overcoming Metaphysics: Carnap and Heidegger

In § 5 of "Overcoming Metaphysics," entitled "Metaphysical Pseudo-Sentences," Carnap introduces his consideration of examples from Heidegger (see note 15 above) by remarking that, although "we could just as well have selected passages from any other of the numerous metaphysicians of the present or the past," Carnap has here chosen to "select a few sentences from that metaphysical doctrine which at present exerts the strongest influence in Germany" [Carnap, 1932a, p. 229 (p. 69)]. There follows a discussion of several of Heidegger's sentences involving the concept of nothingness [*das Nichts*], including especially the notorious "Nothingness itself nothings [*Das Nichts selbst nichtet*]."

Carnap's criticism is more sophisticated and penetrating then one might expect. For, in the first place, Carnap's complaint is not that the sentence in question is unverifiable in terms of sense-data; nor is the most important problem that the sentence coins a bizarre new word and thus violates ordinary usage.[16] The main problem is rather a violation of the logical form of the concept of nothing. Heidegger uses the concept both as a substantive and as a verb, whereas modern logic has shown that it is neither. The logical form of the

16. Whereas *das Nichts* [nothingness] is a perfectly good German (philosophical) noun, there is no verb *nichten* in German (*vernichten* means to destroy or to annihilate). Carnap does not fail to remark on this [1932, pp. 230–31 (p. 71)]: "Here . . . we have one of the rare cases where a new word is introduced that from the very beginning has no meaning." However, as James Conant has emphasized to me, Carnap does not observe that this kind of twisting of the German language constitutes an essential part of Heidegger's philosophical method.

concept of nothing is constituted solely by existential quantifi-
cation and negation. In the second place, however, Carnap also
clearly recognizes that this kind of criticism would not affect
Heidegger himself in the slightest; for the real issue between
the two lies in the circumstance that Heidegger denies while
Carnap affirms the philosophical centrality of logic and the
exact sciences. Carnap accordingly refers explicitly to such
Heideggerian passages as the following:

> [N]othingness is the source of negation, not vice versa. If the power of
> the understanding in the field of questions concerning nothingness and
> being is thus broken, then the fate of the dominion of "logic" within phi-
> losophy is also decided therewith. The idea of "logic" itself dissolves in
> the turbulence of a more original questioning.

> The supposed soberness and superiority of science becomes ridiculous if it
> does not take nothingness seriously. Only because nothingness is manifest
> can science make what is itself into an object of investigation? Only if sci-
> ence takes its existence from metaphysics can it always reclaim anew its
> essential task, which does not consist in the accumulation and ordering of
> objects of acquaintance but in the ever to be newly accomplished disclo-
> sure of the entire expanse of truth of nature and history.

> Therefore no rigor of a science can attain the seriousness of metaphysics.
> Philosophy can never be measured by the standard of the idea of
> science.[17]

Carnap concludes, in his own characteristically sober fashion
[1932, p. 232 (p. 72)]: "We thus find a good confirmation for
our thesis; a metaphysician here arrives himself at the statement
that his questions and answers are not consistent with logic and
the scientific mode of thinking."

The "Postscript" to [Heidegger, 1929b], published in
[Heidegger, 1943], considers three types of criticism that have
been made of the original lecture. Heidegger reserves his most
extensive and militant response for the third criticism, namely,
that "the lecture decides against 'logic'." The heart of his
response is as follows:

17. [Heidegger, 1929b, pp. 14, 18 (pp. 107, 111–12)]. [Carnap, 1932a, pp.
231–32 (pp. 71–72)] quotes selections from these passages.

The suspicion directed against "logic," whose conclusive degeneration may be seen in logistic [modern mathematical logic], arises from the knowledge of that thinking that finds its source in the truth of being, but not in the consideration of the objectivity [*Gegenständlichkeit*] of what is. Exact thinking is never the most rigorous thinking, if rigor [*Strenge*] receives its essence otherwise from the mode of strenuousness [*Anstrengung*] with which knowledge always maintains the relation to what is essential in what is. Exact thinking ties itself down solely in calculation with what is and serves this [end] exclusively. [1943, p. 104 (p. 356)]

It is clear, then, that Heidegger and Carnap are actually in remarkable agreement. "Metaphysical" thought of the type Heidegger is trying to awaken is possible only on the basis of a prior overthrow of the authority and primacy of logic and the exact sciences. The difference is that Heidegger eagerly embraces such an overthrow, whereas Carnap is determined to resist it at all costs.

This sheds considerable light, I believe, on the context and force of Carnap's anti-metaphysical attitude. For, by rejecting "metaphysics" as a field of cognitively meaningless pseudo-sentences, Carnap is by no means similarly rejecting all forms of traditional philosophy. He makes this perfectly clear, in fact, in his "Remarks by the Author" appended to the English translation in 1957:

To section 1, "metaphysics." This term is used in this paper, as usually in Europe, for the field of alleged knowledge of the essence of things which transcends the realm of empirically founded, inductive science. Metaphysics in this sense includes systems like those of Fichte, Schelling, Hegel, Bergson, Heidegger. But it does not include endeavors towards a synthesis and generalization of the results of the various sciences. [Ayer, 1959, p. 80]

In [Carnap, 1963b] the point is made even more explicitly:

Note that the characterization as pseudo-statements does not refer to all systems or theses in the field of metaphysics. At the time of the Vienna Circle, the characterization was applied mainly to those metaphysical systems which had exerted the greatest influence upon continental philosophy during the last century, viz., the post-Kantian systems of German

idealism and, among contemporary ones, those of Bergson and Heidegger. On the basis of later, more cautious analyses, the judgment was not applied to the main theses of those philosophers whose thinking had been in close contact with the science of their times, as in the cases of Aristotle and Kant; the latter's epistemological theses about the synthetic a priori character of certain judgments were regarded by us as false, not as meaningless. [Carnap, 1963b, pp. 874–75][18]

So Carnap is primarily concerned with "overcoming" a very particular kind of "metaphysics." The main target is the post-Kantian German idealism Carnap views as dominating European thought, and he views Heidegger, in particular, as a leading contemporary representative of this trend.

When Carnap emigrated to the United States in December 1935 he was therefore especially relieved to have finally left this European metaphysical tradition behind:

I was not only relieved to escape the stifling political and cultural atmosphere and the danger of war in Europe, but was also very gratified to see that in the United States there was a considerable interest, especially among the younger philosophers, in the scientific method of philosophy, based on modern logic, and that this interest was growing from year to year. [Carnap, 1963a, p. 34]

In 1936, when I came to this country, the traditional schools of philosophy did not have nearly the same influence as on the European continent. The movement of German idealism, in particular Hegelianism, which had earlier been quite influential in the United States, had by then almost completely disappeared. Neo-Kantian philosophical conceptions were represented here and there, not in an orthodox form but rather influenced by recent developments in scientific thinking, much like the conceptions of Cassirer in Germany. Phenomenology had a number of adherents mostly in a liberalized form, not in Husserl's orthodox form, and even less in Heidegger's version. [Ibid., p. 40]

18. On the following page Carnap continues: "I think, however, that our [anti-metaphysical] principle excludes not only a great number of assertions in systems like those of Hegel and Heidegger, especially since the latter says explicitly that logic is not applicable to statements in metaphysics, but also in contemporary discussions, e.g., those concerning the reality of space or of time." Compare [Carnap, 1963a, pp. 42-3]: "It is encouraging to remember that philosophical thinking has made great progress in the course of two thousand years through the work of men like Aristotle, Leibniz, Hume, Kant, Dewey, Russell, and many others, who were basically thinking in a scientific way."

Carnap's sense of liberation in thus putting the "stifling" political, cultural, and philosophical atmosphere in Central Europe behind him is palpable.

It is important, then, to understand Carnap's anti-metaphysical attitude in its philosophical, cultural, and political context. Carnap's concern for this broader context is characteristic of him and, in fact, formed one of the main bonds uniting him with his more activist colleague Otto Neurath. Neurath himself, as is well known, contributed an extremely engaged, neo-Marxist perspective to the Vienna Circle.[19] Indeed, he had served as economics minister in the short-lived Bavarian Soviet Republic in 1919 and received an eighteen-month sentence when it was crushed. Carnap relates how later, as a member of the Circle, Neurath continued to press for political engagement:

> One of the important contributions made by Neurath consisted in his frequent remarks on the social and historical conditions for the development of philosophical conceptions. He criticized strongly the customary view, held among others by Schlick and Russell, that a wide-spread acceptance of a philosophical doctrine depends chiefly on its truth. He emphasized that the sociological situation in a given culture and in a given historical period is favorable to certain kinds of ideology or philosophical attitude and unfavorable to others. . . .
>
> Up to this point Neurath did not find much opposition. But he went further and often presented arguments of a more pragmatic-political rather than of a theoretical nature for the desirability or undesirability of certain logical or empirical investigations. All of us in the Circle were strongly interested in social and political progress. Most of us, myself included, were socialists. But we liked to keep our philosophical work separated from our political aims. In our view, logic, including applied logic, and the theory of knowledge, the analysis of language, and the methodology of science, are, like science itself, neutral with respect to practical aims, whether they are moral aims for the individual or political aims for a society. Neurath strongly criticized this neutralist attitude, which in his opinion gave aid and comfort to the enemies of social progress. [Carnap, 1963a, pp. 22–23]

19. For a comprehensive treatment of Neurath's thought in its political context see [Cartwright, *et. al.*, 1996]. See also, and especially, [Uebel, 1996].

In spite of the difference of opinion between Neurath and the other members of the Circle at certain points, we certainly owed very much to his collaboration. Of particular importance to me personally was his emphasis on the connection between our philosophical activity and the great historical processes going on in the world: Philosophy leads to an improvement in scientific ways of thinking and thereby to a better understanding of all that is going on in the world, both in nature and in society; this understanding in turn serves to improve human life. In numerous private conversations I came into even closer contact with Neurath's ideas. [Ibid., pp. 23–24][20]

Carnap disagrees with Neurath over whether social and political arguments can be used in support of philosophical—that is, *logical*—conclusions, but he just as strongly agrees with his more activist friend and colleague that philosophy can and should serve social and political aims in its particular historical context.

As is well known, an especially striking example of Carnap's attitude towards the relationship between his philosophical work and the wider social and political context is the Preface to the *Aufbau*, dated May 1928. After calling for a radically new scientific, rational, and anti-individualistic conception of philosophy which is to emulate the slow process of mutual cooperation and collaboration typical of the special sciences, Carnap continues:

20. In the following paragraph Carnap explains Neurath's neo-Marxism: "Neurath's views about social problems were strongly influenced by Marx. But he was not a dogmatic Marxist; for him every theory must be further developed by constant criticism and re-examination. In a series of private discussion meetings with me and some younger members of the Circle, he explained the basic ideas of Marxism and showed their relevance to a better understanding of the sociological function of philosophy. He believed that our form of physicalism was an improved, non-metaphysical and logically unobjectionable version which today should supersede both mechanistic and dialectical forms of nineteenth century materialism. His expositions and the subsequent discussions were very illuminating for all of us." Carnap's own leftist and socialist political leanings were shaped much earlier, however, during his experience as an army physicist in Berlin during the Great War [Ibid., pp. 9–10]: "In Berlin I had opportunities to study political problems by reading and talking with friends; my aim was to understand the causes of the war and possible ways of ending it and of avoiding future wars. I observed that in various countries the labor parties were the only large groups which had preserved at least a remnant of the aims of internationalism and the anti-war attitude. I gradually gained a clearer understanding of the connection between the international order and the economic order, and I began to study the ideas of the socialist worker's movement in greater detail. . . . My friends in Berlin and I welcomed the German revolution at least for its negative effect, the liberation from the old powers. Similarly, we had welcomed the revolution in Russia one year earlier."

We cannot hide from ourselves the fact that trends from philosophi-cal-metaphysical and from religious spheres, which protect themselves against this kind of orientation, again exert a strong influence precisely at the present time. Where do we derive the confidence, in spite of this, that our call for clarity, for a science that is free from metaphysics, will pre-vail?—From the knowledge, or, to put it more cautiously, from the belief, that these opposing powers belong to the past. We sense an inner kinship between the attitude on which our philosophical work is based and the spiritual attitude that currently manifests itself in entirely different spheres of life. We sense this attitude in trends in art, especially in architecture, and in the movements that concern themselves with an intelligent re-shaping [*sinnvolle Gestaltung*] of human life: of personal life and the life of the community, of education, of external organization at large. We sense here everywhere the same basic attitude, the same style of thinking and working. It is the orientation that is directed everywhere towards clarity yet recognizes at the same time the never entirely comprehensible interweaving of life, towards care in the individual details and equally towards the greater shape of the whole, towards the bonds between men and equally towards the free development of the individual. The belief that this orientation belongs to the future inspires our work. [1928a, pp. x–xi (pp. xvii–viii)]

And, as Carnap explains in his diary, he is here expressing pre-cisely the attitude that he and Neurath share.[21]

Carnap suggests that his and Neurath's orientation has much in common with that of modern architecture and, in par-ticular, with that of the Bauhaus—a point which is borne out by the recollections of a younger member of the Vienna Circle, Herbert Feigl:

Carnap and Neurath also had a great deal in common in that they were somewhat utopian social reformers—Neurath quite actively, Carnap more "philosophically." . . . I owe [Neurath] a special debt of gratitude for sending me (I think as the first "emissary" of the Vienna Circle) to Bauhaus Dessau, then, in 1929, a highly progressive school of art and

21. [ASP RC 025-73-03, May 26, 1928]: "In the evening with Waismann at Neurath's. I read the Preface to the 'Logischen Aufbau' aloud; Neurath is astonished and overjoyed at my open confession. He believes that it will affect young people very sympathetically. I say that I still want to ask Schlick whether it is too radical." (Schlick did think it was too radical: see [Ibid., May 31, 1928].) Friedrich Waismann was per-haps Schlick's favorite student and the author of *Wittgenstein und der Wiener Kreis* [Waismann, 1967]. Waismann often accompanied Carnap to the meetings with Neurath on Marxism mentioned in note 20 above, although his attitude, like Schlick's, was much more skeptical.

architecture. It was there in a week's sojourn of lectures and discussions that I became acquainted with Kandinsky and Klee. Neurath and Carnap felt that the Circle's philosophy was an expression of the *neue Sachlichkeit* which was part of the ideology of the Bauhaus. [Feigl, 1969, p. 637]

Carnap's basic philosophical-political orientation is thus best expressed by the *neue Sachlichkeit* (the new objectivity, soberness, matter-of-factness)—a social, cultural, and artistic movement committed to internationalism, some form of socialism, and, above all, to a more objective, scientific, and anti-individualistic reorganization of both art and public life inspired equally by the new Russian communism and the new American technology.[22]

Carnap and Heidegger are therefore not only at opposite ends of the spectrum philosophically, they are at opposite ends of the spectrum in social and political terms as well. And I think there is no doubt that this social and political dimension of their disagreement represents at least part of the explanation for the circumstance that Carnap chooses precisely Heidegger for his examples of metaphysical pseudo-sentences. Indeed, particularly when read in the context of such programmatic statements as the Preface to the *Aufbau*, this is already suggested by the sentence, quoted above, where Carnap explains that he has here chosen to "select a few sentences from that metaphysical doctrine which at present exerts the strongest influence in Germany." Such a social and political context is also suggested by a passage in § 6 of "Überwindung der

22. For a general cultural and political history of this orientation see [Willett, 1978]. For a discussion of the relationship between the Vienna Circle and the Bauhaus see [Galison, 1990]. Not all members of the Vienna Circle shared in this orientation, however. Moritz Schlick, in particular, was attracted neither to Marxism nor to anti-individualism more generally. Thus, for example, [Feigl, 1969, p. 646] poignantly describes Schlick's reaction when he was presented with *Wissenschaftliche Weltauffassung*—which calls for a new international and collaborative form of philosophy and, in keeping with this spirit, is not even signed by its authors—on his return from Stanford in 1929: "Schlick was moved by our amicable intentions; but as I could tell from his facial expression, and from what he told me later, he was actually appalled and dismayed by the thought that we were propagating our views as a 'system' or 'movement'. He was deeply committed to an individualistic conception of philosophizing, and while he considered group discussion and mutual criticism to be greatly helpful and intellectually profitable, he believed that everyone should think creatively for himself. A 'movement', like large scale meetings or conferences, was something he loathed."

Metaphysik," where Carnap explains that the method of logical analysis has both a negative aspect (anti-metaphysical) and a positive aspect (constructive analysis of science): "This negative application of method is necessary and important in the present historical situation. But the positive application—already even in contemporary practice—is more fruitful."[23] Carnap expresses this last idea in stronger and more militant terms, however, in the second lecture version of "Überwindung der Metaphysik," presented at Berlin and Brünn in July and December 1932. In this version the lecture closes with a discussion of the positive task of the method of logical analysis (that is, the clarification of the sentences of science) and, in particular, with the following words:

> These indications [are presented] only so that one will *not* think that the *struggle [Kampf] against metaphysics is our primary task*. On the contrary: in the meaningful realm [there are] many tasks and difficulties, there will always be enough struggle<?>. The struggle against metaphysics is only necessary because of the historical situation, in order to reject hindrances. There will, I hope, come a time when one no longer needs to present lectures against metaphysics. [ASP RC 110-07-19, p. 4]

Coming at the very end of Carnap's lecture at Berlin in July of 1932, one can imagine that this statement had a much more dramatic impact than the more subtle suggestions buried in the published version.[24]

23. [Carnap, 1932a, p. 238 (p. 77)]. Compare also the Preface to *Logical Syntax of Language*, dated May, 1934 [Carnap, 1934, p. iii (p. xiii)]: "In our 'Vienna Circle' and in many similarly-oriented groups (in Poland, France, England, USA and *in isolated cases even in Germany*) the view has currently grown stronger and stronger that traditional metaphysical philosophy can make no claim to scientific status" (my emphasis). For Carnap's view (from Prague) of the situation in Germany and Central Europe in 1934 see his [1963a, p. 34]: "With the beginning of the Hitler regime in Germany in 1933, the political atmosphere, even in Austria and Czechoslovakia, became more and more intolerable. . . . [T]he Nazi ideology spread more and more among the German-speaking population of the Sudeten region and therewith among the students of our university and even among some of the professors." (This, of course, refers to a time later than the publication of "Überwindung der Metaphysik" in 1932, when, in particular, Hitler had not yet come to power—nor had Heidegger yet assumed the rectorate at Freiburg under the Nazi regime.)

24. [ASP RC 025-73-03, July 5, 1932] triumphantly records the fact that there were 250 people in the audience at Berlin.

Neurath, for his part, dispenses entirely with all such sub-
tleties. He never tires, for example, of characterizing "meta-
physicians" and "school philosophers"—among whom
Heidegger is a prominent representative—as enemies of the
proletariat:

> Science and art are today above all in the hands of the ruling classes and
> will also be used as instruments in the class struggle against the prole-
> tariat. Only a small number of scholars and artists place themselves on the
> side of the coming order and set themselves up as protection against this
> form of reactionary thought.
>
> The idealistic school philosophers of our day from Spann to
> Heidegger want to rule, as the theologians once ruled; but the scholastics
> could support themselves on the substructure of the feudal order of pro-
> duction, whereas our school philosophers do not notice that their sub-
> structure is being pulled out from beneath their feet.[25]

Neurath was particularly ill-disposed towards attempts by such
thinkers as Heinrich Rickert, Wilhelm Dilthey, and Heidegger
to underwrite a special status for the *Geisteswissenschaften* in
relation to the *Naturwissenschaften* (the humanities or cultural
sciences in relation to the natural sciences), which attempts,
according to Neurath, constitute one of the principal obstacles
to rational and scientific social progress.[26]

That Carnap was in fact in basic agreement with Neurath
here emerges clearly in a conversation he records after his final
presentation of "Überwindung der Metaphysik" at Brünn in
December 1932:

> My lecture "Die Überwindung der Metaphysik" (Il . . . had added: and
> the world-view of modern philosophy) in the banquet hall. Pretty well

25. [Neurath, 1932 (1981), pp. 572-3]. Orthmar Spann was an especially virulent
Austrian-Catholic right-wing ideologue of the time: compare note 7 above.

26. See, for example, the remarks (made in 1933) in [Neurath, 1981, p. 597n]:
"Here [in Austria] there is not an exclusive dominance by metaphysics as it is practiced
by Rickert, Heidegger, and others—through which those of a new generation become
well known through 'geisteswissenschaftlicher Psychologie', 'geisteswissenschaftlicher
Soziologie', and similar things." Compare Carnap's remarks on Neurath's commitment
to physicalism and unified science in [1963a, p. 23], together with his remarks on
Marxism and physicalism in the passage quoted in note 20 above.

attended, lively participation, $1\frac{1}{4}$ hours. Afterwards various questions. *Erkenntnis* is here completely unknown. Then to a cafe. Prof. B . . . , chemist, gives philosophical courses at the popular university, will report on my lecture in the socialistic . . . newspaper. Marxist, is pleased with my Marxist views on how metaphysics will be overcome through reformation [*Umgestaltung*] of the substructure. [ASP RC 025-73-03, December 10, 1932]

[handwritten margin note: contrast to today]

There can be very little doubt, therefore, that Carnap's attack on Heidegger, articulated and presented at a critical moment during the last years of the Weimar Republic, had more than purely philosophical motivations—or, perhaps better: that Carnap, like Neurath, conceived his philosophical work (and the attack on Heidegger in particular) as a necessary piece of a much larger social, political, and cultural struggle.[27]

It is noteworthy, finally, that Heidegger was aware of Carnap's attack and, indeed, explicitly responded to it—in a draft of the original 1935 lecture course, *Introduction to Metaphysics,* that does not appear in the published version in 1953. Heidegger explains how, with the collapse of German idealism in the second half of the nineteenth century, the philosophical understanding of Being degenerated into a consideration of the "is"—that is, a logical consideration of the propositional copula. He continues in a memorable paragraph which is worth quoting in full:

> Going further in this direction, which in a certain sense has been marked out since Aristotle, and which determines "being" from the "is" of the proposition and thus finally destroys it, is a tendency of thought

27. Compare also the following retrospective remarks (made in 1936) in [Neurath, 1981, p. 743]: "The strong metaphysical trends in Central Europe are probably the reason that within the Vienna Circle the anti-metaphysical attitude became of central significance and was purposefully practiced—much more, for example, then would have been the case with the adherents of similar tendencies in the United States, among whom a particular, more neutral commonsense empiricism is very widespread and where metaphysics could not exert the influence that it did in Germany, say. . . . It is entirely understandable that a Frenchman is at first surprised when he hears how the adherents of the Vienna Circle distance themselves in sharp terms from 'philosophers'—he thinks perhaps of Descartes and Comte in this connection, the others however of Fichte and Heidegger."

that has been assembled in the journal *Erkenntnis*. Here the traditional logic is to be for the first time grounded with scientific rigor through mathematics and the mathematical calculus, in order to construct a "logically correct" language in which the propositions of metaphysics—which are all pseudo-propositions—are to become impossible in the future. Thus, an article in this Journal II (1931 f.), pp. 219 ff. bears the title "Überwindung der Metaphysik durch logische Analyse der Sprache." Here the most extreme flattening out and uprooting of the traditional theory of judgment is accomplished under the semblance of mathematical science. Here the last consequences of a mode of thinking which began with Descartes are brought to a conclusion: a mode of thinking according to which truth is no longer disclosedness of what is and thus accommodation and grounding of Dasein in the disclosing being, but truth is rather diverted into *certainty*—to the mere securing of thought, and in fact the securing of mathematical thought against all that is not thinkable by it. The conception of truth as the securing of thought led to the definitive profaning [*Entgötterung*] of the world. The supposed "philosophical" tendency of mathematical-physical positivism wishes to supply the grounding of this position. It is no accident that this kind of "philosophy" wishes to supply the foundations of modern physics, in which all relations to nature are in fact destroyed. It is also no accident that this kind of "philosophy" stands in internal and external connection with Russian communism. And it is no accident, moreover, that this kind of thinking celebrates its triumph in America. All of this is only the ultimate consequence of an apparently merely grammatical affair, according to which Being is conceived through the "is," and the "is" is interpreted in accordance with one's conception of the proposition and of thought.[28]

Thus Heidegger, in terms no more subtle than Neurath's, once again expresses a rather remarkable agreement with Carnap

28. [Heidegger, 1983, pp. 227–28]; the unpublished pages apparently were replaced by [Heidegger, 1953, pp. 78-90 (pp. 86–99)]. I am indebted to Kathleen Wright for first calling my attention to this passage. Wright also pointed out to me that the noted Heidegger scholar Otto Pöggeler comments on this passage as follows [Pöggeler, 1991, pp. 218–19]: "Heidegger had sufficient taste not to deliver a previous version of his lecture in which Carnap's emigration to America was put forth as confirmation of the convergence between Russian communism and the 'type of thinking in America'." Given that Carnap did not emigrate until December 1935, however, whereas Heidegger's lectures were delivered in the summer of that year, Heidegger cannot be referring to Carnap's emigration. It is more likely, for example, that he is referring to Schlick's trip to Stanford in 1929, which is prominently mentioned in the forward to *Wissenschaftliche Weltauffassung* (see note 22 above). The remark about Russian communism, on the other hand, almost certainly refers to Neurath's activities.

concerning the underlying sources of their opposition, which, as is now clear, extend far beyond the purely philosophical issues between them.[29]

29. In the mid to late 1930s, in connection with his work on Nietzsche and his increasing concern with technology, Heidegger began to use the expression "overcoming metaphysics" to characterize his own philosophical ambitions. See for example [Heidegger, 1954], written in the years 1936–41 (contemporaneous with his Nietzsche lectures). This period marks Heidegger's attempt to come to terms with the failure of his rectorate and his consequent disenchantment with the Nazi regime (in particular, with its overwhelmingly technological character). See [Safranski, 1994, chapter 17] for an illuminating description of this period. It is possible that Carnap, too, made a connection between "overcoming metaphysics" and Nietzsche. For [Carnap, 1932a, p. 241 (p. 80)] refers explicitly and very favorably to *Thus Spake Zarathustra*, where the themes of the *Überwindung* and *Selbstüberwindung* of man (leading to the *Übermensch*) figure prominently. Here I am especially indebted to perceptive comments by Peter Gordon.

3

The Neo-Kantian
Background

As we have seen, the philosophical issues between Carnap and Heidegger are based, in the end, on a stark and profound disagreement about the nature and centrality of logic. Thus Carnap criticizes "Nothingness itself nothings" primarily on the grounds of logical form. Modern mathematical logic shows that the concept of nothing is to be explained in terms of existential quantification and negation and can therefore by no means function either as a substantive (individual constant) or as a verb (predicate). For Heidegger, by contrast, such a purely logical analysis misses precisely his point. What he calls nothingness is prior to logic and hence prior, in particular, to the concept of negation. In tracing out the roots of this fundamental disagreement over the philosophical centrality of logic, it turns out, we need to return to the issues about neo-Kantianism and the "transcendental schematism of the understanding" raised in the Cassirer-Heidegger disputation at Davos in 1929.

The first point to notice is that all three men—Carnap, Cassirer, and Heidegger—were philosophically trained within the neo-Kantian tradition that dominated the German-speaking world at the end of the nineteenth century and the beginning of the twentieth. One should really not say "the" neo-Kantian tradition here, for there were in fact several quite distinguishable versions. But the two largest "schools" (which are also of most importance for our purposes) were the so-called Marburg School of neo-Kantianism founded by Hermann Cohen and then continued by Paul Natorp and (at least until about 1920)

25

Cassirer himself,[30] and the so-called Southwest School of neo-Kantianism founded by Wilhelm Windelband and systematically developed by Heinrich Rickert. Heidegger studied with Rickert at Freiburg (before the latter succeeded Windelband at Heidelberg) and, as noted above, completed his habilitation under Rickert. Carnap, for his part, studied Kant at Jena with Bruno Bauch—also a student of Rickert's from Freiburg—and, in fact, wrote his doctoral dissertation under Bauch. It is clear, moreover, that Carnap carefully studied several versions of neo-Kantianism, including, in particular, the writings of Natorp, Cassirer, and Rickert.[31]

Common to both the Marburg and Southwest Schools of neo-Kantianism is a certain conception of epistemology and the object of knowledge inherited from Kant.[32] Our knowledge or true judgments should not be construed, according to this conception, as representing or picturing objects or entities that exist independently of our judgments, whether these independent entities are the "transcendent" objects of the metaphysical realist existing somehow "behind" our sense experience or the naked, unconceptualized sense experience itself beloved of the empiricist. In the first case ("transcendent" objects) knowledge or true judgment would be impossible for us, since, by hypothesis, we have absolutely no independent access to such entities by which we could compare our judgments with them so as to verify whether the desired relation of representation or picturing actually holds. In the second case (naive empiricism) knowledge or true judgment would be equally impossible, for the stream of unconceptualized sense experience is in fact utterly chaotic and intrinsically undifferentiated. Comparing the articulated structures of our judgments

30. The qualification is necessary because, as Krois [1987] especially has argued, it would be a mistake to regard Cassirer's philosophy of symbolic forms as simply a continuation of Marburg neo-Kantianism. This issue will be pursued further below.

31. Carnap explains his neo-Kantian philosophical training in [Carnap, 1963a, pp. 4, 11–12]. Writings of Cassirer, Natorp, and Rickert (as well as Bauch) play an important role in the *Aufbau*: see [Carnap, 1928a, §§ 5, 12, 64, 65, 75, 162, 163, 179].

32. Some of the most important epistemological works of the two traditions are [Cohen, 1902], [Natorp, 1910], [Cassirer, 1910], and [Rickert, 1882]. Very useful summary presentations of the basic ideas of the two traditions are [Rickert, 1909] and [Natorp, 1912].

to this chaos of sensations simply makes no sense. How, then, is knowledge or true judgment possible? What does it mean for our judgments to relate to an object? The answer is given by Kant's "Copernican Revolution." The object of knowledge does not exist independently of our judgments at all. On the contrary, this object is first created or "constituted" when the unconceptualized data of sense are organized or framed within the a priori logical structures of judgment itself. In this way, the initially unconceptualized data of sense are brought under a priori "categories" and thus first become capable of empirical objectivity.

Yet there is a crucially important difference between this neo-Kantian account of the object of knowledge and judgment and Kant's original account. For Kant, we cannot explain how the object of knowledge becomes possible on the basis of the a priori logical structures of judgment alone. We need additional a priori structures that mediate between the pure forms of judgment comprising what Kant calls general logic and the unconceptualized manifold of impressions supplied by the senses. These mediating structures are the pure forms of sensible intuition, space, and time. What Kant calls the pure logical forms of judgment only become categories in virtue of the transcendental schematism of the understanding—that is, when pure forms of thought are given a determinate spatio-temporal content in relation to the pure forms of sensible intuition. The pure logical form of a categorical judgment, for example, becomes the category of *substance* when it is schematized in terms of the temporal representation of permanence; the pure logical form of a hypothetical judgment becomes the category of *causality* when it is schematized in terms of the temporal representation of succession; and so on. For Kant, then, pure formal logic (general logic) must, if it is to play an epistemological role, be supplemented by what he calls transcendental logic—with the theory of how logical forms become schematized in terms of pure spatio-temporal representations belonging to the independent faculty of pure intuition. And it is precisely this theory, in fact, that forms the heart of the transcendental analytic of the *Critique of Pure Reason*—the so-called metaphysical and transcendental deductions of the categories.

Now both versions of neo-Kantianism entirely reject the idea of an independent faculty of pure intuition. The neo-Kantians here follow the tradition of post-Kantian idealism in vigorously opposing the dualistic conception of mind characteristic of Kant's own position: the dualism, that is, between a logical, conceptual, or discursive faculty of pure understanding and an intuitive, non-conceptual, or receptive faculty of pure sensibility. For the neo-Kantians, the a priori formal structures in virtue of which the object of knowledge becomes possible must therefore derive from the logical faculty of the understanding and from this faculty alone. Since space and time no longer function as independent forms of pure sensibility, the constitution of experience described by "transcendental logic" must now proceed on the basis of purely conceptual—*and thus essentially non-spatio-temporal*—a priori structures.

It is this last feature of their conception of epistemology, moreover, that associates the neo-Kantians with Husserlian phenomenology and, in particular, with the polemic against psychologism of the *Logical Investigations* [Husserl, 1900]. For the neo-Kantians had also arrived, albeit by a different route, at a conception of pure thought or "pure logic [*reine Logik*]" whose subject matter is an essentially non-temporal, and therefore certainly not psychological realm—an "ideal" realm of timeless, formal-logical structures.[33] Thus, in a well-known passage in the course of his own polemic against psychologism Natorp [1912, p. 198] explains that "from Husserl's beautiful exposition (in the first volume of the *Logical Investigations*), which we could only welcome, there still remains not so much new for us to learn." And Rickert comments on the relationship between his own version of Kantianism and the anti-psychologistic tendencies epitomized by the idea of "pure logic" as follows:

> Certainly, important ideas precisely concerning a "pure" logic have also arisen independently of Kant. Bolzano's theory of the "proposition in

33. This needs qualification in the case of the *Marburg* neo-Kantian view of "transcendental" (as opposed to merely "formal") logic: see note 35 below. As we shall see, the Marburg conception of "transcendental" logic centrally involves the idea of knowledge as a developmental *process*.

itself" contains—no matter how much one may take exception to its details—a permanent kernel [of truth], and Husserl has built further on this foundation in an interesting fashion. But, on the other hand, it is precisely Husserl who shows that a "pure" logic has not yet achieved a thoroughgoing delimitation from psychology.[34]

As Rickert here intimates, however, although he indeed champions the idea of a "pure," non-psychological logic, he nonetheless finds problems in maintaining a complete divorce between the two realms.

In order properly to understand the problems Rickert finds here, however, it is necessary to appreciate the main points of difference between the Marburg and Southwest traditions. For present purposes there are basically three such points, which involve, first, the relationship between mathematics and the realm of pure logic; second, the relationship between the realm of pure logic and the "pre-conceptual" manifold of sensation; and third, the relationship between the logical realm and the realm of values.

With respect to the first point, the relationship between mathematics and the realm of pure logic, the central difference is that the Marburg School includes the former within the latter, whereas the Southwest School sharply and expressly separates them. This emerges with particular explicitness in a dispute between Natorp and Rickert in the years 1910–11. Natorp [1910] argues that the concept of number belongs to "pure thought" and thus neither to pure intuition nor to psychology. Rickert [1911] directly challenges Natorp's conception, arguing that the concept of one as a number (as the first element of the number series) cannot be derived from the logical concepts of identity and difference, and is therefore "alogical." For Rickert, the numerical concept of one, unlike the logical concepts of identity and difference, does not apply to all objects of thought as such but presupposes that we are given certain specific objects arranged in a homogeneous serial order.

34. [Rickert, 1909, p. 227]. Bolzano, Herbart, Lotze, and Meinong were generally recognized as central nineteenth-century sources for the idea of "pure logic," both within neo-Kantianism and by Husserl himself.

The numerical concept of *quantity* can therefore not belong to logic.

The underlying issues stand out most clearly from the point of view of Cassirer's own version of the Marburg doctrine. For Cassirer's outstanding contribution here was to articulate, for the first time, a clear and coherent conception of formal logic within the context of the Marburg School.[35] *Substance and Function* [Cassirer, 1910] identifies formal logic with the new theory of relations developed especially by Bertrand Russell in *The Principles of Mathematics* [Russell, 1903]. Following Dedekind's work, in particular, we can then identify the object of arithmetic or the theory of number with a particular species of relational structure—with what we now call a simply infinite series or progression. What the numbers are, therefore, are simply "places" within such a series or progression, and the concept of number is just as logical as any other relational concept. Indeed, since the concept of number (unlike empirical concepts, for example) is thus entirely exhausted by the formal properties of a particular kind of relational structure, it is the very paradigm of a purely logical concept.[36] Thus, what really separates the Marburg School from Rickert is the latter's much narrower conception of logic. Rickert still identifies formal logic with the traditional subject-predicate logic, which is indeed confined to relations of genus and species and thus to the purely symmetrical relations of identity and difference. For Cassirer, by contrast, formal logic embraces the entire theory of relations, including (paradigmatically) such *asymmetrical* relations as that which generates the number series.[37]

35. It is important to note, nevertheless, that for Cassirer (and for the Marburg School more generally) pure formal logic is itself an abstraction from a more fundamental, non-formal or transcendental logic. This will be discussed in detail in chapter 6 below.

36. [Cassirer, 1910, chapter 2]. Cassirer is of course basing his account on [Dedekind, 1883]. Note that it is central to Cassirer's conception of the logical nature of arithmetic that we define the number series *solely* through the formal properties of a particular relational system, and, accordingly, he explicitly rejects Frege's and Russell's logicist reduction of numbers to classes.

37. See especially [Cassirer, 1929b, p. 406 (p. 348)]: "Rickert's proof-procedure, in so far as it is simply supposed to verify this proposition [that number is not derivable from identity and difference], could have been essentially simplified and sharpened if he had availed himself of the tools of the modern logical calculus, especially the calculus of relations. For *identity* and *difference* are, expressed in the language of this calculus, *symmetrical* relations; whereas for the construction of the number series, as for the concept of an ordered sequence in general, an *asymmetrical* relation is indispensable."

With respect to the second point, the relationship between the realm of pure logic and the manifold of sensation, the main difference is that the Southwest School affirms an explicitly dualistic conception according to which the realm of pure thought stands over and against a not yet synthesized manifold of sensation (a not yet formed "matter"), whereas the Marburg School strives, above all, to avoid this dualism. This is the entire point, in fact, of their "genetic" conception of knowledge as an infinitely progressing series wherein more and more layers of "form" are successively injected by the application of our scientific methods so as gradually to constitute the object of empirical natural science. In this methodological progression we never find either pure unformed matter or pure contentless form, but only an infinite series of levels in which any two succeeding stages relate to one another *relatively* as matter and form. The object of knowledge itself, as the "reality" standing over and against pure thought, is simply the ideal limit point— the never completed "X"—towards which the methodological progress of science is converging. There is thus no "pre-conceptual" manifold of sensations existing independently of pure thought at all. There is only an infinite methodological series in which the forms of pure thought are successively and asymptotically applied. In this way, for the Marburg School, "reality" becomes incorporated within the realm of pure thought itself, and it is with good reason, then, that their epistemological conception becomes known as "logical idealism."

Once again, the clearest and most sophisticated expression of this distinctively Marburg conception is found in *Substance and Function* [Cassirer, 1910]. For Cassirer, as we have seen, the realm of pure formal logic is constituted by the totality of pure relational structures characterized by the new logical theory of relations. Within this realm considered in itself there is thus no change and no temporality. In mathematical natural science, however, the problem is to describe the spatio-temporal empirical world of experience by precisely such pure (atemporal) relational structures. This problem, unlike a purely mathematical problem, can never be completely and definitively solved. On the contrary, the method of mathematical natural science essentially involves a never completed series of more and more accurate approximations, whereby we represent the

object of natural science by successively more adequate pure relational structures. And it is this methodological series, for Cassirer, that represents the ultimate datum for epistemology. Hence, since we never in fact find either unformed matter or contentless form within this series, these concepts must be viewed rather as abstractions having only a relative meaning at some or another particular stage.[38]

What is at stake here becomes clearer if we contrast both approaches, that of the Southwest and that of the Marburg School, with the approach originally taken by Kant himself. Kant, like the Southwest School, identifies formal logic with traditional syllogistic logic and, accordingly, he also sharply separates logic and mathematics. Moreover, Kant, again like the Southwest School, sets a not yet conceptualized manifold of sensation over and against the pure forms of logical thought. The problem of the categories is then precisely to explain how such pure forms of thought apply to the manifold of sensation so as to make the object of cognition possible in the first place. For Kant himself, however, this application of the forms of thought to the given manifold of sensations is itself only possible on the basis of an *intermediate* structure, the pure forms of sensibility, through which, in particular, the pure forms of thought acquire a spatio-temporal and therefore mathematical content. For Kant, now like the Marburg School, it is above all mathematical physics (what Kant calls "pure natural science") that exemplifies the application of the categories to objects of experience. According to neo-Kantianism generally, however, there is no independent faculty of pure intuition, and so this deficiency is made good, in the approach of the Marburg School, by incorporating pure mathematics into formal logic

38. See, e.g., [Cassirer, 1910, pp. 412–13 (p. 311)]: "Matter *is* only in relation to form, just as form *is* valid [*gilt*] only in relation to matter. If one neglects this coordination [*Zuordnung*] then there remains no 'existence' for either—into whose ground and origin one could inquire. The material particularity of the empirical content can therefore never be adduced as a proof of the dependence of all cognition of objects on a simply 'transcendent' ground of determination: for this determinateness, which as such undeniably subsists, is nothing other than a characteristic of *cognition itself*, through which the concept of knowledge is first completed." Empirical determinateness, for Cassirer, refers only to the never ending but convergent series exemplified by the methodological progress of mathematical natural science.

and by *replacing* the given manifold of sensation with the methodological progression of mathematical natural science. In the approach of the Southwest School, by contrast, we are left only with the forms of judgment of traditional formal logic on the one side and the "pre-conceptual" given manifold of sensations on the other—the crucial mathematical intermediary is missing. So, as one would expect, particularly vexing problems arise within the Southwest School in attempting to explain the application of the categories to objects of experience.

These problems are further exacerbated by the third point of difference between the Marburg and Southwest Schools, with respect to the relationship between the logical realm and the realm of values. For, from the fact that logic is a normative science, the Southwest School concludes that the "ideality" of logic is ultimately that of the realm of values in general—the realm of what Rickert calls "transcendental value" or the "transcendental ought."[39] In this way, the gulf between pure logic and "reality" (together with the closely related gulf between pure logic and psychology) becomes, in the end, the gulf between value and fact. It is then in order to overcome precisely this gulf that Rickert finds it necessary to supplement "transcendental logic":

> The first step on this way [transcendental logic] consisted in the separation of psychological being from sense, of the act of thinking from the thought. Only because this separation was accomplished was the particular mode of this investigation, together with all its resulting advantages, based on the radical gulf between value and reality. But these advantages have their other side. It must be clear that an investigation consisting essentially in separation is then incapable of reestablishing a connection between object and cognition. And thus this procedure is shown to be in principle one sided and incomplete. It is thereby shown to be in need of supplementation. In order to become complete and to yield a system of epistemology a way back must be found from the transcendent values at rest in themselves to the psychological process of cognition; but this way

39. This provides Rickert, in particular, with a further means of distinguishing between mathematics and logic. For mathematical entities are certainly "ideal"—they are timeless, necessary, and so on—but they are nevertheless not "valid" (that is, capable of truth and falsity). Hence the "ideal" realm of mathematical entities is distinct from the logical realm of "valid" propositions; for the latter, but not the former, belongs to the "ideal" realm of *value*: see [Rickert, 1909, pp. 201–02].

back has been cut off once and for all through the first step, which estab-
lished an unbridgeable cleft between being and value. [Rickert, 1909, p.
218]

Rickert is thereby led back to what he calls the "first way,"
namely, to "transcendental psychology." And it is in this con-
text, finally, that he makes the remark about Husserl and psy-
chology quoted above (in the passage to which note 34 is
appended).

Cassirer, for his part, rejects all such essentially dualistic con-
ceptions as "metaphysical." He rejects the equation of logical
"validity" with value, in particular, but, more importantly, he
refuses to allow any of Rickert's basic distinctions to be taken
as ultimate:

> [T]he sense of all objective judgments reduces to a final original relation,
> which can be expressed in different formulations as the relation of "form"
> to "content," as the relation of "universal" to "particular," as the relation
> of "validity [*Geltung*]" to "being [*Sein*]." Whatever designation one may
> finally choose here, what is alone decisive is that the basic relation itself is
> to be retained as a strictly *unitary* relation, which can only be designated
> through the two opposed moments that enter into it—but never con-
> structed out of them, as if they were independent constituents present in
> themselves. The original relation is not to be defined in such a way that
> the "universal" somehow "subsists" next to or above the "particular"—
> the form somehow separate from the content—so that the two are then
> melded with one another by means of some or another fundamental syn-
> thesis of knowledge. Rather, the unity of mutual *determination* consti-
> tutes the absolutely first datum, behind which one can go back no
> further, and which can only be analyzed via the duality of two "view-
> points" in an artificially isolating process of abstraction. It is the basic flaw
> of all metaphysical epistemologies that they always attempt to reinterpret
> this duality of "moments" as a duality of "elements."[40]

Cassirer's criticism is thus that all the fundamental distinctions
of the Southwest School—between the "ideal" forms of judg-

40. [Cassirer, 1913, pp. 13–14]. This essay is a critical review of contemporary
trends in epistemology, with particular attention to the views of Rickert and the
Southwest School. I am indebted to Werner Sauer for first calling my attention to this
essay and for emphasizing to me, in this connection especially, the crucially important
differences between Cassirer and the Southwest School.

ment and the "preconceptual" manifold of sensation, between
thought and "reality," between "validity" and "being,"
between value and fact, between pure logic and (transcenden-
tal) psychology—have only a *relative* meaning, which, as we
have seen, must always be understood in the context of some
or another stage of the never ending methodological progress
of science.[41]

The underlying tensions expressed in the epistemology of
the Southwest School—the gulf, in particular, between the
forms of judgment of traditional logic and the unsynthesized
manifold of sensation—are articulated most starkly and explic-
itly in the work of Emil Lask, a brilliant former student of
Rickert's who then held an associate professorship at
Heidelberg and was killed in the Great War in 1915.[42] The
basic argument of [Lask, 1912] is that, whereas the Kantian
philosophy has indeed closed the gap between knowledge and
its object, we are nonetheless left with a new gap between what
Lask calls "transcendental," "epistemological," or "material"
logic on the one side and "formal" logic on the other. Formal
logic is the subject matter of the theory of judgment—the
realm of necessarily valid and timeless "senses," "objective
thoughts," or "propositions in themselves" familiar under the

41. How this relativity works is expressed most clearly, perhaps, in Cassirer's rein-
terpretation of the Kantian distinction between "judgments of perception" (mere sub-
jective apprehension of sensation) and "judgments of experience" (genuinely objective
knowledge claims). According to [Cassirer, 1910, pp. 324–26 (pp. 245–46)] this does
not express a dualistic opposition between two essentially different *types* of judgment
but rather a gradual and successive *increase* of objectification: the (relatively) perceptual
judgment "bodies are heavy," for example, is replaced first by the Galilean law of fall,
then by the law of universal gravitation, and so on. A similar relativity applies even to
"consciousness" and the "I"—they, too, have meaning only *within* the unitary
methodological progress of scientific knowledge [Cassirer, 1910, p. 411 (p. 310)]:
"[W]ithout a *temporal* sequence and order of contents, without the possibility of col-
lecting them into determinate *unities* and of separating them again into different *plu-
ralities*, without the possibility, finally, of distinguishing relatively constant subsistent
entities [*Bestände*] from relatively changing ones, the thought of the I has no specifi-
able meaning and application. Analysis teaches us with univocal determinateness *that* all
these relational forms enter into the concept of 'being' as into that of 'thought', but it
never shows us *how* they are joined, nor *whence* they have their origin. Every question
as to this origin, every reduction of the fundamental forms to an action of things or to
a type of activity of mind would involve an obvious *petitio principi*: for the 'whence' is
itself nothing but a determinate form of logical relation."
42. See Rickert's homage to Lask in the Preface to the third edition of *Der
Gegenstand der Erkenntnis* [Rickert, 1882 (1915), pp. xii–xiv].

rubric of "pure logic."[43] Transcendental or material logic, by contrast, is the theory of the categories—the theory of how the concrete object of knowledge and experience is made possible by the constitutive activity of thought. But, and here is the central idea of Lask's argument, transcendental or material logic is not based on formal logic, and, accordingly, we explicitly reject Kant's metaphysical deduction of the categories, whose entire point, as noted above, is precisely to derive the categories from the logical forms of judgment.[44] For Lask, what is fundamental is the concrete, already categorized real object of experience. The subject matter of formal logic (which include all the structures of the traditional logical theory of judgment) only arises subsequently in an artificial process of abstraction, by which the originally unitary categorized object is broken down into form and matter, subject and predicate, and so on. Moreover, since this comes about due to a fundamental weakness or peculiarity of our human understanding—our inability to grasp the unitary categorized object as a unity—the entire realm of "pure logic," despite its timeless and necessary character, is, in the end, an artifact of subjectivity. What really and ultimately exists is simply the (non-sensible) valuable in itself on the one side and the sensible and intuitive valueless manifold of perception on the other. The entire realm of "pure logic" is nothing but an artificially constructed intermediary possessing no explanatory power whatsoever.

From the perspective of our earlier contrast between the neo-Kantian conception of epistemology and that of Kant himself it is clear, I think, what has happened here. After we have discarded the Kantian theory of space and time as pure forms of sensibility (which provide the crucial mathematical intermediary between the pure forms of thought and the unsynthe-

43. Here [Lask, 1912, pp. 23–24] cites, among others, the theories of Herbart, Bolzano, Husserl, Rickert, Meinong, and (Heinrich) Gomperz. Note that what Lask calls "formal logic" corresponds to what Rickert calls "transcendental logic," where the pure forms of thought are considered entirely in abstraction from their real application. This is *not* what the Marburg School means by transcendental logic, which is in fact much closer to Lask's meaning (see note 35 above).

44. [Lask, 1912, p. 55]: "The 'form' of judgment, concept, inference etc. is a completely different thing from form in the sense of the category. One best distinguishes these two kinds of form as structural form and contentful form."

sized manifold of sensation), it then makes no sense at all to attempt a metaphysical deduction of the categories from the pure logical forms of judgment—a deduction that rests wholly and completely on the idea that "the same understanding, through precisely the same actions whereby, in concepts, by means of analytic unity, it brought about the logical form of a judgment, also, by means of the synthetic unity of the manifold of intuition in general, brings a transcendental content into its representations in virtue of which they are called pure concepts of the understanding" (A79/B105). On the contrary, the pure forms of judgment of traditional logic now appear as bereft of all power even to begin the "constitution" of any real empirical object. And what this shows, finally, is that the transcendental schematism of the understanding is indeed essential to the Kantian system. We cannot simply discard it without, at the same time, distorting the rest of the Kantian framework entirely beyond recognition.[45]

45. The Marburg School also discards the transcendental schematism of the understanding in Kant's original sense, but their basic move is to reject the theory of traditional formal logic as well. Thus for Cassirer, as we have seen, the realm of pure formal logic is given by the modern theory of relations, the totality of what we now call pure relational structures, and it is in precisely this way that the mathematical intermediary between pure thought and empirical reality is then restored via the "genetic" conception of empirical knowledge. It is on this basis, in fact, that Cassirer rejects both the general attempt to include logic within the theory of value and Lask's particular arguments for the artificiality of logical structure: see [Cassirer, 1913, pp. 6–13]. Cassirer's treatment of this central post-Kantian problematic will be explored in detail in chapter 6 below.

4

Heidegger

Heidegger, as we noted, received his philosophical education within the neo-Kantian tradition of the Southwest School as it was articulated by Rickert at Freiburg. It is by no means surprising, therefore, that his earliest writings are largely concerned with the idea of "pure logic" and its ensuing problematic. Heidegger's first publication, "Neuere Forschungen über Logik" (1912), is a critical review of recent contributions to logic with particular emphasis on the need to overcome psychologism. His doctoral dissertation, *Die Lehre vom Urteil im Psychologismus* (1913), is a much more extended treatment of the same theme which exposes some of the most popular current theories of judgment (of Wundt, Maier, Brentano, Marty, and Lipps) as psychologistic and therefore unacceptable. Finally, Heidegger's habilitation, *Die Kategorien- und Bedeutungslehre des Duns Scotus* (1915), is a reading of the *Grammaticae speculativae* (which was then attributed to Scotus) through the lenses of the contemporary logical investigations of Rickert, Lask, and Husserl.[46]

Heidegger's early investigations revolve around the central distinctions between psychological act and logical content, between real thought process and ideal atemporal "sense," between being [*Sein*] and validity [*Geltung*]. For, as Lotze in

46. All three works are reprinted in [Heidegger, 1978], to which we refer in our citations. Among the logical works Heidegger comments upon are some of Frege's (on which Heidegger comments positively [1978, p. 20]) and Russell's (on which Heidegger comments negatively [1978, pp. 42–43, 174]). Heidegger seems to see in Frege's ideas a concern for *meaning* appropriate to a "philosophical" logic, whereas Russell's work appears to him to tend in the direction of a mere "calculus" thereby divorced from the genuine problem of judgment.

particular has shown, the realm of pure logic has a completely different mode of existence (validity or *Geltung*) than that of the realm of actual spatio-temporal entities (being or *Sein*).[47] Moreover, as Rickert has shown, the realm of pure logic (the realm of validity) is also distinct from that of mathematics. For, although the latter is equally atemporal and hence ideal, it presupposes the existence of a particular object—the existence of "quantity" or a homogeneous serial order—and therefore lacks the complete generality characteristic of logic. It follows that we must sharply distinguish the realm of pure logic both from the given heterogeneous qualitative continuum of empirical reality and from the homogeneous quantitative continuum of mathematics.[48] In emphasizing these fundamental distinctions, and, above all, in maintaining *"the absolute primacy of valid sense [den absoluten Primat des geltenden Sinnes],"*[49] Heidegger shows himself to be a faithful follower of Rickert indeed.

Now, as explained above, Rickert's fundamental distinctions lead naturally to equally fundamental problems—problems which stand out especially vividly in the work of Lask. In particular, once we have so sharply delimited the realm of pure logic from all "neighboring" realms, it then becomes radically unclear how the logical realm is at all connected with the real world of temporal being [*Sein*], with either the realm of empirical nature where the objects of our (empirical) cognition reside or the realm of psychological happenings where our acts of judgment reside. The realm of "valid sense," originally intended as an intermediary between these last two realms wherein our cognition of objects is "constituted" and thus made possible, thereby becomes deprived of all explanatory power. We know that Rickert himself responds to this problem by appealing to "transcendental psychology." As he explains in

47. The reference is to [Lotze, 1874, §§ 316–320]; see, for example, [Heidegger, 1978, p. 170].

48. See [Heidegger, 1978, pp. 214–289]; as Heidegger notes, his discussion here is based on [Rickert, 1911]. See the discussion of the dispute between Natorp and Rickert on this matter in chapter 3 above.

49. [Heidegger, 1978, p. 273]. The realm of valid sense enjoys this primacy because *all* realms of existence as such (the natural, the metaphysical-theological, the mathematical, and the logical itself) only become objects of our cognition through the mediation of the logical realm [Ibid., p. 287].

the Preface to the third edition of *Der Gegenstand der Erkenntnis* (1915, dedicated to Lask), it is precisely the role of the "transcendental subject" (in Rickert's own terms, the "cognitive subject" or the "theoretical subject") to bind the realms of being and validity together:

> We thus arrive at two worlds, a [world of] being [*einer seinden*] and a [world of] validity [*einer geltenden*]. But between them stands the theoretical subject, which binds the two together through its *judgments*, whose essence only becomes understandable in this way, and without which we could not meaningfully speak of existent [*seienden*] or real "objects" of cognition. [Rickert, 1882 (1915), p. xi]

Unfortunately, Rickert is never able to develop in any detail a "transcendental psychology" that could perform this "binding" role.

Heidegger, for his part, is very sensitive indeed to the difficult position in which Rickert has become entangled. Accordingly, he also thinks that some version of "transcendental psychology" is necessary here. For Heidegger, however, it is above all the phenomenology of Husserl that offers us a way out of Rickert's impasse:

> [T]he sharp separation of logic from psychology is perhaps not achievable. We must distinguish here. It is one question whether psychology founds logic in principle and secures its *validity* [*Geltungswert*], it is another whether it assumes the role of its primary theater of action and basis of operation. And the second is in fact the case; for we are here concerned precisely with the remarkable fact, which perhaps involves problems that can never be completely illuminated, that the logical is embedded in the psychological. But this just determined role of psychology requires to be made more precise. Experimental psychology remains irrelevant for logic. Moreover, even so-called introspective [*selbstbeobacht-ende*] psychology only becomes relevant from a particular point of view. The investigation concerns the *meanings*, the *sense* of the acts and thus becomes theory of meaning, *phenomenology*[3] of consciousness. Husserl, simultaneously with the critical rejection of psychologism, also theoretically grounded phenomenology in a positive fashion and himself made fruitful contributions to this difficult subject.[50]

50. [Heidegger, 1978, pp. 29–30]; the footnote is to [Husserl, 1911].

Whereas Rickert himself has serious doubts whether Husserl's phenomenology can fulfill the function of what he calls "transcendental psychology," Heidegger is convinced that *only* Husserlian phenomenology can possibly play this role.[51]

It is in "Philosophy as a Rigorous Science" that Husserl first makes the "transcendental-psychological" nature of his phenomenology completely clear. Husserl explains, in particular, that phenomenology is not *empirical* psychology, because it aims to elucidate the underlying a priori structures or "essences" of psychological phenomena. Just as in physics (in the *Naturwissenschaften*) empirical investigations must be preceded by an a priori (mathematical) delineation of the conceptual structure of the domain of inquiry (elucidation of the concepts of space, time, motion, velocity, and so on), so in psychology (and, more generally, in the *Geisteswissenschaften*) all properly empirical investigations must be preceded by an a priori (phenomenological) delineation of the conceptual structure of the domain of consciousness (elucidation of the nature of perception, recollection, imaginative representation, and so on). Merely experimental or introspective psychology ("naturalistic" psychology) is therefore in the same insecure position as pre-Galilean science of nature. Only when psychology (like physics) becomes grounded and established on the basis of a preceding a priori and thus "transcendental" delineation of its subject matter, can psychology (like physics) become a science strictly speaking.[52]

51. The passage from [Rickert, 1909] concerning Husserl cited above (see note 34) continues as follows: "The concept of his [Husserl's] 'phenomenology' involves even more difficult problems, and if Husserl says that transcendental psychology is also psychology, then one may add that phenomenology is also transcendental psychology and can only as such—i.e., through logical value-relations—achieve anything." One of the underlying problems here is that Rickert had at this time seen only Husserl's preliminary characterization of phenomenology in the Introduction to volume two of the *Logical Investigations,* where, in particular, Husserl characterizes phenomenology as "descriptive psychology." Husserl himself immediately realized that this characterization was hasty and misleading, for it concealed precisely the "transcendental" relation in which he intended phenomenology to stand to (empirical) psychology. Accordingly, in later editions of the *Logical Investigations* he completely revised this characterization. See [Husserl, 1911, p. 318n (pp. 115–16n)].

52. This is the crux of Husserl's criticism of "naturalistic philosophy" in [Husserl, 1911, pp. 294–322 (pp. 79–122)], where the explicit comparison with Galilean science figures prominently.

By the same token, this kind of "transcendental" psychology—phenomenology—has a special relation to philosophy and, in particular, to the ideal realm of sense studied by pure logic. For, on the one hand, it is only by elucidating the a priori or essential structure of the intentional acts by which ideal senses are grasped by our consciousness that we can possibly arrive at an "epistemology of the logical" that does not itself collapse into psychologism.[53] And, on the other hand, the psychological structures thereby elucidated, precisely because they are essential structures investigated purely a priori, *themselves belong to the ideal realm of sense.* Our inquiry proceeds by means of essential analysis [*Wesensanalyse*] rather than empirical investigation: it attempts to grasp the essence or nature of certain structures and is thus entirely independent of all actual instances of these structures that may or may not exist. Just as, in geometry, we are interested in the essence or nature of spatial forms entirely independently of which such forms actually exist in the real world, so, in the essential analysis of structures of consciousness, we are completely indifferent to the existence of these structures in any real empirical conscious subject. We are only interested in the essential structures of psychological phenomena—in "pure consciousness."

But how do we investigate these essential psychological structures? How do we carry out the required essential analyses? We use the very same method employed in more familiar types of essential analysis, namely, essential intuition [*Wesensschau, Wesensschauung, Wesenserschauung*]. In ordinary sense perception (whether of external objects or inner psychological events and processes) we are presented with particular items existing at definite spatio-temporal (in the case of external objects) or at least temporal (in the case of internal objects) locations. In essential intuition, by contrast, we grasp the universal natures or essences of such items, which are thus independent of all questions of existence and all questions of spatial

53. The idea of phenomenology, conceived as such an "epistemology of the logical," is first presented in the Introduction to [Husserl, 1901]. The problematic characterization as "descriptive psychology" mentioned in note 51 above occurs in the third note to § 6 of this Introduction (the second [1913] edition corrects this note).

or temporal location.[54] In geometry, for example, we grasp the general natures of intuitively presented spatial forms and thereby establish the a priori science of geometrical space. Similarly, we can grasp the general natures of intuitively presented colors or tones and thereby establish a priori "eidetic sciences" of the structures of "color space" or "tone space." And by the same method, in phenomenology, we can grasp the general natures of intuitively presented psychological phenomena and thereby establish the a priori "eidetic science" of "pure consciousness." In this way, moreover, we can establish a special and unique a priori science (which, in particular, is essentially non-mathematical)—a science that can serve as the foundation for all other a priori sciences (whether in the *Naturwissenschaften* or the *Geisteswissenschaften*) and can thus take the place of traditional philosophy.[55]

Husserl was therefore in possession of a much more explicit and developed conception of a "transcendental" (that is, a priori) psychology than was Rickert—a conception which, accordingly, could and did issue in a wealth of detailed essential analyses of particular psychological phenomena. It is no wonder, then, that when Rickert left Freiburg to take Windelband's position at Heidelberg and Husserl left Göttingen to take Rickert's position at Freiburg in 1916, Heidegger became an enthusiastic proponent of the new phenomenology and, in par-

54. Thus, as Husserl [1913, § 4] explains, items presented merely imaginatively can be even more important for essential intuition than those actually presented sensibly in "real time."

55. These ideas, which are sketched out for the first time in [Husserl, 1911], are developed in full detail in [Husserl, 1913]. The crucial notion of *Wesenserschauung* is explained in the first chapter of Part One. The essentially non-mathematical character of pure phenomenology (its status as a "*descriptive* eidetic science") is explained in the first chapter of Part Three. The idea is that phenomenology, while a priori, is nonetheless not "exact" (mathematical), for the eidetic structures we study here cannot (as in the case of mathematics) be generated systematically from certain elementary structures in such a way that a deductive axiomatic treatment then becomes possible. It is here worth noting, by way of contrast, that Husserl's conception of an a priori "pure" psychology—and, in particular, his conception of it as an essentially non-mathematical a priori "eidetic science"—is completely incompatible with Kant's conception of psychology. For Kant, psychology can never become a science properly speaking precisely because, first, psychology is essentially non-mathematical, and, second, all science properly so-called depends on the application of mathematics: see the Preface to Kant's *Metaphysische Anfangsgründe der Naturwissenschaft* (1786), and compare also the *Critique of Pure Reason* at A381.

ticular, distanced himself further and further from Rickert.[56] Nevertheless, in the very same year, in a concluding chapter added to the published version of his habilitation, there also appear rumblings in a new and quite un-Husserlian direction. For Heidegger there suggests that a genuine reconciliation of psychology and logic—here equated with a reconciliation of change and absolute validity, time and eternity—can only be effected through the concept of "living spirit [*der lebendige Geist*]" construed as a concrete and essentially historical subject. The "subjective logic" sought for by Rickert and Husserl requires a radically new point of view according to which the subject is no merely cognitive ("punctiform") subject, but rather an actual concrete subject comprehending the entire fullness of its temporal-historical involvements. And such an investigation of the concrete historical subject must, according to Heidegger, be a "trans-logical" or "metaphysical" investigation. Thus, Heidegger is here already beginning to come to terms with the historically oriented *Lebensphilosophie* of Wilhelm Dilthey, an influence which will prove decisive in *Being and Time*.[57]

56. This distance from Rickert becomes quite extreme by 1925–26, when Heidegger is completing *Being and Time*, and can be graphically seen in lectures Heidegger presented at Marburg in the summer semester of 1925 on the concept of time [Heidegger, 1979] and in the winter semester of 1925–26 on logic [Heidegger, 1976]. Heidegger speaks of Rickert with almost entirely undisguised contempt, whereas Husserl appears as the leader of a new "breakthrough" in philosophy which, in particular, has definitively overcome neo-Kantianism. Extensive discussion of these lectures, together with Heidegger's other lecture courses leading up to *Being and Time*, can be found in [Kisiel, 1993].

57. [Heidegger, 1978, pp. 341–411]. For Heidegger's assessment of Dilthey's conception of the subject as "living person with an understanding of active history," in contrast to Husserl's more formal conception of the subject, see [Heidegger, 1979, pp. 161–71]. As is well known, in *Being and Time* Heidegger is quite explicit that the crucial chapter on "Temporality and History" (chapter 5 of Division Two, §§ 72–77) depends fundamentally on Dilthey [Ibid., § 77, p. 396]: "The just completed analysis of the problem of history has arisen out of the appropriation of Dilthey's work." The influence of Dilthey is further exhibited in 1916 in Heidegger's Preface to his habilitation, with its call for philosophy to become *weltanschaulich*, that is, engaged in the concrete historical events of the time [Heidegger, 1978, p. 191; and compare note 10 on p. 205]. This call contrasts sharply with Husserl's own arguments (contra Dilthey) in the section of "Philosophie als strenge Wissenschaft" entitled "Historismus und Weltanschauungsphilosophie" that philosophy *as a science* must be eternally valid and thus essentially ahistorical [Husserl, 1911, pp. 323–41 (pp. 122–47)].

Here, the problematic he inherited from Rickert and Lask helps to explain why Heidegger could not ultimately remain satisfied with Husserl's conception of phenomenology.[58] The problem arising so acutely within the tradition of the Southwest School was precisely that of the application of abstract formal-logical structures to concrete real objects of cognition—the problem of the application of the categories in Kant's sense to actual spatio-temporal objects. And *this* problem, it is clear, cannot be solved within the framework of Husserl's conception of "pure consciousness." For "pure consciousness," as we have seen, itself belongs to the purely ideal realm of essences and is thus entirely independent of the existence of any and all concrete instances, whether of consciousness itself or of its objects of (empirical) cognition. Hence, if our problem is the relationship in general between the abstract and concrete, ideal and real, formal and empirical realms, we need a fundamentally new type of investigation that does not itself take place wholly within the entirely abstract ideal realm. We need a "subjective logic" with a *concrete* subject.[59]

It is of course in *Being and Time,* completed ten years later, that Heidegger finally works out such a "subjective logic"—the so-called existential analytic of Dasein. From this point of view, Husserl's own version of "subjective logic" (the phenomenology of "pure consciousness") appears as excessively formal and abstract in three fundamental respects. First, the "phenomenological reduction" or "bracketing" ("epoche") suspends "pure

58. For a discussion of Heidegger's habilitation paying particular attention to the influence of Lask see [Kisiel, 1993, pp. 25–38].

59. [Heidegger, 1978, p. 407] explicitly links his conception of "subjective logic" with the problem of the *application* of the categories: "If anywhere, then precisely in connection with the problem of the application of the categories—in so far as one admits this in general as a *possible* problem—the *merely* objective-logical treatment of the problem of the categories must be recognized as one-sided."[6] The attached footnote then emphasizes the importance of [Lask, 1912]. For Husserl himself, by contrast, since he developed the idea of phenomenology entirely independently of the Kantian and neo-Kantian traditions, the application of the categories in this sense was never a problem for him. Husserl's own problem was always rather the relationship between logic and psychology—a problem that need not involve the relationship in general between the abstract and the concrete, the ideal and the real. This problem could be solved by a purely abstract or "eidetic" investigation into the relationship between the ideal realm of sense in general and the (equally ideal) intentional structures of consciousness in virtue of which we grasp such ideal senses.

consciousness" from its immersion in the world—the world, that is, of "transcendent" objects existing independently of consciousness itself. By taking as its field of objects only items "immanent" to consciousness, and, especially, by then abstracting from all questions of real existence in the more radical "eidetic reduction" (essential analysis), Husserlian phenomenology self-consciously and explicitly conceives the subject as a bare "Cartesian" stream of mental items deliberately isolated from external "reality." Second, the relationship between the phenomenological subject and the items with which it is presented is conceived first and foremost as cognitive or theoretical. The subject "has" the relevant mental items in the sense that it is simply aware of them as cognitively given to it. The subject's practical or pragmatic involvements with its world, like all questions concerning the real existence of this world as such, are also deliberately abstracted away. Third, the subject of "pure consciousness" is thoroughly ahistorical. We are interested in precisely the essential structures of consciousness eternally present in all historical epochs whatsoever, for it is only so, in fact, that phenomenological philosophy can be a strict science as opposed to a mere historically relative *Weltanschauung*.[60]

Heidegger's concrete subject—Dasein, the concrete living human being—diverges from the "pure consciousness" of Husserlian phenomenology in all three of these respects. First, Dasein necessarily exists in a world—a world of objects existing independently of it, which it does not create and over which it has only very limited control, and into which (without its consent, as it were) it is "thrown." Indeed, for Heidegger, Dasein is *defined* as "being-in-the-world." Second, Dasein's relationship to this world is first and foremost practical and pragmatic: it is originally involved with its world precisely in the sense of

60. Again, this last point constitutes the heart of Husserl's criticism of Dilthey in "Philosophie als strenge Wissenschaft" (see note 57 above). For Heidegger's attitude towards the issue between Husserl and Dilthey here see, e.g., [Heidegger, 1979, pp. 164–71]. More generally, for Heidegger's delimitation of the shortcomings he finds in pure phenomenology, see the entire third chapter of this volume [Ibid., pp. 123–82], entitled "Die erste Ausbildung der phänomenologischen Forschung und die Notwendigkeit einer radikalen Besinnung in ihr Selbst und aus ihr selbst heraus."

using the items in its environment for one or another practical or pragmatic end. The items in Dasein's world therefore appear to it originally as practically "ready-to-hand [*Zuhanden*]," as items to be used in the service of particular concrete projects, rather than as merely "present-at-hand [*Vorhanden*]" for theoretical inspection and consideration. Indeed, for Heidegger, theoretical cognition of the merely "present-at-hand" is a *derivative* mode of Dasein, a particular "modification" of the more basic, essentially practical and pragmatic mode of involvement with the "ready-to-hand."[61] Finally, Dasein is essentially an historical being; in an important sense it is *the* historical being. For the essence or "being" of Dasein is "care [*Sorge*]" (roughly, the above-described orientation towards its world from the point of view of the totality of its practical involvements and projects), and the "ontological meaning of care" is *temporality*, where temporality in this sense is essentially historical and is thus to be sharply and explicitly distinguished from the uniform and featureless "time" of mathematical natural science.[62]

Hegelian: concepts all the way down?

61. The idea of "being-in-the-world," together with the idea that the theoretical orientation towards the "present-at-hand" is founded on the more basic practical orientation towards the "ready-to-hand," is presented in [Heidegger, 1927, § 12–13] and is then developed in detail in the remainder of Division One.

62. For "Care as the Being of Dasein" see [Ibid., §§ 39–44]; for "Temporality as the Ontological Meaning of Care" see [Ibid., §§ 61–66]; for "Temporality and Historicality" see [Ibid., §§ 72–77]. For the relationship between the time of history and the time of natural science, compare also Heidegger's 1916 essay, "Der Zeitbegriff in der Geschichtswissenschaft," reprinted in [Heidegger, 1978]. In developing this conception of the essential "historicality [*Geschichtlichkeit*]" of Dasein, Heidegger, as remarked in note 57 above, is self-consciously following the work of Dilthey, which he explicitly opposes to the "superficial" attempt to distinguish the *Geisteswissenschaften* from the *Naturwissenschaften* developed within the school of Windelband and Rickert. For this attempt, as developed especially in [Rickert, 1902], is purely "logical" or "methodological," based on the contrast between "generalizing" (natural science) and "individuating" (historical science) concept formation. Dilthey's conception, by contrast, is much more radical. For it involves precisely a new concept of the object—or rather the subject—of history. See the comments on Rickert in [Heidegger, 1927, § 72, p. 375], and compare the polemic on "Die Trivialisierung der Diltheyschen Fragestellung durch Windelband und Rickert" presented in [Heidegger, 1979, pp. 20–21]. (In this connection it is also worth noting that the third edition of Rickert's book, published in 1921, adds an extended new chapter devoted to Dilthey, entitled "Die irrealen Sinngebilde und das geschichtliche Verstehen.") For a discussion of the relationship between Dilthey and (especially Rickert's) neo-Kantianism see [Makkreel, 1969].

There is no doubt, then, that Heidegger's Dasein is much more concrete than Husserl's "pure consciousness," in the sense that the former has more of the features of a real human being than does the latter. From the point of view of Husserlian phenomenology, however, an obvious dilemma for Heidegger arises here. For, what can Heidegger's existential analytic of Dasein possibly mean from Husserl's point of view? Either Heidegger is trying to describe the concrete reality of empirical human beings in their concrete and empirical character, in which case his enterprise is simply a branch of empirical anthropology having no specifically philosophical interest whatsoever; or Heidegger is trying to elucidate the essence or nature of the concrete human being by means of an essential analysis of that nature, in which case Heidegger, too, must perform the "eidetic" reduction and abstract from all questions involving the real existence of the entities under consideration. Thus, either Heidegger falls prey to the charge of naturalism and psychologism after all, or his existential analytic of Dasein is in the end no closer to actual concrete reality than is Husserl's phenomenology. It is in response to this dilemma, I believe, that Heidegger's true philosophical radicalism emerges. For it is precisely here, in attempting to construct an *a priori* analysis of the real concrete subject, that Heidegger fundamentally changes the terms framing both Husserlian phenomenology and the two leading schools of neo-Kantianism.

How do we construct an a priori analysis of the real concrete subject? We start with a feature of Dasein that is even more fundamental than the three features noted above, namely, its *finitude*. Dasein is no atemporal eternal being but rather a being that is finite—temporally finite—at its very core. The crucial question, then, is how to represent this essentially temporal finitude of Dasein, and how then to put this representation to use in grounding and articulating an a priori analysis of Dasein. Such a representation of finitude does not appear to be available within the framework of Husserlian "pure consciousness." Pure phenomenological consciousness, for Husserl, is characterized as a flow of phenomena or immanent experiences with respect to a punctual or momentary "now," from the perspective of which this flow is intentionally grasped (as past,

present, and future, earlier and later, and so on), and it is nec-
essarily experienced as temporally unlimited at both ends.
Husserl's phenomenological time is thus essentially infinite, not
finite.[63] And it is clear, moreover, that simply adding temporal
finitude to Husserl's characterization (adding the stipulation
that the intentional flow of phenomena is *limited* at both ends)
takes us no further. A finite sequence of such flowing phenom-
ena passing in review for the intentional "now" is not interest-
ingly or essentially different from an infinite sequence of such
phenomena.

Suppose, however, that we conceive our subject not as pri-
marily theoretical or cognitive (not as simply contemplating a
sequence of phenomena passing in review), but rather as pri-
marily oriented towards pragmatic engagements and practical
projects. For such a subject the thought of temporal finitude is
not simply the thought of an eventual limit or boundary to the
sequence of passing phenomena. It is rather the thought of the
subject's own *death*—the radical possibility that, at any given
moment, one's ongoing projects and pragmatic engagements
may simply cease to be. And this possibility, for such a practical
subject, is indeed a truly a radical one. For, in thus representing
the possibility of death at any given moment, the practical sub-
ject is suspended or removed from the normal context of prag-
matic engagements that define its ordinary or everyday
understanding of itself, and, as Heidegger puts it, Dasein is
thereby brought face to face with its own "uncanniness
[*Unheimlichkeit*]." Whereas, in its everyday understanding of
itself, Dasein is completely unaware of its own peculiar charac-
ter and is simply caught up in its projects and practical involve-
ments, in "being-towards-death" Dasein is revealed to itself for
what it is—as "*thrown* being-in-the-world."

63. See [Husserl, 1911, p. 313 (p. 108)]: "It is a flux of phenomena unlimited on
both sides, with a traversing intentional line that is, as it were, the index of the all-pene-
trating unity: namely, the line of immanent time without beginning or end, a time that
no chronometer measures." Compare the more detailed analysis in [Husserl, 1913, §§
81–83]. Husserl's most developed analysis of phenomenological time-consciousness
appears in lectures given at Göttingen and published under Heidegger's editorship as
[Husserl, 1928]. A thorough discussion of Husserl's views on temporality, taking care-
ful account of these lectures, lies beyond the scope of this essay.

In the normal course of events Dasein takes the context of its projects and practical activities for granted, as a framework that is fixed and simply given. In "being-towards-death" Dasein then steps out of this given context, which is thereby recognized as neither fixed nor given after all. On the contrary, in "being-towards-death" Dasein recognizes, for the first time, that its normal or everyday practical context is simply one possibility among others, *one which is thereby subject to its own free choice*. This context need not be taken up unquestioningly from tradition or society, or even from the past choices that Dasein itself has already made. "Being-towards-death" thus opens up the possibility for a very particular kind of liberation—the possibility of a truly "authentic" existence in which Dasein's own choices and decisions rest on no taken for granted background framework at all. In "inauthentic" existence, by contrast, Dasein operates unquestioningly in its "everydayness." It stops, at some level, with a context of projects and engagements taken simply as given. This representation of temporal finitude— "being-towards-death"—therefore makes an essential difference indeed for the *practical* subject. For it is on this basis alone that the crucial distinction between "authentic" and "inauthentic" existence is defined.[64]

Temporality, for Heidegger, is therefore neither the all-embracing public time within which events are dated and ordered nor the subjective time of "pure consciousness" in which experienced phenomena flow in review past the intentional "now." Temporality is rather first manifested in the being-towards-the-future of primarily practically oriented Dasein, a being-towards-the-future that necessarily includes "being-towards-death" and can therefore be either "authentic" or "inauthentic." Thus, in "authentic" existence Dasein's concernful practical orientation (its "care") is unified by a "resolute" and thoroughgoing decision, a decision that goes all the

64. The analysis of "being-towards-death" and the ensuing possibility of "authentic" existence is presented in the first and second chapters of Division Two of *Being and Time* [Ibid., §§ 46–60]. This analysis is intended to present the "being of Dasein" (which was presented fragmentarily, as it were, in the preceding Division) for the first time as a unitary and unified whole.

way down, as it were. In "inauthentic" existence, by contrast, Dasein's "care" is dispersed and "fallen." Dasein has, so to speak, lost itself in its world. Finally, in "authentic" existence Dasein's practically oriented being-towards-the-future is at the same time a practically oriented (historical) being-towards-the-past. For, at precisely the moment of an "authentic" decision, Dasein must choose among possibilities which must themselves be already present and available in the historically given situation. Dasein, at the moment of its most "authentic" freedom, reveals itself as nonetheless dependent on *possibilities* that have been handed down or inherited. Dasein must thus appropriate its "fate" and is therefore necessarily historical.[65]

It is in this sense, then, that the "being" of Dasein is "care" and the "ontological meaning of care" is temporality. And it is crucial for Heidegger's whole perspective that this statement not be taken as a description of the "essence" of Dasein in the traditional philosophical meaning of this term, according to which "essence" or "whatness" is contrasted with "existence" or "thatness." For Heidegger, what distinguishes Dasein from other beings encountered within the world is that Dasein has no essence in this sense at all. *What* Dasein is can only be determined by Dasein's own choice (whether "authentic" or "inauthentic"), and this "whatness" therefore presupposes the more fundamental structures of "care" and temporality. These structures, in turn, can then not themselves be part of Dasein's "essence" or "whatness." Rather, they characterize Dasein's peculiar *mode of existence*, which is fundamentally different from both the "being" of entities "ready-to-hand" encountered practically within the world and that of objects "present-

65. The temporality of "authentic" existence is articulated in chapter 3 of Division Two [Ibid., §§ 61–66], the temporality of everyday "inauthentic" existence in chapter 4 [Ibid., §§ 67–71], the temporality of "historicality" in chapter 5 [Ibid., §§ 72–77]. How the temporality of Dasein is actually the prior ground of the "ordinary conception of time" (viz., the all-embracing public time within which events are dated and ordered) is explained in [Ibid., §§ 78–81]. Note that the historicality of Dasein means only that the totality of its possible practical involvements is historically determined (and, indeed, by its own *interpretation* of this history). Dasein's *actual* practical involvements are up to its own free choice from among these historically determined possibilities. True authenticity, for Heidegger, rests on the correct understanding of precisely this situation.

at-hand" considered theoretically within the world. In this sense, Dasein's essence *is* existence. The dilemma raised above from the point of view of Husserlian phenomenology therefore has no force at all from Heidegger's own point of view. By replacing phenomenological essential analysis with what he calls "existential-ontological" analysis Heidegger has transcended the traditional distinction between essence and existence and opened up the paradoxical-sounding possibility of an a priori analysis of concrete existence itself.[66]

At the same time, Heidegger has thereby transcended the problematic of neo-Kantian epistemology as well. This problematic, as explained in chapter 3 above, arises in the context of Kant's "Copernican Revolution"—the idea that the object of cognition does not stand "behind" or opposed to our experience but is rather constituted out of our experience by the application of a priori forms of thought. We thus reject both realism and empiricism in favor of a "transcendental idealism" wherein objectivity is constituted through a synthesis or interweaving of real given experiences with ideal formal-logical structures. And, as we have seen, it is precisely in trying to explain the nature of this synthesis or interweaving—and trying to do this, moreover, without Kant's own mediating structures provided by pure sensibility and the transcendental schematism of the understanding—that neo-Kantianism epistemology (especially that of the Southwest School) runs into severe philosophical problems.

Now Heidegger, in *Being and Time*, emphatically rejects this entire problematic. Indeed, in a crucial section on "Dasein, Disclosedness, and Truth," Heidegger [1927, § 44] explicitly rejects the "Copernican Revolution" in favor of an apparently

66. For the priority of "existence" over "essence" in the analytic of Dasein, see [Ibid., § 9]. For Heidegger's diagnosis of the failure of Husserlian phenomenology as resting on a neglect of the question of the *existence* of "pure consciousness," see [Heidegger, 1979, pp. 148–57, in particular p. 152]: "Above all, however, this conception of ideation [i.e., *Wesenserschauung*] as abstraction from real individuation rests on the belief that the What of any being is to be determined in abstraction from its existence. If, however, there were beings *whose What is precisely to be and nothing but to be*, then this ideational mode of consideration with respect to such a being would be the most fundamental misunderstanding."

"direct realist" conception of truth. After explaining [Ibid., p. 215] that "[t]he neo-Kantian theory of knowledge of the nineteenth century frequently characterized this definition of truth [as agreement with the object] as an expression of a methodologically backward naive realism and described it as incompatible with a posing of the question having undergone Kant's 'Copernican Revolution',", Heidegger articulates the "standard" epistemological position he wishes to oppose as follows [Ibid., p. 216]: "Truth according to the general opinion is cognition. But cognition is judgment. And in the judgment we must distinguish: the judging as *real* psychical process and the judged as *ideal* content. It is said of the latter that it is 'true.' The real psychical process, by contrast, is either present or not." Heidegger then protests vehemently against this latter distinction:

> And is not with reference to the "actual" judging of the judged the separation of real execution and ideal content as such unjustified? Is not the actuality of cognition and judging not broken apart into two types of being and "levels," whose piecing-together never touches the mode of being of knowing? Is not psychologism correct to resist this separation—even though it itself neither clarifies the mode of being of the thinking of the thought ontologically, nor even is acquainted with this as a problem? [1927, p. 217]

Finally, Heidegger formulates his own "direct realist" account of truth:

> The meant being itself shows itself *so, as* it is in itself, i.e., that *it* in its self-sameness [*Selbigkeit*] is so, as how *it*, being pointed out in the assertion, is uncovered. Representations are not compared, either among themselves or in *relation* to the real thing. In identification there is not an agreement between knowing and object and certainly not between psychical and physical—but also not between "contents of consciousness" among themselves. In identification there is only the being-uncoveredness [*Entdeckt-sein*] of the being itself, *it* [itself] in the How of its uncoveredness. This [uncoveredness] proves true [*bewährt sich*] in that what is asserted—that is, the being itself—shows itself *as the same*. [Such] proof [*Bewährung*] means: *the showing itself of the being in its self-sameness.*[1] [Ibid., p. 218]

The footnote then refers us to the Sixth Investigation of volume two of Husserl's *Logical Investigations* and to the work of Lask.[67]

Heidegger is a "direct realist" in so far as he begins with the idea of "being-in-the-world." We do not start with a cognitive subject together with its contents of consciousness, but rather with a living practical subject necessarily engaged with its environment. Assertion, as Heidegger [1927, § 33] explains, is a "derivative mode of interpretation" in which the "hermeneutical 'as'" of practical understanding of the "ready-to-hand" (where an item "ready-to-hand" is understood "as" suited for a given end or purpose) is transformed into the "apophantical 'as'" of theoretical understanding of the "present-at-hand" (where an item "present-at-hand" is understood "as" determined by a given predicate). Truth in the traditional sense—as a relation of agreement with an object—then emerges [Ibid., § 44] as itself a derivative phenomena (where an assertion is compared with a "present-at-hand" object it points out in a relation that is itself "present-at-hand"). If we forget this derivative character, however, all the misunderstandings currently prevalent in the "theory of judgment" then arise: "If the

67. The footnote warns us against relying exclusively on the first volume of the *Logical Investigations*, which appears merely to represent the traditional theory of the proposition [in itself] derived from Bolzano. The relevant sections of volume two [Husserl, 1901, §§ 36–52], by contrast, present a "direct realist" conception of truth in which an intention or meaning is directly "identified"—in immediate intuition—with the very thing that is intended or meant. According to the theory of truth articulated in these sections of the *Logical Investigations*, truth in general is not even propositional. My representation of the table may be immediately compared with the table, just as my assertion that the table is brown may be immediately compared with the table's being brown. Thus, truth in general need involve none of the structures (subject and predicate, ground and consequent, and so on) studied in traditional formal logic. On the contrary, such peculiarly logical structures only emerge subsequently in the very special circumstances of "categorial intuition," where specifically propositional intentions or meanings are intuitively grasped in their most abstract—and, as it were, secondary and derivative—formal features. In this sense, Husserl's "direct realist" conception of the relationship between logical form and truth in general parallels Lask's view of the artificiality and subjectivity of logical form. In neither case can formal logic be in any way foundational or explanatory for truth as "relation to an object." For Heidegger's assessment of the notion of "categorial intuition" in the context of Husserl and Lask (which Heidegger sees as destroying once and for all the Kantian "mythology" of a synthesis of understanding and sensibility, form and matter) see [Heidegger, 1979, pp. 63–99].

phenomenon of the 'as' remains hidden, and, above all, if its existential origin in the hermeneutical 'as' remains covered over, then Aristotle's phenomenological approach to the analysis of the *logos* collapses into a superficial 'theory of judgment' according to which judging is a connection and/or separation of representations and concepts."[68]

Heidegger [1927, § 33, pp. 155–56] discusses "the presently dominant theory of 'judgment' oriented around the phenomenon of 'validity [*Geltung*]'" in more detail. In particular, he emphasizes "the manifold questionableness of this phenomenon of 'validity,' which since Lotze has been fondly passed off as a not further reducible 'basic phenomenon'." For Heidegger, this "dominant" theory of judgment is the result of a multiple series of conflations involving three different notions. First, validity is understood as "ideal being," as "the *'form' of actuality* that pertains to the content of judgment in so far as it subsists unchanged with respect to the changeable 'psychical' process of judgment." Second, validity is also understood as "validity of the valid judgment-sense with respect to the 'object' meant therein, and thus advances to the significance of 'objective validity' and objectivity as such." Finally, "[t]he sense thus 'valid' *of* a being and in itself 'timelessly' valid is then 'valid' once again in the sense of validity *for* every rational judger. Validity now means *bindingness*, 'universal validity'." Depending on such a nest of conflations is obviously methodologically dangerous; for "[t]he three meanings of 'validity' we have set forth—as manner of being of the ideal, as objectivity, and as bindingness—are not only unperspicuous in themselves, but they are constantly confused with one another."

What Heidegger has in mind here becomes clearer in an extended discussion of Lotze's theory of validity in his lecture course on *Logik: Die Frage nach der Wahrheit* in 1925–26 [Heidegger, 1977, pp. 62–88]—a discussion presented as an

68. [Heidegger, 1927, § 33, p. 159]. A critical allusion to modern mathematical logic then follows: "Combination and separation can then be further formalized as a 'relation'. Judgment is dissolved in a system of 'coordinations [*Zuordnungen*]'; it becomes the object of a 'calculus' but not the theme of an ontological investigation."

analysis of the "roots" of Husserl's critique of psychologism. Lotze begins with the standard "Cartesian" picture of the subject as enclosed within the psychical world of its own representations. Truth, for such a subject, cannot consist in a relation between its representations and an object existing independently of them, for (as in the standard neo-Kantian argument) precisely this comparison is by hypothesis impossible. Truth can therefore only mean what is constant and unchangeable in the flux of representations and is thus understood as "form" or "essence" in the "Platonic" sense standing over and against the realm of flux and change. We thereby arrive at the distinction between "being" and "validity," "real" and "ideal." And this distinction, by the "Copernican" conception of the object of knowledge, is now equated with the distinction between subjective and objective. Finally, since "objectivity" is thus equated with "validity" in the sense of atemporal or eternal "ideal being," "objectivity" is also equated with necessary *intersubjectivity*, with "bindingness" for all subjects. Heidegger, in rejecting the "Copernican Revolution," is actually rejecting this whole complex of ideas.

Heidegger's discussion of Lotze clarifies the relationship he perceives between the "Cartesian" predicament of the worldless subject enclosed within its own contents of consciousness and the "Husserlian" predicament of the ideal subject isolated from all questions of real existence. In Husserlian terminology, what is in question is the relationship between the phenomenological reduction, which withdraws our attention from the external world and focusses on the contents of consciousness themselves, and the more radical eidetic reduction, which then focusses only on the essence or formal structure of these same conscious phenomena, arriving, in the end, at "pure" or "absolute" consciousness. Heidegger's diagnosis of the multiple conflations underlying the "presently dominant" theory of judgment then connects these two predicaments (reductions) in the following way. If we start with the "Cartesian" predicament (phenomenological reduction) but nonetheless demand a kind of objectivity, then all we have left, as it were, is the contrast between change and constancy, the real and the ideal. We thus arrive at a conception of truth or objectivity according to

which truth is fundamentally characterized as necessary, essential, or eternal truth, and, in this way, the denial of "direct realism" leads naturally to "essentialism" (eidetic reduction).

For Heidegger himself, by contrast, it is precisely this last predicament that is his ultimate target. In particular, by dissolving the traditional philosophical distinction between "essence" and "existence" in the temporality of Dasein, he is able to reinstitute a form of "direct realism" founded on Dasein's necessary "being-in-the-world." This form of "direct realism" is very special, however, for Dasein's most fundamental relation to the world is not a cognitive relation at all. Indeed, Dasein's most fundamental relation to the world is one of either "authentic" or "inauthentic" existence, in which Dasein's own peculiar mode of being (that is, "being-in-the-world") is itself either disclosed or covered over.[69] Heidegger's version of "direct realism" is thus only possible on the basis of the *historical* nature of Dasein, and so all truth is in the end historical.[70]

We are now in a position to clarify Heidegger's notorious defense of the idea that "all truth is relative to the being of Dasein" and his accompanying denial of the existence of "eternal truths." Heidegger explains that "the question about the being of truth" has traditionally led to the postulation of an "ideal subject." This postulation is motivated by "the justified requirement—which, however, still needs to be ontologically grounded—that philosophy has the 'a priori' as its theme, and not 'empirical facts' as such." Nevertheless, such an "ideal subject" in the end appears as a *"fantastic idealization"* in which we miss "precisely the a priori of the merely 'factual' subject, Dasein." Heidegger concludes:

> The ideas of a "pure I" and of a "consciousness in general" so little contain the a priori of the "actual" subject that they either pass over the

69. See [Heidegger, 1927, §44, p. 221]: "Dasein *can* understand *itself* as understanding from the side of the 'world' and the other or from the side of its ownmost possibility-for-being [*aus seinem eigensten Seinkönnen*]. The last-mentioned possibility means: Dasein discloses itself to itself in and as its ownmost possibility-for-being. This *authentic* disclosedness shows the phenomenon of the most original truth in the mode of its authenticity. The most original and authentic disclosedness in which Dasein as possibility-for-being can be, is the *truth of existence*."

70. See note 65 above, together with the text to which it is appended.

ontological character of the factuality and the constitution of being of Dasein or they do not see it at all. Rejection of a "consciousness in general" does not mean the negation of the a priori, any more than the positing of an idealized subject guarantees the objectively grounded [*sachgegründete*] a priority of Dasein.

The assertion of "eternal truths," together with the mixing up of the phenomenally grounded "ideality" of Dasein with an idealized absolute subject, belong to the residues of Christian theology within the philosophical problematic that have still not yet been radically driven out. [Heidegger, 1927, p. 229][71]

In this sense, Heidegger's rejection of Husserlian "pure" or "absolute" consciousness, his historical conception of truth, his rejection of the problematic of "being" and "validity," and his rejection of the "Copernican Revolution" (his "direct realism"), are all connected together in the idea of an existential analytic of Dasein.

Yet it is appropriate to remind ourselves here, finally, that the problematic of the "Copernican Revolution" here rejected by Heidegger is not at all that of Kant's original "Copernican Revolution." For, in the first place, whereas Kant of course holds that empirical truths are "constituted" or made possible by a framework of a priori necessary truths, and that "relation to an object" accordingly means necessity of connection within experience rather than comparison with a "transcendent" object "behind" or outside our experience, Kant does not

71. This discussion contains the provocative assertions that [Ibid., pp. 226–27] "[b]efore Newton's laws were uncovered they were not 'true'" and that "[these] laws became true through Newton, with him a being became accessible in itself for Dasein." Given Heidegger's fundamentally historical conception of truth, together with his "existential conception of science" [Ibid., §69, pp. 362–64], the meaning of these assertions is relatively straightforward. Newton arrived at the laws of motion by means of an "authentic projection" of a particular scientific framework in a given historical situation—the context of the scientific revolution of the sixteenth and seventeenth centuries (compare [Ibid., §3, pp. 9–10] on "scientific revolutions"). Outside of this historical context, Newton's "discovery" and accompanying "assertion" of the laws of motion simply makes no sense. For Heidegger, there is then no "valid sense" or "proposition in itself" beyond Newton's (and our) actual historical "assertions" capable of serving as a "vehicle" for "eternal truth." Nevertheless, *what* Newton discovered of course existed before Newton [Ibid., p. 227]: "With the uncoveredness the being showed itself precisely as that being that was already there before. So to uncover is the mode of being of 'truth.'" Here we should recall that the crucial notion of "identification" constitutive of "uncoveredness" does not fundamentally involve *propositional* structures at all (see note 67 above).

connect this idea with a "Platonic" distinction between atem-
poral ideal being and temporal real being—with a distinction,
in Lotze's sense, between "being" and "validity." As we
emphasized in chapter 3 above, Kant's application of the forms
of thought to experience is necessarily mediated by the pure
forms of sensibility, space and time, and it is only on the basis
of this transcendental schematism of the understanding that
categories can apply to objects of experience and thus make
objective knowledge possible. Kant's framework of a priori nec-
essary truths therefore essentially includes *spatio-temporal*
truths—i.e., truths of mathematics and of mathematical natural
science. And these truths are spatio-temporal, moreover, not
simply in the trivial sense that they are "about" spatio-temporal
structures. They, as truths, themselves *contain* spatio-temporal
structures, in that only via pure sensibility (and not by pure
understanding alone) is it even possible to "think" such repre-
sentations in the first place.[72]

Further, and in the second place, Kant thereby also sub-
scribes to "direct realism"—to the view that we directly per-
ceive external objects outside ourselves in space in outer sense
just as we directly perceive internal objects in time in inner
sense.[73] For Kant, there is no "veil of perception" and thus no
"Cartesian" isolation of the subject within its own contents of
consciousness. Kant's "phenomenal objects" or "appearances"
are, first and foremost, material objects located in both space
and time, and the merely temporal stream of experiences or
mental items is not epistemologically privileged in relation to
such external "appearances." Both space and time are pure

72. See, e.g., A162-3/B203: "I can represent no line, however small, except by
drawing it in thought, i.e., gradually generating all its parts from a point and thereby
first delineating this intuition." For an extensive discussion of these issues see
[Friedman, 1992] and [Friedman, 2000].

73. See the Refutation of Idealism appended to the second edition of the *Critique*
at B274–79 (especially B276n), as well as the Fourth Paralogism in the first edition
(A366–80). Heidegger [1927, §44, p. 215] notes, in his remarks on the "traditional
conception of truth" as opposed to the "Copernican Revolution" discussed above, that
Kant himself (in contradistinction to the neo-Kantian tradition) embraces "direct real-
ism" in the sense of the traditional definition of truth as agreement with the object. But
Heidegger does not discuss either the Refutation of Idealism or the Fourth
Paralogism—a circumstance which is undoubtedly due to his consistent emphasis on
time at the expense of space.

forms of our sensibility and hence equally "transcendentally ideal." To be sure, there are also purely subjective representations—"sensations"—on which both the forms of sensibility and the forms of thought must operate in order to "constitute" or "synthesize" the empirical object of cognition (the "appearance"). But these purely subjective "sensations" are not yet ordered *either* temporally or spatially, and are not yet objects of consciousness at all. They represent merely the a posteriori content in accordance with which the a priori structures of intuition and thought are specialized or realized in the guise of a determinate object of empirical cognition. All objects of empirical cognition, both inner and outer, are then equally "constituted" and, at the same time, nevertheless equally "given."[74]

For Kant himself, therefore, there is neither a "Cartesian" predicament of a world-less subject ("veil of perception") nor a "Platonic" predicament of a realm of atemporal ideal senses ("essentialism"). On the contrary, precisely in virtue of the transcendental schematism of the understanding with respect to the pure forms of sensible intuition, Kant effects an a priori "constitution" of the concrete (spatio-temporal) empirical world as an object of direct and immediate perception. When Heidegger, in his phenomenological-metaphysical interpretation of the *Critique of Pure Reason* first presented publicly at Davos and published immediately thereafter as *Kant and the Problem of Metaphysics,* then reads Kant as arriving (perhaps not fully consciously) at a dissolution of both sensibility and understanding in a "common root" (the transcendental imagination understood as "temporality"), he is turning Kant's original problematic entirely on its head. We are not here confronted with an exercise in Kant interpretation at all, but rather with Heidegger's own radical attempt finally to bring the neo-Kantian tradition to an end.[75]

74. I am indebted to Graciela De Pierris for emphasizing the importance of Kant's "direct realism" to me. For more on the peculiarly Kantian conception of the "constitution" of empirical knowledge on the basis of a priori knowledge see [De Pierris, 1993].

75. Heidegger later explicitly "retracted" his reading as an "over-interpretation" in the prefaces to the third (1965) and fourth (1973) editions—which can be found in [Heidegger, 1991] and [Heidegger, 1990].

5

Carnap

Carnap, like Heidegger, began his philosophical career in close association with neo-Kantian epistemology. Indeed, as we observed in chapter 3, Carnap studied both Kant and neo-Kantianism under Rickert's student Bruno Bauch at Jena. The latter, however, was also influenced by the more scientifically oriented Marburg School, and published several significant works in what we would now call philosophy of science. Moreover, Bauch was also influenced by his colleague at Jena, Gottlob Frege (the great founder of modern mathematical logic), with whom Carnap also intensively studied.[76] Carnap describes his initial studies with Bauch before the Great War as follows:

> I studied Kant's philosophy with Bruno Bauch in Jena. In his seminar, the *Critique of Pure Reason* was discussed in detail for an entire year. I was strongly impressed by Kant's conception that the geometrical structure of space is determined by the form of our intuition. The after-effects of this influence were still noticeable in the chapter on the space of intuition in my dissertation, *Der Raum*. [Carnap, 1963a, p. 4]

After the war Carnap then returned to Jena to complete his doctorate. Since he had studied mathematics (including the

76. Bauch's works in philosophy of science include [Bauch, 1911] and [Bauch, 1914], both of which are cited by Carnap in his dissertation. [Bauch, 1923], to which Carnap refers in the *Aufbau*, shows the influence of both Cassirer and Frege. Some discussion of Bauch in relation to both Frege and Carnap can be found in [Sluga, 1980]. For Carnap's own discussion of his studies with Frege see his "Intellectual Autobiography" [1963a, pp. 4–6].

new mathematical logic), physics, and philosophy, he first pursued an interdisciplinary project—an "Axiomatic Foundations of Kinematics" formulated within the space-time structure of relativity theory. However, the head of the Institute of Physics, Max Wien (a leading relativity theorist), found this unsuitable as a physics dissertation and sent Carnap back to Bauch; but Bauch found it unsuitable as a philosophy dissertation. Carnap ended up, then, writing a more conventionally philosophical dissertation under Bauch, namely, the above-mentioned *Der Raum* (Space).[77]

Carnap's dissertation exhibits a quite astonishing mastery of the relevant literature in mathematics and logic, in physics (particularly in Einstein's theory of relativity), in the foundations or philosophy of physics, and in the literature of neo-Kantian and other recent forms of "transcendental" epistemology as well. The aim is to show that the last century's disputes between physicists, mathematicians, and philosophers concerning the nature of space have been fruitless, because the proper distinctions were not made among the various meanings or types of space. Accordingly, Carnap articulates a threefold distinction—between *formal*, *intuitive*, and *physical* space—and argues, on this basis, that the different competing points of view are in fact referring to different types of space, so that there is actually nothing to dispute about after all. *Formal* space is a pure relational structure or order structure, developed within the new mathematical logic, for which the "mathematician's" point of view (Russell, Couturat) is correct. *Physical* space, by contrast, is an object of empirical natural science, for which the "physicist's" point of view (Riemann, Helmholtz, Einstein) is correct. *Intuitive* space, finally, is an object of "a priori intuition," for which the "philosopher's" point of view (Kant and the neo-Kantians) is correct.[78]

Yet Kant was not in fact correct in thinking that the three-dimensional and Euclidean character of intuitive space is

77. [Carnap, 1963a, p. 11]. The dissertation was completed in 1921 (with Wien on the examining committee) and published as *Der Raum* [Carnap, 1922].

78. See [Carnap, 1922, p. 64]: "[all] parties were correct and could have easily been reconciled if clarity had prevailed concerning the three different meanings of space."

secured by "a priori intuition." Rather, as Einstein's general theory of relativity has made especially clear, we need to extend Kant's "experience-constituting" function of space to a more general structure:

> It has already been explained more than once, from both mathematical and philosophical points of view, that Kant's contention concerning the significance of space for experience is not shaken by the theory of non-Euclidean spaces, but must be transferred from the three-dimensional Euclidean structure, which was alone known to him, to a more general structure. . . . According to the foregoing reflections, the Kantian conception must be accepted. And, indeed, the spatial structure possessing experience-constituting significance (in place of that supposed by Kant) can be precisely specified as topological intuitive space with indefinitely many dimensions. We thereby declare, not only the determinations of this structure, but at the same time those of its form of order [n-dimensional topological *formal* space] to be conditions of the possibility of any object of experience whatsoever. [Carnap, 1922, p. 67]

And Carnap retrospectively describes his project in essentially the same terms in his "Intellectual Autobiography":

> Knowledge of intuitive space I regarded at that time, under the influence of Kant and the neo-Kantians, especially Natorp and Cassirer, as based on "pure intuition" and independent of contingent experience. But, in contrast to Kant, I limited the features of intuitive space grasped by pure intuition to certain topological properties; the metrical structure (in Kant's view, the Euclidean structure) and the three-dimensionality I regarded not as purely intuitive, but rather as empirical. [Carnap, 1963a, p. 12]

Carnap's view, more specifically, is that the n-dimensional "topological" property of being *infinitesimally* Euclidean is indeed given to us as synthetic a priori via "pure intuition." But this structure is of course compatible with all possible (Riemannian) metrical structures (and, in particular, with the spaces of *variable* curvature employed in the general theory of relativity). We must then consult experience in picking out one such metrical structure to serve as the space of empirical physics (and for picking out a determinate dimension number as well).

Carnap's appeal to "pure intuition" here is at first sight quite puzzling, however. For, as we have seen, it was a commonplace within neo-Kantianism (for both the Marburg and Southwest Schools) that Kant's original distinction between a conceptual or discursive faculty of pure understanding and a sensible or receptive faculty of pure intuition is untenable. It was generally agreed that Kant's dualistic conception of our a priori faculties must be replaced by a unitary or monistic conception. Moreover, this rejection of an independent faculty of pure intuition was especially firm and explicit within the Marburg School. Why, then, does Carnap appeal to "pure intuition" here, and why, in particular, does he make a special point of naming precisely Natorp and Cassirer as inspirations for this appeal?

The first point to notice is that, in appealing to "pure intuition," Carnap is not in fact referring to the original Kantian conception of intuition at all, but rather to *Husserl's* notion of "essential intuition [*Wesenserschauung*]," through which, according to Carnap, the infinitesimally Euclidean character of "topological space" is given to us a priori.[79] And, in the second place, Husserl's notion of "essential intuition," unlike Kant's conception of pure intuition, is not associated with a distinction between two independent faculties of the mind, a logical or discursive faculty and a sensible or non-discursive faculty. On the contrary, for Husserl all a priori knowledge whatsoever rests on "essential intuition," including our knowledge of pure formal logic. Pure formal logic (or *"mathesis universalis"*) is the

79. [Carnap, 1922, pp. 22–23]: "[H]ere, as Husserl has shown, we are certainly not dealing with facts in the sense of experiential reality, but rather with the essence ('Eidos') of certain data which can already be grasped in its particular nature by being given in a single instance. Thus, just as I can establish in only a single perception—or even mere imagination—of three particular colors, dark green, blue, and red, that the first is by its nature more akin to the second than to the third, so I find by imagining spatial forms that several curves pass through two points, that on each such curve still more points lie, that a simple line-segment, but not a surface-element, is divided into two pieces by any point lying on it, and so on. Because we are not focussing here on the individual fact—shade of color seen here-now—but on its atemporal nature, its 'essence', it is important to distinguish this mode of apprehension from intuition in the narrower sense, which is focussed on the fact itself, by calling it 'essential intuition [*Wesenserschauung*]' (Husserl)." In his endnote [Ibid., p. 80] Carnap then cites [Husserl, 1913, § 3].

(equally intuitive) science of the essence or "eidos" of all objects of thought in general, regardless of all specification of such objects into different "regions" of "eidetic science" (such as geometry, the a priori "eidetic science" of color, and so on). As such, pure formal logic (which, for Husserl, includes arithmetic, algebra and analysis) is a "*formal* eidetic science" (or "formal ontology") and thereby stands in contrast with all "*material* eidetic sciences" (or "regional ontologies"). This contrast between pure logic (as a "formal eidetic science") and pure spatial geometry (as a "material eidetic science") has therefore nothing at all to do with a distinction between two independent faculties of the mind. It is rather simply a contrast between two different levels of generality, both of which are grasped by the very same faculty of mind.[80]

Hence, in appealing to "pure intuition" here, Carnap is drawing no distinction between a logical or discursive faculty on the one side and a sensible or non-discursive faculty on the other. Rather, following Husserl, he is simply contrasting the absolutely universal generality of logic (including the purely logical theory of "formal space") with the more particular and thus "material" generality of geometry (as a theory of properly *spatial* structures).[81] Carnap's point, in other words, is that our knowledge of what he calls intuitive space (in contradistinction to our completely general, purely logical knowledge of formal space) is *synthetic* a priori.[82] It is a priori knowledge that nevertheless characterizes a particular species of objects of sense perception (sensibly and empirically given spatial objects) and thereby constitutes a "form" of empirical reality or a condition of the possibility of objects of experience. And here, in particular, Carnap strongly agrees with Natorp and Cassirer. Cassirer's

80. See [Husserl, 1913, §§ 8–16].

81. It is clear that Carnap follows Husserl completely here. Thus, he states explicitly [1922, p. 61] that his own progression from formal to intuitive and then physical space "corresponds (in Husserl's terminology) to the step-wise progression: formal ontology (Leibniz's '*mathesis universalis*'), regional ontology, factual science"; [Carnap, 1922, pp. 64–65] explains that even knowledge of formal space depends on "essential intuition," but here "it is formal in nature (Husserl: 'formal ontology')."

82. Husserl [1913, § 16] explains that the notion of a "material" or "regional eidetic science" corresponds to the Kantian notion of synthetic a priori.

primary disagreement with the purely logical conception of mathematics defended by such authors as Russell and Couturat, for example, concerns precisely the problem of the application of mathematics to empirical reality. Whereas these authors are correct that *pure* mathematics involves only purely formal relational structures, they miss the circumstance that the *application* of pure mathematics in mathematical physics involves also an appeal to the particular structures disclosed in empirical science and thus a priori *synthetic* factors.[83]

Carnap's own account of the application of geometry to the space of mathematical physics is rather subtle. We know a priori that physical space, as an object of sensible intuition, is necessarily infinitesimally Euclidean, but this still leaves it entirely undetermined which of the infinite number of particular metrical structures (Riemannian geometries) characterizes this space. Moreover, although Carnap sometimes gives the impression (for example, in the passage appealing to Natorp and Cassirer cited above) that the selection of a particular metrical structure is then determined by experience, this is not in fact his view. On the contrary, as he takes Poincaré and Dingler to have shown, there is an irreducible element of purely conventional choice in this determination, by which we either freely stipulate a method of physical-spatial measurement (in accordance with which a particular metrical structure emerges empirically) or instead stipulate the desired metrical structure directly (in accordance with which our method of physical-spatial measurement is then adjusted). Carnap's full account of the application of geometry to physical space therefore involves two very different levels of non-empirical, "experience-constituting" structure. Topological structure is necessary and unique, but metrical structure is conventionally chosen from a wide spectrum of alternatives. Carnap [1922, p. 39] characterizes this distinction as a "division within the realm of form . . . between necessary [i.e., topological] and optional [i.e., metrical] form."

83. See [Cassirer, 1907b, especially § VI, pp. 42–49], which is prominently cited by Carnap in *Der Raum*. Cassirer's views on the synthetic a priori will be considered in more detail in chapters 6 and 7 below.

This distinction between two levels of form—"necessary" and "optional [*wahlfrei*]"—turns out to be crucial for Carnap's further philosophical development. For it is on this basis that he then begins to distance himself from neo-Kantianism. In particular, [Carnap, 1924] distinguishes between the "primary world" of immediately given sense experience ("experience of the first level") and the "secondary world" of three-dimensional, causally ordered physical objects ("experience of the second level"). Carnap explains that the "positivistic" critique of Kantianism is indeed correct, in so far as the full spatio-temporal-causal structure of the "secondary world" does not in fact fall under "necessary" form. This structure, unlike the merely "topological" structure of the "primary world," is rather a product of conventional choice.[84] The central problem with neo-Kantianism, for Carnap, is thus its neglect of such purely conventional "form factors":

> The neo-Kantian philosophy is not acquainted with the primary world, since their conception that the forms of experience of [the secondary world] are necessary and unique prevents them from recognizing the distinction between the primary and the secondary world. Their true achievement, namely, the demonstration of the object-generating function of thought, remains untouched, however, and underlies our conception of the secondary world as well. [Carnap, 1924, p. 108]

As the last sentence clearly indicates, Carnap certainly does not regard neo-Kantianism as completely discredited. Although it

84. See, in particular, [Carnap, 1924, pp. 106–07]: "The critique that has been exerted on the Kantian concept of experience especially from the positivistic side has taught us that not all form factors in experience to which Kant ascribes necessity actually possess it. (Sensible) experience in fact exhibits necessarily a certain spatial and temporal order, together with specific relations of equality and inequality. On the other hand, the connection of certain elements of experience into 'things' with 'qualities', together with the coordination [*Zuordnung*] of certain elements to others as their 'causes', is not necessary—i.e., not a condition of every possible experience. Rather, it is a matter of free choice *whether* this working-up [*Verarbeitung*] takes place and also, to a great extent, *how* this takes place. We designate experience bearing only necessary formation as '*experience of the first level*', the further worked-up [experience] as '*experience of the second level*'." [Carnap, 1923] had earlier explained that the form of the most fundamental causal laws, like that of the metric of physical space, is also determined by conventional choice. These ideas of the early Carnap are illuminatingly discussed in [Sauer, 1989, § III, pp. 113–15].

indeed goes too far in attributing synthetic a priori necessity to all the activities of thought, "positivism" goes too far in the other direction in failing to acknowledge any "object-generating" function of thought at all.[85]

It was during this period, in the years 1922–25, that Carnap completed most of the work on the project that was eventually to issue in *Der logische Aufbau der Welt*.[86] And it was on this basis, moreover, that Carnap caught the attention of the "Philosophical Circle" that had gathered around Moritz Schlick at the University of Vienna. Carnap had become acquainted with Schlick in the summer of 1924 and was invited to give lectures to Schlick's Circle in the winter of 1925. These lectures on the *Aufbau* project, which, at the time, was entitled *Entwurf einer Konstitutionstheorie der Erkenntnisgegenstände* [*Outline of a Constitutional Theory of the Objects of Experience*], were extremely well received. Carnap returned to Vienna as *Privatdozent*, with his *Entwurf* (then being eagerly read within Schlick's Circle) serving as his habilitation.[87] A revised version was finally published as the *Aufbau* [Carnap, 1928a].

From its reputation, one might expect to find that the *Aufbau* continues the process of Carnap's gradual "emancipation" from neo-Kantianism and, in fact, that we here find a now completed conversion to the point of view of phenome-

85. The reference to the "object-generating" function of thought here indicates that Carnap has primarily Marburg neo-Kantianism in mind. Carnap [1924, pp. 109–110] further expresses his neutrality between the two opposing positions as follows: "Now which is the '*real*' *world*, the primary [world] or the secondary [world]? According to the conception on which both idealistic and realistic philosophy agree— which is also customary in physical research and in everyday life—the construction of the secondary world leads to the formation [*Aufbau*] of 'reality'. Positivistic philosophy, on the other hand, apportions reality-value only to the primary [world]; the secondary world is only an arbitrary reformulation [*willkürliche Umgestaltung*] of [the primary world], performed on grounds of economy. We leave these properly speaking transcendent questions to metaphysics; our immanent explanation has only to do with the constitution of experience itself: in particular, with the distinguishing of its form factors into necessary and optional [*wahlfrei*]—which we call primary and secondary— and with the relations between the two types."

86. See [Carnap, 1963a, pp. 16–19].

87. See [Carnap, 1963a, pp. 20–22]. An outline of Carnap's lecture to the Circle on January 21, 1925, bearing the title "Gedanken zum Kategorien Problem. Prolegomena zu einer Konstitutionstheorie," is document [ASP RC 081-05-03]. The *Entwurf* manuscript has not yet been found. A table of contents, bearing the dates December 17, 1924 and January 28, 1925 (a revision after the lecture in Vienna), is document [ASP RC 081-05-02].

nalistic or extreme empiricist "positivism."[88] When one looks
closely at the text of the *Aufbau*, however, it turns out that this
"standard" interpretation is at the very least greatly exaggerated. Indeed, Carnap himself explains the relationship between
"positivism" and neo-Kantianism as follows:

> Cassirer ([*Substanzbegr.*], 292ff.) has shown that a science having the
> goal of determining the individual through lawful interconnections
> [*Gesetzseszusammenhänge*] without its individuality being lost must apply,
> not class ("species") concepts, but rather *relational concepts*; for the latter
> can lead to the formation of series and thereby to the establishing of
> order-systems. It hereby also results that relations are necessary as first
> posits, since one can in fact easily make the transition from relations to
> classes, whereas the contrary procedure is only possible to a very limited
> extent.
>
> The merit of having discovered the necessary basis of the constitu-
> tional system thereby belongs to two entirely different, and often mutu-
> ally hostile, philosophical tendencies. *Positivism* has stressed that the sole
> *material* for cognition lies in the undigested [*unverarbeitet*] experiential
> given; here is to be sought the *basic elements* of the constitutional system.
> *Transcendental idealism*, however, especially the neo-Kantian tendency
> (Rickert, Cassirer, Bauch), has rightly emphasized that these elements do
> not suffice; *order-posits* [*Ordnungssetzungen*] must be added, our "basic
> relations." [Carnap, 1928a, § 75][89]

Carnap by no means intends simply to supplant neo-
Kantianism by "positivism" in the *Aufbau*. On the contrary, he
still hopes (just as in the passage from 1924 quoted above) to
retain the insights of *both* views.[90]

88. For classical presentations of the "standard" empiricist-phenomenalist reading
of the *Aufbau* see [Quine, 1951], [Quine, 1969], and [Goodman, 1963]. Carnap him-
self presents such a picture in [Carnap, 1963a, pp. 50, 57] (but see note 90 below).

89. The passage from Cassirer's *Substance and Function* to which Carnap is here
referring, [Cassirer, 1910, chapter 4, § IX], is a criticism of the argument of [Rickert,
1902] that concepts in the *Naturwissenschaften* cannot individuate (see note 62
above). Cassirer, once again, diagnosis Rickert's error here as a neglect of the essentially
relational mode of concept formation of modern mathematics and logic (compare note
37 above). Carnap [1928a, § 12] points out, again referring to this discussion of
Cassirer's (and also to Rickert, Windelband, and Dilthey), that the "logic of individual-
ity" desired in the *Geisteswissenschaften* can be attained precisely in the modern theory
of relations.

90. There has been growing awareness in recent years of the Kantian and neo-
Kantian aspects of the *Aufbau*. See for example: [Haack, 1977], [Moulines, 1985],
[Sauer, 1985], and [Sauer, 1989] (Sauer particularly stresses the importance of Cassirer

As Carnap suggests, the influence of Cassirer's *Substance and Function* is especially important to the *Aufbau*. This is not surprising, for the agreement between the two conceptions actually extends far beyond the emphasis on the significance of the modern logical theory of relations stressed here. According to *Substance and Function,* as indicated above, the theory of knowledge consists of two parts. The theory of the *concept* (Part One) is given by the totality of pure relational structures provided by the new logic. In the theory of *reality* (Part Two), however, these pure relational structures are successively applied in the methodological progress of mathematical natural science. At each stage we (approximately) embed a preceding mathematical-physical theory in its successor theory in such a way that a never completed but convergent sequence results. Thus, whereas pure logic and mathematics comprise all possible pure or abstract relational structures, mathematical natural science constructs a specific infinite methodological series of such structures; and this methodological series of abstract structures then represents the empirical side of knowledge given by "sensation." The concrete empirical world of sense perception is not a separate reality existing somehow outside of this methodological series, it is simply the fully determinate and complete limit structure towards which the series is converging.

Now Carnap, in the *Aufbau,* also represents empirical knowledge by a serial or stepwise methodological sequence— depicting, in an idealized fashion, how our scientific methods for acquiring knowledge actually play out in practice. This sequence does not represent the historical progression of mathematical-physical successor theories, however, but rather the epistemological progress of a single individual or cognitive subject, as its knowledge extends from the initial subjective sensory data belonging to the *autopsychological* realm, through the world of public external objects constituting the *physical* realm,

and the passage from § 75), [Richardson 1992] (which also emphasizes the importance of Cassirer and the Marburg School), [Webb, 1992], [Richardson, 1998], [Friedman, 1999] (where, in chapter 6, § 4, I attempt to account for the empiricist-phenomenalist picture, mentioned in note 88 above, Carnap himself presents in his "Intellectual Autobiography"). [Coffa, 1991] presents an extended treatment of the development of logical positivism as a whole, and is also well worth consulting in this connection.

and finally to the intersubjective and cultural realities belonging to the *heteropsychological* realm. Carnap's methodological series is thus a "rational reconstruction" intended formally to represent the "actual process of cognition."[91] For Carnap, however, this is not a series of successor theories ordered by the relation of (approximate) embedding, but *a sequence of levels or ranks in the hierarchy of logical type*s of Whitehead's and Russell's *Principia Mathematica* [Whitehead and Russell, 1910–13], a sequence of levels *ordered by type-theoretic definitions*. Objects on any level (other than the first) are thus defined as classes of objects (or relations between objects) from the preceding level.[92]

The construction or "constitution of reality" begins with "elementary experiences" (holistic momentary cross-sections of the stream of experience) ordered by a (holistically conceived) "basic relation" of remembrance-of-part-similarity-in-some-arbitrary-respect. The main formal problem within the autopsychological realm is then to differentiate, on this initially entirely holistic basis alone, the particular sense qualities and sense modalities from one another. After grouping elementary experiences into classes (and classes of classes . . .) via the one given relation of similarity and a complex procedure of "quasi-analysis," Carnap is in a position to define the *visual field* as the unique sense modality possessing exactly five dimensions (two of spatial location and three of color quality).[93] We can now define the "visual things" in the perceptual realm by embedding the visual fields of our subject in a four-dimensional continuous number-manifold (\mathbf{R}^4), and projecting colored points of these visual fields along "lines of sight" onto colored surfaces (in three-dimensional sub-spaces of \mathbf{R}^4) in such a way that princi-

[handwritten margin note: Holistic but pre-conceptual?]

91. See [Carnap, 1928a, §§ 100, 143]. Compare [Carnap, 1963a, p. 18]: "The system was intended to give, though not a description, still a rational reconstruction of the actual process of the formation of concepts."

92. See especially the discussion of "ascension forms [*Stufenformen*]" in [Carnap, 1928a, Part III.B]. There are exactly two such "ascension forms"—namely, class and relation extensions [Ibid., §40]. Carnap [1963a, p. 11] explains that he first studied *Principia Mathematica*, whose type-theoretic conception of logic pervades the *Aufbau*, in 1919.

93. See [Carnap, 1928a, Part IV.A, and §§ 67–94]. The procedure of "quasi-analysis" is a generalization (to non-transitive relations) of the "principle of abstraction" employed by Frege and Russell in the definition of cardinal number [Ibid., § 73].

ples of constancy and continuity are satisfied. And, in an analogous fashion, we can define the "physical things" or objects of mathematical physics via the "physico-qualitative coordination." We coordinate purely numerical "physical state magnitudes" with sensible qualities in accordance with the laws and methodological principles of the relevant sciences (e.g., the electrodynamic theory of light and color).[94] Finally, we can constitute the heteropsychological realm by constructing other subjects of experience analogous to the initial subject (i.e., systems of elementary experiences coordinated to "other" human bodies), and by then constructing an "intersubjective world" common to all such subjects obtained by an abstraction (via an equivalence relation) from the resulting diversity in "points of view."[95]

What are Carnap's epistemological motivations for undertaking this "constitution of reality" in the first place? It turns out that the standard motivations of empiricist phenomenalism (the attempt to justify our apparently uncertain and insecure knowledge of the external world on the basis of the more certain and secure immediate data of sense) are in fact nowhere in evidence in the text of the *Aufbau* itself. And the epistemological motivations that we do find expressed, by contrast, are closely akin to those of neo-Kantianism. Thus, whereas the neo-Kantians aimed to implement Kant's "Copernican Revolution" by showing how the object of knowledge is "constituted" by the pure forms of thought, Carnap here aims to explain how the objectivity of knowledge is possible on the basis of what he calls "purely structural definite descriptions"—definitions (like that of the visual field sketched above) that individuate their objects in purely formal-logical terms making no reference whatsoever to their intrinsic or ostensive phenomenal qualities.[96] In this way, the constitutional system demon-

94. See [Carnap, 1928a, Part IV.B]. As Carnap makes clear, the constitution of the world of physics [Ibid., § 136], in particular, is based on his earlier methodological studies [Carnap, 1923], [Carnap, 1924].

95. See [Carnap, 1928a, Part IV.C]. According to Carnap, *only* the purely abstract world of physics (and not the qualitative world of common-sense perceptual experience) "provides the possibility of a univocal, consistent intersubjectivization" [Ibid., § 136; and compare § 133].

96. For the independence of the definition of the visual field, in particular, from all reference to phenomenal qualities see [Carnap, 1928a, § 86].

strates that objective (that is, intersubjectively communicable) knowledge is possible, *despite* its necessary origin in purely subjective experience.[97]

Carnap's epistemological aim, therefore, is not so much to justify our higher level mathematical-physical knowledge on the basis of the more certain data of immediate sense-experience, but rather to show how even our subjective immediate sense-experience contributes to the objectivity of knowledge in virtue of an embedding of this experience within a system of purely formal, logical-mathematical structures.[98] In this respect, Carnap's "constitution of reality" is especially close to the doctrine of the Marburg School, for it involves nothing less than a transformation of sense-experience itself into a purely formal sequence of abstract logical structures. Carnap again explicitly remarks upon this kinship:

> Constitutional theory and *transcendental idealism* agree in representing the following position: all objects of cognition are constituted (in idealistic language, are "generated in thought"); and, moreover, the constituted objects are only objects of cognition qua logical forms constructed in a determinate way. This holds ultimately also for the basic elements of the constitutional system. They are, to be sure, taken as basis as unanalyzed unities, but they are then furnished with various properties and analyzed into (quasi-) constituents (§ 116); first hereby, and thus also first as constituted objects, do they become objects of cognition properly speaking—and, indeed, objects of psychology. [Carnap, 1928a, § 177][99]

97. See [Carnap, 1928a, Part II.A, especially § 16]: *"[E]very scientific statement can in principle be so transformed that it is only a structural statement.* This transformation is not only possible, however, but required. For science wants to speak about the objective; however, everything that does not belong to structure but to the material, everything that is ostended concretely, is in the end subjective. . . . From the point of view of constitutional theory this state of affairs is to be expressed in the following way. The series of experiences is different for each subject. If we aim, in spite of this, at agreement in the names given for the objects [*Gebilde*] constituted on the basis of the experiences, then this cannot occur through reference to the completely diverging material but only through the formal indicators of the object-structures [*Gebildestrukturen*]." For a fuller discussion, as well as detailed arguments against an empiricist-phenomenalist interpretation of Carnap's epistemological motivations, see [Friedman, 1999, Part Two].

98. It is noteworthy, in this connection, that Carnap [1928a, § 3] explicitly associates his aims with Husserl's notion of a "mathesis of experiences," which, as we know from note 55 above, would actually be anathema to Husserl himself.

99. The phrase "generated in thought" again alludes to the "genetic" view of knowledge of the Marburg School (see the next quotation below). Section 116

Indeed, there is one important respect in which Carnap's conception is even more radical than that of the Marburg School. Cassirer's *Substance and Function,* for example, retains an element of dualism between pure thought and empirical reality, namely, the contrast between the pure relational structures of pure logic and mathematics, on the one side, and the historical sequence of successor theories representing the methodological progress of empirical natural science, on the other. For Carnap, by contrast, empirical reality is represented by a *particular* relational structure—a type-theoretic structure (depicting the epistemological progress of an initial cognitive subject) erected on the basis of a single primitive non-logical relation.[100]

Carnap himself articulates the difference between his conception of the object of empirical knowledge and that of the Marburg School in [Ibid., § 5], entitled "Concept and Object." After explaining that "the generality of a concept appears to us to be relative, and therefore the boundary between general concept and individual concept can be shifted in accordance with the point of view (§ 158)," Carnap explicitly situates his own notion of the "constitution" of objects with respect to that of the Marburg School:

> Are the constituted structures "generated in thought," as the Marburg School teaches, or "only recognized" by thought, as realism asserts? Constitutional theory employs a neutral language; according to it the structures are neither "generated" nor "recognized," but rather "*constituted*"; and even at this early stage it cannot be too strongly emphasized that this word "constitution" is always meant completely *neutrally*. From the point of view of constitutional theory the dispute involving "generation" versus "recognition" is therefore an idle linguistic dispute.

presents the actual constitution of *sensations,* defined via a purely structural definite description containing only the basic relation as a non-logical primitive.

100. Carnap's type-theoretic sequential construction therefore takes the place of the "general serial form" Cassirer sees as expressing the essence of empirical knowledge. Carnap agrees with Cassirer, however, that this kind of methodological sequence is the ultimate "datum" for epistemology and, in particular, that the contrast between "being" and "validity" (which, as we have seen, generates fundamental problems for the Southwest School) therefore has only a *relative* meaning in the context of such a sequence: see [Carnap, 1928a, § 42], and compare note 38 above.

Carnap stresses the even more radical character of his conception immediately following:

> But we can go even further (without justifying it here) and say openly that a concept and its object are the same. This identity does not signify a substantialization of the concept, however, but, on the contrary, rather a "functionalization" of the object.

And the language of "substance" and "function" unmistakably suggests an allusion to Cassirer. It is not immediately clear, however, what Carnap has in mind here. *No, it is not*

What, for Carnap, is the relationship between a "concept" and "its object"? The first point to notice is that, as is emphasized in [Ibid., § 158], (almost) all structures in Carnap's constitutional system appear as classes (and classes of classes, . . .). All structures (except for the elementary experiences at the very first level) therefore appear as higher-level objects in the hierarchy of types and are thus, in the terminology of [Ibid., § 27], "quasi-objects." Hence, every structure (except for those of the first level) appears both as a class (relative to objects of lower types) and as an element of classes in turn (relative to objects of higher types). In this sense, "to every concept there belongs one and only one object, 'its object' (not to be confused with the objects falling *under* the concept."[101] Thus, a concept is an object viewed as a class (in relation to lower levels in the hierarchy of types), whereas the corresponding object is that concept viewed as an element of classes in turn (relative to higher levels). When Carnap states that a concept and its corresponding object are identical, therefore, he is simply saying that these two structures in the type hierarchy are in fact the very same structure.

In the second place, however, as is also explained in [Ibid., § 158], the difference between "individual" objects belonging to the realm of reality and "universal" concepts having only an "ideal" being is in the end a purely formal-logical difference, *This is what Heidegger would hate*

101. [Carnap, 1928a, § 5]; this is reiterated in [Ibid., § 158].

which, accordingly, must itself be defined within the constitutional system. This difference in fact reduces to a formal-logical distinction between the spatio-temporal order and all other systems of order, ultimately, to the circumstance that there cannot be two different colors appearing at the same location in the visual field (whereas there can be two different locations with the same color). This formal-logical difference between the spatio-temporal order and all other systems of order (such as the order of colors) then makes the former system particularly well-suited to play the role of a "principle of individuation" and thus a "principle of realization"—so that objects belonging to the realm of reality are just those having determinate positions with respect to the spatio-temporal order.[102] Hence, although (almost) all objects, and, in particular, all real objects, are actually higher-level structures in the hierarchy of types, we can still articulate a purely formal-logical criterion for picking out the real objects from the "ideal" objects within this hierarchy.[103]

Now this conception of the individual or real object of empirical cognition stands in sharp contrast with that of the Marburg School. For, according to this latter conception, the real individual object of empirical cognition is in fact never actually present in the methodological progress of science at all. On the contrary, we here have only a sequence of ever more determinate structures, which, however, only become fully determinate and individualized in the ideal limit. Cassirer, in *Substance and Function,* expresses the idea as follows:

> That this function [of empirical cognition] does not arrive at an end in any of its activities, that it sees rather behind every solution that may be given to it a new task, is certainly indubitable. Here, in fact, "individual [*individuelle*]" reality confirms its fundamental character of inexhaustibil-

102. See [Carnap, 1928a, § 158]; and compare [Ibid., § 172], where the concept of "real-typical [*wirklichkeitsartig*]" object is explained. Thus a "real-typical" object is an object *capable* of "reality," as opposed to a "universal" concept having only "ideal" being, and Carnap here refers to a work by B. Christiansen where the concept of real-typicality, defined as "empirical objectivity," is put forward as an interpretation of Kant's use of the term "object." (For the relevant formal-logical features of the visual field see [Ibid., §§ 88–91, 117–18].)

103. It follows, according to [Carnap, 1928a, § 52], that "all real objects (they are recognized in constitutional theory in the same sphere as real as in the sciences, see § 170) are quasi-objects."

ity. But, at the same time, this forms the characteristic advantage of true scientific relational concepts: that they undertake this task in spite of its incompleteability in principle. Every new postulation, in so far as it connects itself with the preceding, constitutes a new step in the *determination* of being and happening. The individual [*Das Einzelne*] determines the direction of cognition as infinitely distant point.[104]

The real object of empirical cognition is thus a never completed "X" towards which the methodological progress of science is converging.

For Natorp and Cassirer, this conception of the necessarily never fully realized object of empirical cognition is the essence of their "genetic" view of knowledge,[105] and Carnap, for his part, explicitly rejects this view:

> According to the conception of the *Marburg School* (cf. Natorp [*Grundlagen*], 18ff.) the object is the eternal X, its determination is an incompleteable task. In opposition to this it is to be noted that finitely many determinations suffice for the constitution of the object—and thus for its univocal description among the objects in general. Once such a description is set up the object is no longer an X, but rather something univocally determined—whose complete description then certainly still remains an incompleteable task.[106]

When Carnap [1928a, § 5] rejects the idea that the object of knowledge is "generated in thought," he is therefore rejecting precisely the "genetic" view of knowledge—the idea that the object of empirical knowledge, in contradistinction to the purely formal objects of mathematical knowledge, is to be conceived as a never ending progression.[107] For Carnap, all objects

104. [Cassirer, 1910, p. 309 (p. 232)]. This comes at the very end of Cassirer's criticism of Rickert to which [Carnap, 1928a, § 75] refers (see note 89 above).

105. See [Natorp, 1910, chapter 1, §§ 4–6], [Cassirer, 1910, chapter 7, especially pp. 418–19 (p. 315)].

106. [Carnap, 1928a, § 179]. The passage referred to from Natorp is the discussion of the "genetic" view of knowledge cited in note 105 above. I am indebted to Alison Laywine for emphasizing to me the importance of this aspect of Natorp's view in the present context.

107. Compare [Cassirer, 1910, p. 337 (p. 254)]: "In contrast to the mathematical concept, however, [in empirical science] the characteristic difference emerges that the construction [*Aufbau*], which within mathematics arrives at a fixed end, remains in principle *incompleteable* within experience."

whatsoever, whether formal or empirical, "ideal" or real, are rather defined or "constituted" at *definite finite ranks* within the hierarchy of types in the particular relational structure he is constructing. And, in this way, Carnap's constitutional system is in fact entirely neutral between "realism" on the one side and "transcendental idealism" on the other.[108]

For the same reason, moreover, Carnap here entirely rejects the idea of the synthetic a priori. Since an object is always defined or "constituted" at a definite finite rank, we can always separate those aspects of our characterization of the object that specify its definition (a purely structural definite description picking it out uniquely from among all other objects) from those aspects that record further information about the object uncovered in the course of properly scientific investigation. Fully determining the latter is indeed an infinite task requiring the whole future progress of empirical science. Establishing the former, however, is simply a matter of stipulation:

> After the first task, that of the constitution of the objects, follows as the *second the task of investigating the remaining,* non-constitutional *properties* and relations of the objects. The first task is solved through a stipulation, the second, on the other hand, through *experience.* (According to the conception of constitutional theory there are no other components in cognition than these two—the conventional and the empirical—and thus no synthetic a priori [components].)[109]

Carnap thus overcomes the remnants of the synthetic a priori found in his pre-*Aufbau* works.[110]

108. For more on Carnap's "neutralism" here see [Friedman, 1999, chapter 6, § 3]. Of central importance is the distinction between "realistic" and "idealistic" *languages* in [Carnap, 1928a, Part III.E]. [Ibid., § 5] insists that "[t]hese two parallel languages, which speak of objects and concepts and still say the same thing, are fundamentally the *languages of realism and idealism.*" Moreover, when Carnap says that he agrees with "transcendental idealism" that all objects of cognition are "generated in thought" [Ibid., § 177], he is careful to add the qualification "in idealistic language."

109. [Carnap, 1928a, § 179], followed by the passage referring to Natorp quoted above.

110. In these works, as we have seen, Carnap invokes a distinction between "necessary" and "optional" form. The former comprises non-conventional, "intuitive" a priori structures, the latter conventional structures determined by arbitrary choice. But Carnap is not at all clear about the status of the latter, conventionally determined structures. For example, [Carnap, 1923, p. 97] characterizes them in terms of

At the same time, Carnap thereby completes the "logiciza-
tion" of experience that the Marburg School had begun. As we
saw in chapter 3 above, the Marburg version of the
"Copernican Revolution" differs from that of the Southwest
School in that the former rejects an epistemologically or meta-
physically ultimate dualism between the forms of thought on
the one side and the "pre-conceptual" manifold of sensation on
the other—the dualism, that is, between "form" and "matter,"
the realm of "validity" and the realm of "being." For, accord-
ing to the Marburg School, we are to replace the side of matter
or sensation with an infinite methodological series of pure logi-
cal structures. We are still left with a residual dualism, however,
namely that between the totality of pure logical structures on
the one side and the infinite methodological series thereof on
the other. And it is precisely this dualism that now represents
the distinction between formal and empirical cognition.[111] But
the *Aufbau* overcomes even this residual dualism. By replacing
the infinite methodological series of the Marburg School with a
stepwise epistemological "constitution" within the type-theo-
retical hierarchy, Carnap is able to represent the world of
empirical cognition as a *particular* formal-logical structure—a
structure which begins with a specific primitive relation and
proceeds through the hierarchy of types via a definite sequence
of purely formal-logical definitions. All that is left of the dis-
tinction between formal and empirical cognition, within this

"*synthetic a priori propositions,* however not exactly in the Kantian transcendental-criti-
cal sense." Here, in the *Aufbau*, such conventions are now viewed as ingredients of the
definitions of the structures in question (purely structural definite descriptions), and are
therefore clearly *analytic* a priori. Of course there is now no question at all of "*neces-
sary* form" in the earlier sense.

111. This element of dualism is especially clear in Cassirer (see, for instance, note
107 above). Heidegger, in his habilitation (written under the marked influence of
Rickert), explains the alternatives here as follows [Heidegger, 1978, p. 318]: "The
modus essendi [the 'passive intellect' or matter] is the experienceable as such; it is that
which stands over and against consciousness in an absolute sense, the 'binding' reality
that forces itself irresistibly upon consciousness and is never to be set aside. As such it
must be called absolute, centered upon itself. This given as such subsists not only for
realism but also for absolute idealism, which strives to dissolve all content into form—
even if it must recognize only the historical fact of science as something *given* for it that
is '*presupposed*'. And in case [idealism] should not even concede this, then at least the
'infinite' process is given, in which and through which the X of the object is to be radi-
cally dissolved into form and system of form." It appears that by "absolute idealism"
Heidegger here intends to refer to the "logical idealism" of the Marburg School.

construction, is the distinction between definitional conventions (by which an object is uniquely picked out at a definite rank in the hierarchy) and further, "non-constitutional" properties and relations (which extend in principle throughout all ranks in the hierarchy).

In this way, Carnap also arrives at an even more radical transformation of the Marburg tradition. For, in the constitutional system of the *Aufbau*, epistemology or philosophy is transformed into a logical-mathematical constructive project—the purely formal project of actually writing down the required purely structural definite descriptions within the logic of *Principia Mathematica*. This formal exercise is to serve as a *replacement* for traditional epistemology, in which we represent the "neutral basis" common to the traditional epistemological tendencies—all of which are in agreement, according to Carnap, that "cognition traces back finally to my experiences, which are set in relation, connected, and worked up; thus cognition can attain in a logical progress to the various structures of my consciousness, then to the physical objects, further with their help to the structures of consciousness of other subjects and thus to the heteropsychological, and through the mediation of the heteropsychological to the cultural objects."[112] Since the constitutional system precisely represents this common ground of agreement within the neutral and uncontroversial domain of formal logic itself, all "metaphysical" disputes between the competing epistemological tendencies (disputes, for example, among "positivism," "realism," and "idealism" concerning which constituted structures are ultimately "real") are also thereby dissolved.[113] The fruitless disputes of the philo-

112. [Carnap, 1928a, § 178]; note that Carnap takes this "agreement" to be entirely uncontroversial.

113. See again [Ibid., § 178]: *"[T]he so-called epistemological tendencies of realism, idealism, and phenomenalism agree within the domain of epistemology. Constitutional theory presents the neutral basis [neutrale Fundament] common to all. They first diverge in the domain of metaphysics and thus (if they are to be epistemological tendencies) only as the result of a transgression of their boundaries."* (Compare note 85 above.) All other properly philosophical disputes are similarly dissolved. Thus, for example, both sides in the debate over the relationship between the *Geisteswissenschaften* and the *Naturwissenschaft* are correct. Cultural objects are constructed out of heteropsychological objects and the latter, in turn, out of physical objects. In this sense the theses of physicalism and the unity of science are correct. It is also true, however, that cultural

sophical tradition are replaced by the seriousness and sobriety of the new mathematical logic, and philosophy is finally in a position, at long last, to become a rigorous science—for Carnap, a purely technical subject.[114]

It is therefore worth noting, finally, that the *Aufbau* construction suffers from serious technical problems that in fact undermine Carnap's attempt to distinguish himself from the Marburg School with respect to the never completed "X" of empirical cognition and the synthetic a priori. These problems are well known and arise precisely when Carnap attempts to move from the subjective realm of the autopsychological to the objective realm of the physical.[115] Here, as sketched above, Carnap outlines a procedure for assigning colors to points of space-time (R^4) in such a way that conditions of continuity and constancy are satisfied. It is never shown, however, that this assignment leads to a definite stable object (a definite relation between space-time points and colors) existing at a definite rank in the type-theoretic hierarchy. Indeed, on closer consideration such a definite stable object appears not to exist. The assignment of colors (and, more generally, of "perceptual qualities") is continually and indefinitely revised as we progress through the hierarchy of types. This is because, first, the initial

objects nonetheless belong to a distinct "object sphere" in the type-theoretic hierarchy. In this sense the thesis of the autonomy and independence of the cultural realm is equally correct. See [Ibid., § 56, and also §§ 25, 29, 41, 151]. (Compare notes 26, 62, and 89 above.)

114. See the first edition Preface to the *Aufbau* [Carnap, 1928a, pp. ix–x (pp. xvi–xvii)]: "The new type of philosophy has arisen in close contact with work in the special sciences, especially in mathematics and physics. This has the consequence that we strive to make the rigorous and responsible basic attitude of scientific researchers also the basic attitude of workers in philosophy, whereas the attitude of the old type of philosophers is more similar to a poetic [attitude]. . . . [T]he individual no longer undertakes to arrive at an entire structure of philosophy by a [single] bold stroke. Instead, each works in his specific place within the *single* total science" Compare also the discussion, in [Carnap, 1963a, p. 13], of the impact of reading [Russell, 1914] in 1921. Carnap is most impressed by Russell's description of "the logical-analytic method of philosophy," together with its accompanying call for a new "scientific" philosophical practice.

115. See [Quine, 1951, § 5], [Quine, 1969, pp. 76–77]. Carnap explains the problem in the Preface to the second edition of the *Aufbau* as follows [Carnap, 1928a (1961), p. xiii (p. viii)]: "Without myself being clearly conscious of it I in fact already went beyond the limits of explicit definition in the constitution of the physical world. For example, for the coordination of colors to space-time points (§ 127f.) only general principles were stated but not univocal operational prescriptions."

assignment, based on the "observations" of a single subject, is subsequently revised on the basis of both the reports of other subjects and the scientific regularities discovered in the world of physics; and, second, the construction of the world of physics suffers from a precisely parallel ambiguity: the methodological procedure leading (via the "physico-qualitative coordination") from sensible qualities to numerical physical state-magnitudes is also continually revised as we progress through the hierarchy. The assignment of colors depends on the subsequently constructed assignment of physical state-magnitudes, and the latter depends on the former, and both depend, moreover, on the reports of other persons which are themselves only available at a still later stage.[116]

Carnap's construction of the physical world therefore appears never to close off at a definite rank in the hierarchy of types—it is continually revised to infinity. And this means, of course, that the Marburg doctrine of the never completed "X" turns out to be correct, at least so far as physical (and hence all higher-level) objects are concerned. Whereas autopsychological objects receive purely structural definite descriptions locating them at definite type-theoretic ranks (as sets of . . . sets of elementary experiences), this is not and cannot be true for the higher-level objects.[117] And it follows, then, that Carnap's rejection of the synthetic a priori, according to which all characterizations of the objects of science are either definitions (conventional stipulations) or ordinary empirical truths (con-

116. For the continual and mutual revisability of the relevant assignments see [Carnap, 1928a, §§ 135, 136, 144]. Note that this process does not involve our initial cognitive subject making revisions in the light of further experience, for all experience is assumed to be already in [Ibid., § 101]. Rather, the relevant revisions take place as the *totality* of given experience is successively reorganized at higher and higher levels in the hierarchy of types.

117. Standard objections to Carnap's construction of the external world here (note 115 above) do not bring out the full force of the problem, I think, for they simply amount to the observation that Carnap's methodological rules provide us with only an implicit definition of the desired assignment. This misses the point, for Carnap's method of purely structural definite description turns *implicit* definitions into explicit ones precisely by adding a *uniqueness* clause (see [Ibid., § 15]). If there *were* a definite and unique relation within the hierarchy of types between colors and space-time points (analogously, between sensory qualities and physical state-magnitudes) satisfying Carnap's methodological constraints, his procedure would therefore be entirely unobjectionable. That such a definite and unique relation does not exist follows from the possibility of mutual and continual revision.

cerning already constituted objects), also fails. In particular, if
the methodological principles governing the relevant assign-
ments at higher levels do not result in sets that become stable
at a definite rank (as required by the uniqueness clause of a
purely structural definite description: compare note 117
above), they can no longer be viewed as simply definitional
conventions—there are in fact no actual definitions (purely
structural definite descriptions) to which they could (analyti-
cally) contribute. The status of these methodological principles
thus remains as unclear as ever, and Carnap ends up without an
objection based on an appeal to conventional stipulation to the
synthetic a priori.[118] Indeed, Carnap is not able satisfactorily to
address this problem until he fundamentally reconsiders both
his conception of logic and his conception of epistemology.
The result, his *Logical Syntax of Language,* appears only in
1934.

118. Compare note 110 above. I am indebted to discussions with Robert Nozick,
and also with Alison Laywine (see note 106 above), for helping me to clarify my think-
ing on this point.

6

Cassirer

Cassirer first learned of Hermann Cohen during his studies at the University of Berlin with Georg Simmel—a noted philosopher of culture, an important early contributor to the discipline of sociology, and, towards the end of his career, a leading representative of *Lebensphilosophie*. Cassirer had just begun to study philosophy, and he reports how the welter of conflicting interpretations of Kant left him extremely confused. Simmel recommended Cohen's writings, and Cassirer (then nineteen years old) promptly devoured them, whereupon he resolved to study with Cohen at Marburg.[119] He studied at Marburg from 1896 to 1899, when he completed his doctoral work with a dissertation on Descartes's analysis of mathematical and natural scientific knowledge. This appeared, in turn, as the Introduction to Cassirer's first published work, *Leibniz' System in seinen wissenschaftlichen Grundlagen* [Cassirer, 1902], which received the highest prize offered by the Berlin Academy of Sciences for its 1901 competition on the overall interpretation of Leibniz's philosophy.[120] Upon returning to Berlin in 1903, Cassirer further developed these themes while working out his monumental interpretation of modern philosophy and science from the Renaissance through Kant, *Das Erkenntnisproblem in der Philosophie und Wissenschaft der*

119. See [Cassirer, 1943, 220–23], along with the biographical works cited in note 5 above.
120. Cassirer received the second prize, and no first prize was offered. Apparently, the Academy found Cassirer's presentation a bit too Kantian. See [Gawronsky, 1949, p. 12], [Paetzold, 1995, pp. 7–9].

neueren Zeit [Cassirer, 1906, 1907a]. He submitted the first volume of this work for his habilitation at the University of Berlin, which he received (not without difficulty) in 1906.[121] As we observed, Cassirer then taught as *Privatdozent* at Berlin from 1906 to 1919.

Cassirer thus began his career as an intellectual historian, one of the very greatest of the twentieth century. *Das Erkenntnisproblem* [Cassirer, 1906, 1907a], in particular, is a magisterial and deeply original contribution to both the history of philosophy and the history of science. It is the first work, in fact, to develop a detailed reading of the scientific revolution as a whole in terms of the "Platonic" idea that the thoroughgoing application of mathematics to nature (the so-called mathematization of nature) is the central and overarching achievement of this revolution. And Cassirer's work is acknowledged as such by the seminal historians, Burtt, Dijksterhuis, and Koyré, who developed this theme later in the century in the course of establishing the discipline of history of science as we know it today.[122] Cassirer, for his part, simultaneously articulates an interpretation of the history of modern philosophy as the development and eventual triumph of what he calls "modern philosophical idealism." This tradition takes its inspiration, according to Cassirer, from idealism in the Platonic sense, from an appreciation for the "ideal" formal structures paradigmatically studied in mathematics, and it is distinctively modern in recognizing the fundamental importance of the systematic application of such structures to empirically given nature in modern mathematical physics—a progressive and synthetic process wherein mathematical models of nature are successively

121. Cassirer was examined by Carl Stumpf and Alois Riehl, both of whom opposed his habilitation. Only the intervention of Wilhelm Dilthey allowed Cassirer to pass. See [Gawronsky, 1949, pp. 16–17].

122. In his recent historiographical study of the literature on the scientific revolution, H. Floris Cohen acknowledges Cassirer's influence, of course, but he nonetheless contends [H.F. Cohen, 1994, p. 543, n. 175 to chapter 2] that "only Burtt, Dijksterhuis, and Koyré were to elaborate such views [on the mathematization of nature] into detailed examinations of the birth of early modern science." This contention is gainsaid by the text of *Das Erkenntnisproblem* itself, however, which treats Kepler, Galileo, Descartes, Bacon, and Newton (along with Copernicus, Bruno, Leonardo, Gilbert, Gassendi, Hobbes, Boyle, and Huygens) in quite considerable detail.

refined and corrected without limit. For Cassirer, it is Galileo, above all, in opposition to both sterile Aristotelian-Scholastic formal logic and sterile Aristotelian-Scholastic empirical induction, who first grasped the essential structure of this synthetic process; and the development of "modern philosophical idealism" in the work of Descartes, Spinoza, Gassendi, Hobbes, Leibniz, and Kant then consists in its increasingly self-conscious philosophical articulation and elaboration.

In both the Leibniz book and *Das Erkenntnisproblem*, then, Cassirer interprets the development of modern thought as a whole from the perspective of the basic philosophical principles of Marburg neo-Kantianism: the idea that philosophy as epistemology [*Erkenntniskritik*] has the articulation and elaboration of the structure of modern mathematical natural science as its primary task; the conviction that, accordingly, philosophy must take the "fact of science" as its starting point and ultimately given datum; and, most especially, the "genetic" conception of scientific knowledge as an ongoing, never completed synthetic process. From a contemporary point of view, Cassirer's history may therefore appear as both "Whiggish" and "triumphalist," but it cannot be denied that his work is, nevertheless, extraordinarily rich and illuminating. Cassirer examines an astonishing variety of textual sources (including both major and minor figures) carefully and in detail, and, without at all neglecting contrary tendencies within the skeptical and empiricist traditions, he develops a compelling portrayal of the evolution of "modern philosophical idealism" through Kant which, even today, reads as extremely compelling and acute.

The second volume of *Das Erkenntnisproblem* culminates in a lengthy and substantial discussion of Kant (Book Eight: The Critical Philosophy). Of particular interest, from our present point of view, is Cassirer's discussion of space and time in Book Eight, Chapter 2, § III, under the heading of "The Separation of Understanding and Sensibility." Here Cassirer follows the basic ideas of Cohen's interpretation in [Cohen, 1871], according to which the sharp separation between two faculties of the mind delineated in the transcendental aesthetic is carried over from the pre-critical doctrine of the *Inaugural Dissertation* (1770) when the critical theory of the transcendental

schematism of the understanding via "productive synthesis" had not yet been articulated. This initial sharp separation must be reevaluated and revised, according to Cohen, when we arrive at the truly critical doctrine of the transcendental analytic in which all "synthetic unity," including that of space and time, is due ultimately to the understanding.[123] Cassirer reads the notion of "productive synthesis," in particular, as a "common superordinate concept" under which the activities of both the understanding and sensibility are to be subsumed [Cassirer, 1907a (1922), p. 684]: "The pure intuitions of space and time, like the concepts of pure understanding, are just different aspects and manifestations [*Entfaltungen und Ausprägungen*] of the basic form of the synthetic unifying function."

"Productive synthesis," for Cassirer, denotes the fundamental creative activity of thought by which it progressively generates the object of empirical natural scientific knowledge. This generation essentially involves the application of mathematics, and pure mathematics itself proceeds by a pure activity of *construction* expressing the very same "original productivity" of thought.[124] That pure mathematics has "sense and meaning," for Kant, only in and through its application to empirical natural scientific knowledge, is then the best possible evidence for the fundamental identity of "productive synthesis" in both pure intuition and pure understanding:

> Synthesis constitutes a unitary, intrinsically undivided process, which, however, can be determined and characterized either in accordance with its beginning or in accordance with its end-point. It arises in the under-

123. See Cassirer's footnote to [Cohen, 1871] in [Cassirer, 1907a (1922), p. 635], under the heading "Raum und Zeit als Grundsätze der Synthesis."

124. According to Cassirer, Kant's interpretation of mathematics in terms of "construction in pure intuition" does not represent a particular point of originality, but is simply inherited from the common rationalist conception (represented by Spinoza, Leibniz, and Hobbes, for example) of "causal" or "genetic" definitions. Kant's originality rather consists in the further idea that this constructive activity has meaning only when applied to empirical intuition. See [Cassirer, 1907a (1922), p. 688–89]: "What is important and new with respect to previous rationalism is precisely that this pure fundamental form [of synthesis] only belongs to transcendental philosophy in so far as it proves itself in geometry, and thereby mediately in the formation of the *empirical spatial* image of reality. . . . Now we have arrived at the decisive new view that all 'spontaneity' of thinking has to serve solely the aims of empirical knowledge itself, and therefore remains bound to the realm of 'appearances'."

standing, but it immediately turns to pure intuition, in order to obtain empirical reality through the mediation of the latter.

Thus the initial separation of intuition and concept dissolves ever more clearly into a pure logical correlation. [Cassirer, 1907a (1922), pp. 697–98]

Space and time count as "pure intuitions," therefore, not because they are expressions of a distinctive non-discursive faculty of the mind, but simply because they are the very first products of constructive empirical thought (and thus especially close, as it were, to empirical intuition) in the progressive constitution of scientific knowledge: "Space and time are 'intuitions' because they are the *first* and *fundamental* orders in which every empirical content must be grasped; because they are that in virtue of which the mere material of sensation is first and originally raised to [the status of] conscious 'representation'."[125]

We indicated in chapter 3 above, however, that such a reading of Kant cannot be sustained. For Kant himself space and time are indeed expressions of a distinctive non-discursive faculty of the mind, and this has pervasive consequences, moreover, for how Kant conceives the relationship between sensibility and understanding.[126] In particular, since sensibility is a distinct and independent faculty of mind, the understanding can also be considered wholly independently of sensibility. Here the pure concepts of the understanding still have a meaning, albeit a purely logical meaning, given by the pure logical forms of judgment. So formal logic, for Kant (that is, what Kant calls general logic), is a purely analytic science whose results also involve no appeal whatever to sensibility. We then move from general logic (that is, pure formal logic) to transcendental logic precisely by the "transcendental synthesis of the imagination," through which the purely logical forms of thought are "schematized" in terms of pure intuition. And Kant accordingly undertakes the task, in the metaphysical and

125. [Cassirer, 1907a (1922), p. 699]; on the following page appears another footnote to [Cohen, 1871].
126. This point is not particularly controversial today. For my own view of the matter see [Friedman, 1992], [Friedman, 2000].

transcendental deductions of the categories, of showing that "the same understanding, through precisely the same actions whereby, in concepts, by means of analytic unity, it brought about the logical form of a judgment, also, by means of the synthetic unity of the manifold of intuition in general, brings a transcendental content into its representations in virtue of which they are called pure concepts of the understanding" (A79/B105).

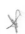

For Kant himself, therefore, pure formal logic deals with a distinctive type of unity, purely analytic unity, which then needs to be explicitly and painstakingly related to the characteristically synthetic unity treated in transcendental logic. For Cassirer, by contrast, we begin with the synthetic unity expressed in the progressive construction of empirical natural scientific knowledge, and pure formal logic, in contradistinction to transcendental logic, is a mere abstraction from this unitary constructive process having decidedly secondary philosophical significance. This aspect of Cassirer's understanding of the Kantian philosophy is clearly expressed in his evaluation of contemporary logicist criticisms of Kant, "Kant und die moderne Mathematik," published in the very same year [Cassirer, 1907b]. Here Cassirer considers the basic logicist idea (particularly as expressed by Louis Couturat) that developments in modern mathematical logic and the foundations of mathematics have shown that Kant's conception of the synthetic character of mathematics is untenable. Mathematics, according to this logicist view, is representable within pure formal logic after all (that is, within modern mathematical logic), and is thus analytic not synthetic. Without in any way rejecting the purely mathematical achievements of modern mathematical logic, Cassirer nonetheless denies that they can possibly show that mathematics is merely analytic in the philosophical sense. For philosophy's distinctive task (the task of epistemology) is developing a "logic of empirical knowledge":

> Thus a new task begins at that point where logistic ends. What the critical philosophy seeks and what it must require is a *logic of objective knowledge*. Only from the standpoint of this question can the opposition between analytic and synthetic judgments be completely understood and evaluated. . . . Only when we have understood that the same fundamental

syntheses on which logic and mathematics rest also govern the scientific construction of empirical knowledge, that they first make it possible for us to speak of a fixed lawful order among appearances and thus of their objective meaning—only then is the true justification of the principles [of logic and mathematics] achieved.[127]

Since pure formal logic, from a philosophical point of view, is just an abstraction from the fundamentally synthetic constitution of natural scientific knowledge, developments in pure formal logic, by themselves, can have no independent philosophical significance. They do not and cannot undermine the essentially Kantian insight into the priority and centrality of "productive synthesis."[128]

Viewed from within the perspective of the "critical" theory of knowledge, however, modern developments in formal logic and the foundations of mathematics have profound philosophical significance indeed. Showing this in elaborate detail is the burden of Cassirer's first "systematic" work, *Substance and Function* [Cassirer, 1910].[129] Cassirer begins by discussing the

127. [Cassirer, 1907b, pp. 44–45]. In developing this point of view Cassirer again refers to Cohen's interpretation of Kant [Ibid., p. 38n]. At one place, however, he indicates that it represents a clear advance *beyond* Kant [Ibid., p. 31]: "Like 'logistic', so modern critical logic has also advanced beyond Kant's doctrine of 'pure sensibility'. For it, too, sensibility certainly signifies an epistemological *problem*, but no longer an independent and peculiar *source of certainty*." There follows a footnote to Cohen's systematic work [Cohen, 1902].

128. We cited this article in chapter 5 above, in connection with Carnap's conception of "intuitive space" in his dissertation (note 83). We now see, however, that Cassirer's conception of the ultimately synthetic character of space and geometry has a rather different emphasis. Carnap follows Husserl's distinction between the completely general "formal eidetic science" of pure logic and the more specific "material eidetic sciences" such as geometry. For Cassirer, by contrast, the synthetic character of space and geometry does not rest on a distinction between two different types of *Wesenserschauung* (formal and material) but rather on the particular role of space and geometry in the constitution of empirical knowledge [Cassirer, 1907b, p. 42]: "That all our connecting forms of thought must finally relate to the fundamental orders of space and time and be 'schematized' therein—this means, for Kant, nothing else but that they have to prove their validity, in the end, in the determination of the *empirical object*."

129. It has frequently been noted that the boundary between "historical" and "systematic" works is somewhat artificial in Cassirer's case. Just as *Das Erkenntnisproblem*, for example, is thoroughly and explicitly informed by Cassirer's own philosophical perspective (which the historical material is taken to confirm), so the philosophical argument of *Substanzbegriff und Funktionsbegriff* (as well as that of later "systematic" works) is largely made through discussion of historical material.

problem of concept formation and by criticizing, in particular, the "abstractionist" theory on which concepts are arrived at by ascending inductively from sensory particulars. This theory, for Cassirer, is an artifact of traditional Aristotelian logic, wherein the only logical relations governing concepts are those of superordination and subordination, genus and species. "Abstractionism" then views the formation of such concepts as an inductively driven ascent from the sensory particulars to ever higher species and genera. Moreover, by this commitment to traditional subject-predicate logic we are also committed, according to Cassirer, to the traditional metaphysical conception of *substance* as the fixed and ultimate substratum of changeable qualities. A metaphysical "copy" theory of knowledge, according to which the truth of our sensory representations consists in a (forever unverifiable) relation of pictorial similarity between them and the ultimate "things" or substances lying behind our representations, is then the natural and inevitable result.

Cassirer is himself concerned, above all, to replace this "copy" theory of knowledge with the "critical" theory. Our sensory representations achieve truth and "relation to an object," not by matching or picturing a realm of metaphysical "things" or substances constituting the stable and enduring substrate of the empirical phenomena, but rather in virtue of an embedding of our sensory representations and the empirical phenomena themselves into an ideal formal structure of mathematical relations—wherein the stability of mathematically formulated *universal laws* takes the place of an enduring substrate of ultimate "things." Developments in modern formal logic (the mathematical theory of relations) and in the foundations of mathematics contribute to securing this "critical" theory of knowledge in two closely related respects. The modern axiomatic conception of mathematics, as exemplified especially in David Hilbert's work on the foundations of geometry [Hilbert, 1899], has shown that mathematics itself has a purely formal and ideal, non-sensory and thus non-intuitive meaning. Pure mathematics describes abstract relational structures whose concepts can in no way be accommodated within the "abstrac-

tionist" conception.[130] In addition, modern scientific episte-
mology, as exemplified especially in Helmholtz's celebrated
Zeichentheorie [theory of signs], has shown ever more clearly
that scientific theories do not provide "copies [*Abbilder*]" or
"pictures [*Bilder*]" of a world of substantial "things" subsist-
ing behind the flux of phenomena. They rather provide mere
formal systems of "signs [*Zeichen*]" corresponding via a non-
pictorial relation of "coordination [*Zuordnung*]" to the univer-
sal law-like relations subsisting within the phenomena
themselves.[131]

Corresponding to the ideal, non-intuitive character of mod-
ern mathematics and mathematical logic is thus a similarly
ideal, non-pictorial mode of representation by which the formal
signs employed in modern mathematical physics relate to their
objects. And it is precisely this increasingly self-conscious use of
purely formal representation, for Cassirer, which then finds its
culmination in Einstein's general theory of relativity. Cassirer
[1921b, p. 14 (p. 357)] begins by explaining that "the reality
of the physicist stands opposite the reality of immediate percep-
tion as a thoroughly mediated [reality]: as a totality, not of
existing things or properties, but rather of abstract symbols of

130. See [Cassirer, 1910, pp. 122–23 (pp. 93–94)]: "This conception of the
method of pure mathematics attains its sharpest expression in the procedure that
Hilbert has applied for the presentation and derivation of geometrical axioms. In con-
trast to the Euclidean definitions, which take the concepts of *point* or *line* from which
they proceed as immediate given [objects] of intuition and which thereby, from the
very beginning, impress on them a determinate unchangeable content, here the stabil-
ity [*Bestand*] of the original geometrical objects is determined entirely by the condi-
tions that they obey. . . . In this sense, Hilbert's geometry has been correctly called a
pure theory of relations."

131. See [Cassirer, 1910, p. 404 (p. 304)]: "This tendency [explaining objectivity
in terms of "pure formal relations on which the coherence of experience rests"] appears
especially pregnantly in Helmholtz's *theory of signs*, which presents a characteristic and
typical version of the general natural scientific theory of knowledge. Our sensations and
representations are signs, not copies [*Abbilder*] of objects. For one requires of pictures
[*Bilder*] some or another kind of similarity with the pictured [*abgebildeten*] object—
which we are never able to secure here. The sign, by contrast, requires no substantial
[*sachliche*] similarity in the elements, but solely a functional correspondence in the two-
sided structure. What is established in this structure is not the particular intrinsic char-
acter [*Eigenart*] of the designated thing, but rather the objective relations in which it
stands to other similar [things]." For discussion of Helmholtz's *Zeichentheorie* see
[Friedman, 1997].

thought that serve as the expression for determinate relations
of magnitude and measure, for determinate functional coordi-
nations [*Zuordnungen*] and dependencies in the appearances."
And Cassirer [1921b, p. 55 (p. 392)] then states the general
point of the argument as the claim that the theory of relativity
can be incorporated within the "critical" conception of knowl-
edge "without difficulty, for this theory is characterized from a
general epistemological point of view precisely by the circum-
stance that in it, more consciously and more clearly than ever
before, the advance from the copy theory of knowledge to the
functional theory is completed." Whereas it is true, in particu-
lar, that Kant himself had envisioned only the use of Euclidean
geometry in mathematical physics, the fact that we now employ
a non-intuitive, non-Euclidean geometry in the general theory
of relativity by no means contradicts the general "critical" point
of view. For, as "Kant also had emphasized decisively" [Ibid., p.
109 (p. 439)], "this form of dynamical determination does not
belong any longer to intuition as such, but rather it is the 'rule
of the *understanding*' alone through which the existence of
appearances can acquire synthetic unity and be taken together
[as a whole] in a determinate concept of experience."[132]

The concluding chapter of [Cassirer, 1921b] outlines an
even greater generalization and relativization of the "critical"
theory of knowledge, not only to include the use of non-
Euclidean as well as Euclidean geometries in the presentation
of natural scientific reality, but also to encompass wholly non-
scientific modes of presentation such as the ethical, the aes-
thetic, and the mythical. Thus, according to [Ibid., p. 117 (p.
446)], "[t]he postulate of relativity may be the purest, the
sharpest and most general expression of the physical concept of

132. [Cassirer, 1921b, p. 109 (pp. 439–40)] continues: "The step beyond [Kant]
that we now had to complete on the basis of the results of the general theory of relativ-
ity consisted in the insight that in these determinations of the understanding, in which
the empirical-physical picture of the world first arises, geometrical axioms and laws
other than those of Euclidean form can enter in, and allowing such axioms not only
does not destroy the unity of the world—that is, the unity of our concept of experience
of a total ordering of the phenomena—but it truly first grounds this unity from a new
point of view, in that in this way the particular laws of nature we have to reckon with in
space-time-determination all finally cohere in the unity of a highest principle: precisely
the general postulate of relativity."

object—but precisely this concept of the *physical* object in no way coincides, from the standpoint of the general critique of knowledge, with reality as such." Indeed, to look for any "ultimate *metaphysical* unity, in the unity and simplicity of an absolute 'world-ground'" subsisting behind the irreducible diversity of our various presentations of reality, is now diagnosed as the fatal "dogmatic" (meaning "non-critical") philosophical error:

> The naive realism of the ordinary world-view, like the realism of dogmatic metaphysics, lapses always and repeatedly into this mistake. It separates out a single one from the totality of possible concepts of reality and erects it as a norm and model for all the rest. Thus certain necessary form-viewpoints, under which we seek to judge, consider, and understand the world of appearances, are refashioned into things, into being as such. Whether we determine "matter" or "life," "nature" or "history," as this ultimate being, a degeneration of our world-view always finally results in this way, because certain spiritual functions that contribute to its construction [*Aufbau*] appear excluded, whereas others, by contrast, appear one-sidedly emphasized and privileged.
>
> It is the task of systematic philosophy—which reaches far beyond that of epistemology—to free our picture of the world from this one-sidedness. It has to grasp the *totality* of symbolic forms, on the basis of which the concept of an articulated reality arises for us—in virtue of which subject and object, I and world, are separated for us and oppose one another in a determinate mode of formation [*Gestaltung*]—and it has to indicate the fixed place of each individual [form] within this totality.[133]

It is appropriate, then, that one of the earliest occurrences of the idea of a general philosophy of "symbolic forms" in print is in a work devoted to the theory of relativity.[134] Whereas,

133. [Cassirer, 1921b, pp. 118–19 (p. 447)]. A few pages later Cassirer relates this point to the criticism of the "copy" theory of knowledge [Ibid., p. 122 (p. 450)]: "Where the copy theory of knowledge seeks and requires a simple identity, there the functional theory of knowledge discovers thoroughgoing diversity, but, at the same time, thoroughgoing correlation of the individual forms."

134. The terminology of "symbolic forms" first appeared in [Cassirer, 1921a] (which is cited in [Cassirer, 1921b, p. 122n (p. 450n)]). Cassirer reports that the idea of a general philosophy of symbolic forms first came to him in 1917 (see [Gawronsky, 1949, p. 25]). His interest in general cultural history as a philosophical problem is already evident in [Cassirer, 1916]; and the third volume of *Das Erkenntnisproblem* [Cassirer, 1920], devoted to the systems of post-Kantian idealism, also expresses his developing interest in this problem.

according to the general postulate of relativity, *all* possible ref-
erence frames and coordinate systems are now viewed as
equally good representations of physical reality, and, as a total-
ity, are together embraced and interrelated by precisely this
postulate, the totality of possible "symbolic forms" are here
envisioned by Cassirer as standing in a closely analogous rela-
tionship.[135]

We noted that Cassirer had moved as professor to the newly
founded University of Hamburg in 1919. There he found a
tremendous, and at first overwhelming, resource for the devel-
opment of a general philosophical theory of culture—the
Kulturwissenschaftliche Bibliothek Warburg—which, as Cassirer
reports, seemed to have been arranged by its founder, Aby
Warburg, with the philosophy of symbolic forms in mind.[136]
Warburg, an eminent art historian, had a particular interest in
ancient cult, ritual, myth, and magic as sources of archetypal
forms of emotional expression later manifested in Renaissance
art, and he thus included, among the materials on artistic and
cultural history, abundant works on myth and ritual that were
to be central for Cassirer's own work on mythical thought.
Some of Cassirer's earliest works on the idea of a philosophy of
symbolic forms in general and mythical thought as a particular
symbolic form then appeared as studies and lectures of the
Warburg library in the years 1922–25.[137] The first volume of
The Philosophy of Symbolic Forms, on *Language,* appeared as
[Cassirer, 1923]; the second volume, on *Mythical Thinking,*
appeared as [Cassirer, 1925]; the third volume, on the
Phenomenology of Knowledge, appeared as [Cassirer, 1929b].

135. The above-cited passage continues [Cassirer, 1921b, p. 119 (p. 447)]: "If
one imagines this task to be solved, the particular conceptual and cognitive forms, such
as the general forms of the theoretical, ethical, aesthetic, and religious understandings
of the world, would have their rights secured and their boundaries delimited. Each par-
ticular form would certainly be relativized in this conception with respect to the oth-
ers—but since this relativization is thoroughly mutual, since no individual form, but
only their systematic totality, would now hold as expression of 'truth' and 'reality', the
limits arising thereby would, on the other side, appear as thoroughly immanent limits—
which would be transcended as soon as we once again relate the individual to the
whole and consider it in the context of the whole."

136. See [Gawronsky, 1949, p. 26].
137. See [Krois, 1987, pp. 22–24].

As Krois [1987], in particular, rightly emphasizes, the philosophy of symbolic forms represents a decisive break with Marburg neo-Kantianism. But it is important to be clear on the precise nature of this break. For the Marburg neo-Kantians, like Kant himself, in no way limited philosophy to *Erkenntniskritik* or the study of scientific knowledge. Just as Kant himself had done, for example, Cohen wrote works on ethics, aesthetics, and religion as well. Indeed, because of their overarching focus on the "genetic" conception of knowledge, it was especially natural for the Marburg School to incorporate ethics, aesthetics, and religion within a broadly Kantian framework. For Kant, scientific knowledge is framed by what he calls the regulative use of reason, through which reason is guided but not constrained by the idea of the unconditioned in pursuing the never to be attained goal of an ideally complete scientific description of the world. In the *Critique of Judgment* (1790) Kant then incorporates aesthetics within this framework as a distinctive exercise of "reflective judgment" (which is closely connected with the regulative use of reason), and secures the unity of practical and theoretical reason by arguing that the idea of the unconditioned, which is wholly indeterminate as far as theoretical reason is unconcerned, first receives determinate meaning and content through the moral law as a product of pure practical reason. The full realization of the moral law in the "idea of the highest good" thereby secures the unity of theoretical, practical, and aesthetic judgment as a "focus imaginarius" or "infinitely distant point,"[138] and this general unifying idea is itself carried over by the Marburg School.

Cassirer himself presents the underlying idea very clearly in *Substance and Function*:

> The individual determines the direction of cognition as infinitely distant point. This last and highest goal of unity certainly reaches beyond the circle of natural scientific concepts and methods. The "individual" of natural

138. Kant incorporates Christianity within this moral framework in *Religion Within the Limits of Reason Alone* (1793). Cohen does something analogous for prophetic Judaism—see the discussion of prophetic religion in [Cassirer, 1925].

science includes and exhausts neither the individual of aesthetic judgment nor the moral personalities constituting the subject of history. For all particularity in natural science reduces to the discovery of univocally determinate *magnitude-values* and *magnitude-relations*, whereas the characteristic classification and value that the object obtains in artistic consideration and in ethical evaluation lie outside of its point of view. But this delimitation of the different methods of judgment does not, nevertheless, create a dualistic opposition between them. The natural scientific concept does not deny or negate the object of ethics and aesthetics, even though it cannot construct it with its means; it does not falsify intuition, even though it consciously considers it under a *single* governing point of view and gives prominence to a single form of determination for it. The further modes of consideration that rise above the natural scientific concept do not stand to it in contradiction, therefore, but in a relation of intellectual *extension*. . . . It is a new teleological order of reality that now appears next to the mere order of magnitudes and in which the individual first obtains its full meaning.[139]

Ethics, aesthetic, and religion thus emerge via a teleological extension, as it were, of the never-ending genetic procedure characteristic of natural scientific knowledge. And there is absolutely nothing here to disturb either Kant himself or the neo-Kantianism of the Marburg School.

However, what distinguishes the philosophy of symbolic forms from traditional Kantian and neo-Kantian attempts to incorporate both scientific and non-scientific modes of thought within a single philosophical framework is precisely its emphasis on more *primitive* forms of world-presentation—on the ordinary perceptual awareness of the world expressed, for Cassirer, primarily in natural language, and, above all, on the mythical view of the world lying at the most primitive level of all. In the philosophy of symbolic forms these more primitive manifestations of consciousness have an independent status and foundational role that is quite incompatible with both Marburg neo-Kantianism and Kant's original conception. In particular, the more primitive forms do not arise through any kind of extension or completion of the scientific form. They lie at a

139. [Cassirer, 1910, pp. 309–10 [pp. 232–33]). I am indebted to André Carus for calling my attention to this passage (which continues the passage cited in note 104). Recall (note 134 above) that Cassirer first developed the idea of the philosophy of symbolic forms in 1917.

deeper, autonomous level of spiritual life, which then gives rise to more sophisticated forms by a developmental process taking its starting point from this given basis. From mythical thought, religion and art develop; from natural language, theoretical science develops. In place of a teleological structure, therefore, we have what has been aptly called a "centrifugal" structure, as the more primitive forms give birth to the more sophisticated forms arranged around a common origin and center.[140] And it is precisely here that Cassirer appeals to "romantic" philosophical tendencies lying outside the Kantian and neo-Kantian traditions—to speculations about the origins of language and human culture in Vico and Herder, to the pioneering work in the comparative study of languages and cultures by Wilhelm von Humboldt, to the *naturphilosophische* and aesthetic ideals of Goethe. It is here that he deploys an historical dialectic self-consciously derived from Hegel,[141] and it is here that he comes to terms with the contemporary *Lebensphilosophie* of Dilthey, Bergson, Scheler, and Simmel.[142]

140. See [Krois, 1987, pp. 78–81] for the contrast between a linear or "hierarchical" conception of dialectical development and Cassirer's "centrifugal" conception. In my view, however, Krois tends to underemphasize the remaining teleological and hierarchical elements in the philosophy of symbolic forms—and, in particular, the idea that the theoretical scientific form represents the *highest* stage of development. This matter will be discussed further below.

141. The Preface to [Cassirer, 1929a, pp. vi–vii (pp. xiv–xv)] asserts that its title, "Phenomenology of Knowledge," does not refer to modern phenomenology, but "goes back to the fundamental meaning of 'phenomenology' as Hegel has established it and systematically grounded and justified it." Cassirer then quotes the Preface to the *Phenomenology of Spirit* to the effect that the individual has the right to demand that science provide him with a "ladder" from more primitive consciousness to that of science itself. Cassirer continues: "It cannot be expressed more sharply that the end, the 'telos' of spirit cannot be grasped and expressed if one takes it as something self-subsistent, if one takes it as dissolved and separated from the beginning and the middle. Philosophical reflection does not set the end against the middle and the beginning in this way, but rather takes all three as integrating moments of a unitary total development." The Preface to [Cassirer, 1925, pp. ix–xi (pp. xv–xvi)] quotes the same passage from the *Phenomenology* and continues: "If, therefore, in accordance with Hegel's demand, 'science' is supposed to offer the ladder to natural consciousness that leads to itself [science], then it must set this ladder one more level lower. . . . For the proper starting point for all development of knowledge, its beginning in the immediate, lies not so much in the sphere of sensible as in that of mythical intuition." For Cassirer, then, it is clear that the "beginning" of this developmental process is myth, its "middle" is ordinary perceptual consciousness, and its "end" is theoretical science.

142. As [Krois, 1987, p. 35] points out, Cassirer himself uses the term *"Lebensphilosophie"* in a broader sense to embrace much of post-idealistic (and non neo-Kantian) philosophy in general, including [Krois and Verene, 1996, p. xi]

All the different modes of world-presentation agree, according to Cassirer, in so far as they are all *symbolic* forms of spiritual expression, systems of sensory signs or images created by man the symbolic animal as intermediaries between self and world:

> In all [the most diverse regions of spiritual activity] it is in fact shown, as the proper vehicle of their immanent progress, that they allow a free *image-world* [*Bildwelt*] of their own to arise alongside of and above the world of perception: a[n image] world which still wholly bears the coloration of the sensible in accordance with its immediate constitution, but which presents an already formed and thus a spiritually governed sensibility. Here we do not have to do with a simply given and encountered sensible [object], but rather with a system of sensible manifolds created in one or another form of free construction [*freien Bildens*]. [Cassirer, 1923, pp. 19–20 (p. 87)]

Just as the "genetic" view of knowledge of the Marburg School replaces the "copy" theory with a "functional" theory, so the more general theory of meaningful representation developed in the philosophy of symbolic forms shows that representation is quite distinct from resemblance in *all* of the spiritual forms:

> This transformation into form [*Wandlung zur Gestalt*] is accomplished in different ways and in accordance with different constructive principles [*Bildungsprinzipien*] in science and in language, in art and in myth; but they all agree in so far as that which finally appears before us as a product of their activity in no way resembles the mere *material* from which they originally proceeded. It is thus that spiritual consciousness in the fundamental function of sign-creation, in general and in its diverse directions, truly differs from sensory consciousness. It is here, in place of the passive givenness of some or another external existent, that an independent shaping given by us first arises, through which it then appears differently for us in different regions and forms of reality. Myth and art, language and science, are in this sense shapings *toward* being; they are not simple copies of an already present reality, but they rather present the great lines of direction of spiritual development, of the ideal process, in which reality constitutes itself for us as one and many—as a manifold of forms [*Gestaltungen*], which are nonetheless finally held together by a unity of meaning. [Ibid., p. 43 (p. 107)]

Schopenhauer, Kierkegaard, Nietzsche, and Heidegger. Cassirer's (and Heidegger's) relationship to *Lebensphilosophie* will be discussed in chapter 8 below.

We overcome the "copy" theory of knowledge by the insight that science must work up our sensory impressions into freely created theoretical structures. We overcome the "copy" theory of meaning in general by the insight that all symbolic forms as such must similarly subject the mere sensory given to the free creative activities of the spirit.[143]

The most basic and primitive type of symbolic meaning is *expressive* meaning—the experience of events in the world around us as charged with affective and emotional significance, as desirable or hateful, comforting or threatening. It is this type of meaning that underlies mythical consciousness, for Cassirer, and which explains its most distinctive feature, namely, its total disregard for the distinction between appearance and reality:

> [In myth] there is no thing-substance lying at the basis of the changing and fleeting appearances, the mere "accidents," as a stable and enduring something. Mythical consciousness does not *infer* from the appearance to the essence, but it possesses the essence, it *has* the essence in the appearance. . . . The demon of the rain itself is that which is living in every water droplet and which is palpably and bodily there. Thus, in the world of myth, each and every appearance is always and essentially an incarnation. The essence does not *distribute* itself here over a manifold of possible modes of presentation, such that each contains a mere fragment of it; rather, it manifests itself in the appearance as a *whole*, as an unbroken and indestructible unity. It is precisely this state of affairs which can be expressed "subjectively" by the idea that the world of mythical experience is not grounded in either representative or significance-giving acts, but in pure experiences of expression. What is here present as "reality" is not a complex of things provided with determinate "marks" and "characteristics," on the basis of which they can be recognized and distinguished from one another; rather, it is a manifold and profusion of originally "physiognomic" characters. [Cassirer, 1929b, pp. 79–80 (pp. 67–68)]

Since the mythical world does not consist of stable and enduring substances that manifest themselves from various points of view and on various occasions, but rather in a fleeting complex of events bound together by their affective and emotional "physiognomic" characters, it also exemplifies its own particu-

143. The title of the section in which the last quotation appears is "The ideal meaning of the sign.—The overcoming of the copy theory."

lar type of causality whereby each part literally contains the whole of which it is a part and can thereby exert all the causal efficacy of the whole.[144] Similarly, there is no essential difference in efficacy between the living and the dead, between waking experiences and dreams, between the name of an object and the object itself, and so on.[145]

What Cassirer calls *representative* meaning, a product not of the expressive function [*Ausdrucksfunktion*] of thought but rather of its representative function [*Darstellungsfunktion*], then has the task of precipitating out of the original mythical flux of "physiognomic" characters a world of stable and enduring substances, distinguishable and reidentifiable as such. Working together with the fundamentally pragmatic orientation towards the world exhibited in the technical and instrumental use of constructed tools, it is in natural language, according to Cassirer, that the representative function of symbolic meaning is most clearly visible.[146] It is primarily through the medium of natural language, that is, that we construct the "intuitive world" of ordinary sense perception, on the basis, for Cassirer, of what he calls intuitive space and intuitive time.[147]

proto-
Heideggerian

144. See [Cassirer, 1925, pp. 83–84 (pp. 64–65)]: "In a man's hair, in his nail clippings, in his clothes, in his footprints, the whole man is still contained. Every trace that a man leaves behind him counts as a real part of him, which can react on him as a whole and can endanger him as a whole. . . . Even the genus does not stand to that which it includes, that which it contains under itself as species or as individual, in the relation by which it logically determines this particular as a universal; rather, it is immediately present in this particular—it lives and acts in it. . . . The structure of the *totemistic* picture of the world, for example, can scarcely be understood except through this essential aspect of mythical thinking. For, in the totemistic classification of men and the totality of the world, there is no mere *coordination* [*Zuordnung*] between the class of men and things on the one side and certain classes of animals and plants on the other; rather, here the individual is thought as dependent in a real fashion on its totemistic ancestor—indeed, as identical with it."

145. See [Cassirer, 1929b, p. 80 (pp. 68–69)]: "For [mythical consciousness] the content of a dream weighs just as heavily as the content of any waking experience; for it the image is equal to the thing, the name is equal to the object. This 'indifference' only becomes comprehensible in the first place when one takes into account that there is not yet any representative or symbolic meaning here; rather, pure expressive meaning still holds unconstrained and almost unrestricted sway."

146. Cassirer does not discuss the relationship between representative meaning and the technical use of tools in detail in *The Philosophy of Symbolic Forms*, although he suggests such a connection at, e.g., [Cassirer, 1923, pp. 163–64 (pp. 212–13)], [Cassirer, 1925, pp. 264–69 (pp. 214–18)]. [Cassirer, 1930b] provides a much more developed discussion. See also [Krois, 1987, pp. 96–105].

147. This process is discussed most extensively in [Cassirer, 1929b, Part Two], entitled "The Problem of Representation and the Construction [*Aufbau*] of the

The demonstrative particles (later articles) and tenses of natural language specify the locations of perceived objects in relation to the changing spatio-temporal positions of the speaker (relative to the "here-and-now").[148] A unified spatio-temporal order thus arises in which each designated object has a determinate relation to the speaker, his point of view, and his potential range of pragmatic activities.[149] We distinguish the enduring thing-substance, on the one side, from its variable manifestations from different point of view and on different occasions, on the other, and we thereby arrive at the fundamental distinction between appearance and reality.[150] This distinction is then expressed in its most developed form, for Cassirer, in the linguistic notion of propositional truth and thus in the propositional copula.

The distinction between appearance and reality, as expressed in the propositional copula, then leads naturally to a new task of thought, the task of theoretical science, of systematic inquiry into this realm of truths. Here we encounter the third and final function of meaning, the *significative* function [*Bedeutungs-*

Intuitive World," in chapters on "the concept and problem of representation," "thing and property," "space," and "the intuition of time." See especially [1929b, p. 138 (p. 119)]: "The power of the linguistic form is not exhausted in that which it accomplishes as vehicle and as medium for logical-discursive thinking. It already penetrates the 'intuitive' conception and formation of the world; no less than in the construction of the realm of concepts, it participates in the construction of perception and in that of intuition."

148. This is discussed most extensively in [Cassirer, 1923, chapter 3, §§ 1–2]. See especially [1923, pp. 155–56 (p. 206)]: "Here [in the Somali articles] we can grasp almost tangibly that and how the universal form of 'substantialization', of the formation of 'things' expressed in the article arises from the function of spatial demonstration and at first still remains completely bound to it—that it conforms as closely as possible to the different modes of demonstration and their modifications, until finally, at a relatively late stage, the dissolution of the pure category of substance from the particular forms of spatial intuition is completed."

149. See [Cassirer, 1923, p. 156 (p. 206)]: "The 'differentiation of regions in space' takes its start from that point at which the speaker finds himself, and it advances from here outwards in concentric expanding circles to the organization of the objective whole, of the system and totality of determinations of location." And compare again [Ibid., pp. 163–64 (pp. 212–13)] (note 146). The quoted reference is to Kant's 1768 essay on the subject.

150. See [Cassirer, 1929b, pp. 165–66 (p. 142)]: "The positing of fixed thing-unities, to which the changing appearances are, as it were, attached, is accomplished in such a way that these unities are, at the same time, determined as *spatial* unities. The 'stability' of the thing is bound up with the fixity of such spatial unities. That a thing is precisely this one [thing], and that it persists as this one [thing]—this results for us, above all, in so far as we designate its 'place' in the whole of intuitive space."

funktion], which is exhibited most clearly, according to Cassirer, in the "pure category of relation."[151] For it is precisely here, in the theoretical view of the world, that the pure relational concepts characteristic of modern mathematics, logic, and mathematical physics are finally freed from the bounds of sensible intuition:

> But with this transition into the realm of pure significance and validity [*Bereich der reinen Bedeutung und Geltung*] a plethora of new problems and difficulties now accumulates for thought. For now the definitive break with mere existence and its "immediacy" is first completed. The sphere we designated as that of *expression* and, even more, the sphere we designated as that of *representation* [*Darstellung*] already reached beyond this immediacy—in so far as neither persisted in the circle of mere "presence [*Präsenz*]" but arose from the fundamental function of "re-presentation [*Repräsentation*]." It is first within the pure *sphere of signification,* however, that this function does not merely obtain an extension—rather, what is specific in the meaning of this function now appears in complete clarity and precision. Now we arrive at a kind of separation, a kind of "abstraction," with which perception and intuition were not yet acquainted. Cognition separates the pure relations from their interweaving with the concrete and individually-determined "reality" of things, in order to present them purely as such in the universality of their "form," in the manner of their relational-*character*. . . . The comprehension, the "synopsis" of the manifold, is not simply here prescribed to thought by the objects; rather, it must now be established by means of intrinsic and independent activities of thought, in accordance with the norms and criteria immanent in thought itself. [Cassirer, 1929b, pp. 330–31 (p. 284)]

151. The propositional copula is therefore associated with a *transition* from the representative to the significative function. See [Cassirer, 1923, pp. 286–87 (p. 313)]: "This [development of "one of the ultimate ideal goals of linguistic formation"] is presented particularly sharply and clearly, finally, in the shaping of that linguistic form which, in accordance with its fundamental meaning [*Grundbedeutung*], is distinct in principle from all thinglike-substantial expression, so that it may serve solely as the expression of synthesis as *such*, as the expression of pure connection. In the use of the *copula* logical synthesis, which finds its completion in judgment, first obtains its adequate linguistic designation [*Bezeichnung*] and determination." This is the last and best example of a series of linguistic phenomena in which [Ibid. p. 285 (p. 312)] "it clearly appears that language grasps the pure category of relation only hesitantly, as it were, and how this category becomes intellectually accessible to it only by means of a detour through other categories—in particular, through those of substance and property." There follows a discussion of the historical philosophical difficulties surrounding the distinction between the "is" of predication and the idea of substantial "being."

Mathematical space and time arise from intuitive space and time, for example, when we abstract from all demonstrative relation to a "here-and-now" and consider instead the single system of relations in which all possible "here-and-now"-points are embedded; the mathematical system of the natural numbers arises when we abstract from all concrete applications of counting and consider instead the single potentially infinite progression wherein all possible applications of counting are comprehended; and so on.[152] The result, in the end, is the world of modern mathematical physics described in Cassirer's earlier scientific works—a pure system of mathematical relations where, in particular, the intuitive concept of substantial thing has finally been replaced by the relational-functional concept of universal law.[153]

In constructing this mathematical-physical world of pure significance and validity, moreover, we need a fundamentally new type of symbolic instrument, namely, that which Leibniz had envisioned in the form of a "universal characteristic." Thus, the above-cited passage continues as follows:

> This task would not be achievable if thought, in posing it, did not simultaneously create a new *organ* for it. It can no longer remain with those formations that the intuitive world brings to it ready made, as it were, but it must rather make the transition to *constructing* [*aufzubauen*] a realm of symbols in complete freedom, in pure self-activity. . . . A complex of *signs* now underlies the system of relations and of conceptual significance—a complex of signs that is built up in such a way that the interconnections

152. For the transition from intuitive to mathematical space see [Cassirer, 1929b, pp. 491–94 (pp. 422–24)]. For the development of the concept of the natural number series see [Ibid., pp. 396–408 (pp. 341–50)].

153. The Preface to [Cassirer, 1929b] explains that he is here returning to the scientific investigations begun in [Cassirer, 1910], although from the new perspective of the philosophy of symbolic forms—which, "starting from the relative 'end' that thought has here [in the exact sciences] achieved, it asks after the middle and the beginning, in order by this retrospective view to understand precisely this end itself and that which it is and signifies [*bedeutet*]" (see note 141 above). This fundamentally new perspective means, in particular, that the intuitive world of ordinary perception has an autonomous status in the philosophy of symbolic forms that it did not have in Cassirer's earlier scientific works written squarely within the Marburg tradition. Cassirer emphasizes the abstract character of modern mathematical physics in [1929b, Part Three, chapter 5, § 3], which places particular emphasis on the theory of relativity and refers to both [Cassirer, 1910] and [Cassirer, 1921b].

holding between the individual elements of the latter system can be sur-
veyed and read off from it. . . . Alongside of the *"Scientia generalis"* a
"Characteristica generalis" is required. The work of *language* continues
in this characteristic, but it simultaneously enters into a new logical
dimension. For the signs of the characteristic have divested themselves of
everything merely expressive, and, indeed, of everything intuitively-repre-
sentative: they have become pure "signs of significance
[*Bedeutungszeichen*]." We are thereby presented with a new type of
"objective" meaning relation that is specifically different from every kind
of "relation to an object" subsisting in perception or in empirical intu-
ition. [Cassirer, 1929b, pp. 331–32 (p. 285)]

The language of mathematical-physical theory transcends all
expressive and representative meaning, as exhibited in the
mythical and intuitive worlds, and we thereby finally attain the
stage of pure signification. All "picturing," that is, must be
replaced by the purely logical *coordination [Zuordnung]*
described in Helmholtz's theory of signs,[154] and this project, as
first clearly envisioned by Leibniz, finds its most precise and
exact fulfillment in modern mathematical logic.[155]

In thus explicitly embracing a Leibnizean conception of
pure signification, however, Cassirer has here broken even
more decisively with the Kantian conception of the transcen-
dental schematism of the understanding. For, from the perspec-
tive of the philosophy of symbolic forms, Kant's original
conception of "productive synthesis" did not clearly distinguish
between those symbolic functions expressed in scientific knowl-
edge and those expressed in ordinary sensory perception.
Indeed, Kant himself, on Cassirer's view, took the form of sci-

154. Cassirer discusses Helmholtz's *Zeichentheorie* in [Cassirer, 1929b, pp. 171–72
(pp. 147–48)], which in turn refers forward to [Ibid., Part Three, chapters 1 and 2]
where the passages we are examining occur.

155. See [Cassirer, 1929b, pp. 54–55 (p. 46)]: "From the fundamental ideas of
the Leibnizean characteristic grew the ideas of modern 'symbolic logic', and from
these, in turn, grew a new formation of the principles of mathematics. Here mathemat-
ics has reached a point where it can never dispense with the help of symbolic logic—
indeed, when one considers work on the modern theory of mathematical principles,
especially that of Russell, it appears to have become more and more questionable
whether mathematics can claim any special place or right at all *outside* of symbolic logic.
Just as, for Leibniz, the concept of symbol constituted the *'vinculum substantiale'*, as it
were, between his metaphysics and his logic, now, in the modern theory of science, it
constitutes the *vinculum substantiale* between logic and mathematics, and, further,
between logic and the exact knowledge of nature."

entific conceptual formation as the form of all conceptual for-
mation in general, and it is precisely this that we must now
specifically rectify in carefully separating the representative
function underlying the intuitive world from the purely signi-
ficative function underlying the theoretical world.[156] Yet, at the
same time, it is only the increasingly abstract character of mod-
ern mathematical physics that now allows us to make this dis-
tinction. From Kant's original point of view, that of classical
Newtonian physics, the theoretical and perceptual worlds fuse
quite naturally together, and it is just this circumstance, in fact,
that lies behind all the difficulties following from the original
Kantian doctrine of pure sensibility.[157] Now, however, these dif-
ficulties have been finally overcome in the development of the
exact sciences themselves, and the way is thereby definitively
cleared for a proper appreciation of non-representative and
wholly non-intuitive significance:

156. See [Cassirer, 1929b, p. 16 (pp. 12–13)]: "Thus, the thought of an original
intellectual 'form' of the perceptual world is carried through by Kant in complete rigor
and in all directions; but precisely this form essentially coincides for him with that of
the mathematical concept. The two are distinguished at most according to clarity and
distinctness, but not in accordance with their essence and structure. . . . As necessary
and consequent as this result may appear in the realm of Kant's general posing of the
question, we can nevertheless not follow him after we have once extended this realm,
after we have attempted to pose the 'transcendental question' itself in a more compre-
hensive sense." Compare note 153 above.

157. See [Cassirer, 1929b, pp. 535–36 (p. 459)]: "If, nonetheless, for Kant him-
self the transposition of the formal principle of substance into the concept of 'matter',
in the assumption of something spatially-unalterable, was achieved without difficulty,
this is conditioned essentially by his historical relation to the Newtonian theory. . . .
The axiom that space itself and that which fills space, the substantially-real [*stofflich-
Wirkliche*] therein, can be separated in this way, that they can be conceptually split
apart, as it were, in two modes of being sharply distinguished from one another, is here
taken from the system of 'classical mechanics'. In this way, however, Kant's theory of
'pure intuition'—and, along with it, the entire relationship he assumes between 'tran-
scendental analytic' and 'transcendental aesthetic'—is infected with a difficulty that had
clearly to appear as soon as this axiom itself was called into question, as soon as the
transition from classical mechanics to the general theory of relativity was achieved." For
the connection between Kant's adherence to the Newtonian model and what Cassirer
calls the intuitive world see [Cassirer, 1923, pp. 170–71 (p. 218)]. What is decisive
here is that Cassirer now recognizes two quite distinct modes of symbolic meaning:
that characteristic of ordinary perceptual consciousness and that characteristic of mathe-
matical theoretical science. Just as Kant, from Cassirer's new point of view, assimilated
the latter too closely to the former, so the earlier Marburg-style conception articulated
in *Substance and Function*, for example, is now seen to be guilty of the opposite assimi-
lation. Compare notes 153 and 156 above.

Thus here [in Kant] "pure sensibility" has acquired a completely different position in the total structure of mathematics than it had in Leibniz. Sensibility has become an independent *ground* of cognition, rather than, as for Leibniz, a mere means of representation: intuition [*Anschauung*] has acquired grounding and legitimizing value. For Leibniz, the realm of intuitive [*intuitiven*] cognition, which relates to the objective connection of the ideas, is separated from the realm of symbolic cognition, in which we deal not with the ideas themselves but with their representative [*stellvertretenden*] signs; but the intuition [*Intuition*] to which he appeals does not constitute a counter instance to the logical but rather contains both the logical and the mathematical as particular forms within it. For Kant, by contrast, the boundary is not drawn between intuitive [*intuitive*] and symbolic thinking, but rather between the "discursive" concept and the "pure intuition [*Anschauung*]," where the content of the mathematical can only be provided and justified by the latter.

If one considers this methodological contrast from the standpoint of *modern* mathematics, then one must acknowledge that the latter has progressed further on the path indicated by Leibniz, not that indicated by Kant. In particular, it has been the discovery of non-Euclidean geometry that has placed it on this path. Thanks to the new problems that have arisen there, mathematics has become more and more a "hypothetical-deductive system," whose truth-value consists purely in its inner logical completeness and consistency, not in any contentful intuitive [*anschaulichen*] assertions.[158]

By sharply distinguishing between intuitive or representative meaning and the purely formal or significative meaning characteristic of modern abstract mathematics, in the tradition of Leibniz's "universal characteristic," Helmholtz's theory of signs, and Hilbert's axiomatic conception of geometry, Cassirer has clearly moved out of the Kantian camp and has come extremely close, in fact, to the position of Carnap and the logical positivists.

158. [Cassirer, 1929b, pp. 422–23 (pp. 363–64)]. Compare the discussion of Leibniz here [Ibid., pp. 416–23 (pp. 357–64)] with that at [Ibid., pp. 532–38 (pp. 455–59)] (see note 157 above).

7

Logic and Objectivity:
Cassirer and Carnap

We observed at the outset that Moritz Schlick had written to Cassirer in 1927 for help with the publication of Carnap's *Aufbau*. Cassirer was very sympathetic, but he clearly had no opportunity to respond to Carnap's book in the period that we have been discussing.[159] Cassirer did have the opportunity to respond to Schlick himself, however, and it is particularly instructive to trace out some of the philosophical interconnections linking all three men. For Schlick's magnum opus, his *Allgemeine Erkenntnislehre (General Theory of Knowledge)* [1918], bears very interesting relations both to Cassirer's conception of theoretical science developed throughout this period and to Carnap's *Aufbau*.

Schlick's epistemological viewpoint is based on a sharp and pervasive distinction between conceptual knowledge [*Erkennen*] on the one side and intuitive acquaintance [*Kennen*] on the other. To know an object is to succeed in (univocally) designating it via concepts, and knowledge is therefore essentially mediated by conceptual thought. To be acquainted with an object, by contrast, is simply to experience it [*Erleben*], as we experience the immediately given data of our consciousness independently of all conceptual thought [Schlick, 1918, p. 311 (p. 365)]: "[i]n intuitive experiences [*anschaulichen Erlebnissen*], the immediate data of consciousness, e.g.,

159. Cassirer's only explicit reference to Carnap in this period is in [Cassirer, 1929b, p. 493n (p. 423n)], where he invokes [Carnap, 1922] on behalf of his own discussion of the relationship between intuitive space and theoretical space (see notes 12, 79–83, 128, and 152 above).

111

pure sensations, we find pure facts that are independent of all thinking." This sharp distinction between knowledge and acquaintance is associated with a parallel distinction between concepts [*Begriffe*] and ideas or images [*Vorstellungen*]. Whereas ideas or images belong to the immediately given data constituting the stream of our consciousness and, as such, share in the privacy, subjectivity, and lack of precisely defined boundaries peculiar to all such immediate data, concepts, by contrast, are public or objective representations with perfectly precise definite boundaries. Following the example of Hilbert's work in the foundations of geometry, in particular, we see that precise and objective concepts, as characterized paradigmatically in the mathematical exact sciences, are made possible by *implicit definitions*, which fully specify concepts through their mutual relationships with one another in a rigorous axiomatic system.

Schlick, following the example of Helmholtz's *Zeichentheorie*, is then in a position definitively to reject the "copy" theory of knowledge. The purely formal meaning exhibited in the exact sciences cannot involve any kind of "picturing" of reality, but only a purely logical relation of "coordination [*Zuordnung*]":

> Thus the concept of agreement [*Übereinstimmung*] melts away under the rays of analysis, in so far as it is supposed to mean sameness or similarity, and what remains is only the univocal coordination. In this consists the relation of true judgments to reality, and all those naive theories, according to which our judgments and concepts could somehow "picture [*abbilden*]" reality, are in principle destroyed. There remains no other meaning for the word agreement than that of univocal coordination.[160]

And the crucial relation of "coordination" or "designation [*Bezeichnung*]" between an abstract formal axiom system and reality is established, for Schlick, by what he calls the "method of coincidences." This method is modelled on spatio-temporal measurement and the use of spatio-temporal coordinates in the

160. [Schlick, 1918, p. 57 (p. 61)]. For an extensive discussion of the relationship between Schlick and Helmholtz's *Zeichentheorie* see [Friedman, 1997], which I draw upon here. For a discussion of Schlick and Cassirer on *Zuordnung* see [Ryckman, 1991].

general theory of relativity, and it proceeds by coordinating intuitive singularities in my subjective sensory fields (for example, the perceived coincidence in my visual field of the point of my pencil with the tip of my finger) with objective or "transcendent" points in the space-time world of mathematical physics (for example, the objective point in physical space where my pencil and the tip of my finger actually meet) that are themselves described via numerical coordinates.[161]

In embracing a purely formal model of mathematical-physical meaning, and in rejecting, accordingly, the "copy" theory of knowledge in favor of a relation of pure "coordination," Schlick has thereby arrived at a conception of scientific knowledge that is closely analogous to the position Cassirer had already reached in *Substance and Function*. But there is also a crucially important difference. Schlick's conception is starkly and explicitly dualistic. On the one side is a formal system of concepts and judgments, on the other is "reality" itself—which, for Schlick, consists of both the domain of private, immediately given data of consciousness constituting the totality of intuitive objects of acquaintance and the domain of "transcendent" objects described by modern mathematical physics (electromagnetic fields and the like) extending far (in objective or "transcendent" space and time) beyond the meager domain of intuitive data immediately present to consciousness. The point of the "method of coincidences" is then to relate our formal system of concepts and judgments to the objective domain of "transcendent" reality, by relating the latter, in turn, to the subjective domain of immediate acquaintance.

Moreover, it is precisely on the basis of this starkly dualistic conception of knowledge that Schlick also explicitly opposes both Kantian and neo-Kantian versions of the synthetic a priori. Any notion of the synthetic a priori, for Schlick, would require that the mind somehow have the ability to impose its "forms" on reality in the act of knowing, and Schlick, in opposition to this idea, focusses specifically on the "genetic" conception of knowledge of the Marburg School, according to which the

161. For details see [Friedman, 1997]. Schlick's seminal discussion of the general theory of relativity is found in [Schlick, 1917].

object of scientific knowledge is not "given [*gegeben*]" but only "set as a task [*aufgegeben*]" (a task which aims at but never actually reaches the incompleteable "X" defined by the genetic process itself). This, for Schlick, is simply to confuse our knowledge of the object with the object itself. For the real object itself is certainly "given" wholly independently of our knowledge of it, and our knowledge of the object thus necessarily lacks all "constitutive" power:

> Thought never creates the relations of reality; it has no form that it could impress on it, and reality permits none to be impressed, for it is itself already formed. . . . [T]hus we are deprived of every hope for arriving at absolute security in our knowledge of reality. Apodictic truths about reality exceed the power of the human cognitive faculty and are not accessible to it. There are no synthetic a priori judgments.[162]

From Cassirer's point of view, by contrast, Schlick's stark opposition between the "matter" of knowledge (the "given"), on the one side, and its "form" (axiomatic conceptual systems), on the other, amounts to a metaphysical hypostatization of what can only be a relative contrast drawn *within* the progress of scientific knowledge. Both the idea of pure unformed matter and that of pure contentless form are mere abstractions from the essentially unitary genetic process.[163]

As we have seen, Cassirer [1921b] argues that the general theory of relativity can be incorporated within a broadly "critical" theory of knowledge "without difficulty." In his bibliography Cassirer cites both Schlick's *Space and Time* [1917] and his *General Theory of Knowledge*, but he does not engage in any substantial philosophical discussion with Schlick.[164]

162. [Schlick, 1918, pp. 326–27 (p. 384)]. Schlick's discussion of the Marburg School in [§§ 38–39 (§§ 39–40)] focusses on [Natorp, 1910], although he does cite [Cassirer, 1910] in [§ 39 (§ 40)]. Schlick is perfectly clear, in particular, that the Marburg School has already rejected the original Kantian doctrine of pure forms of intuition, and so he here concentrates on the question of "pure forms of thought."

163. See note 38 above, as well as the text to which note 40 is appended. From Cassirer's point of view, Schlick (although in the context of a vastly more sophisticated theory of the mathematical-physical concept) is ultimately guilty of the same "metaphysical" mistake as is Rickert.

164. The single such discussion occurs in [Cassirer, 1921b, p. 123n (p. 451n)], where Cassirer points out that Schlick's use of the terminology of "intuitive" space and time diverges fundamentally from Kant's own.

Schlick, by contrast, developed an extensive criticism of Cassirer's book, which appeared as his 1921 paper, "Critical or Empiricist Interpretation of Modern Physics?". Schlick denies that the theory of relativity has any special relation to the "critical" theory of knowledge by challenging the idea, in particular, that this theory is at all compatible with the synthetic a priori. For, not only has the theory of relativity overthrown specifically Euclidean geometry, for example, but it is no longer clear, on the basis of this theory, that *any* particular geometrical statements are fixed and unrevisable. Accordingly, Schlick explicitly challenges Cassirer to produce examples of synthetic a priori principles,[165] and he then finds it not difficult at all to show that Cassirer has very little of a definite character to say here.[166]

Schlick is certainly correct on this point, but his challenge represents a fundamental misconstrual of Cassirer's conception of the a priori. Cassirer outlines his conception in *Substance and Function* [Cassirer, 1910, Part Two, chapter 5, § III], under the heading of "the 'theory of invariants of experience' and the concept of the 'a priori'." Appealing to an analogy with the theory of invariants in geometry, Cassirer explains that, in the critical theory of experience, "we seek to ascertain those universal elements of form that are preserved in all changes of the particular empirical content of experience." He gives as examples of "such elements of form that cannot be lacking in any judgment of experience or in any system of such judgments," "the 'categories' of space and time, of magnitude and the functional dependency of magnitudes," and he then points

165. See [Schlick, 1921, p. 100 (p. 325)]: "[A]nyone who asserts the critical theory must, if we are to give him credence, actually indicate the a priori principles that must constitute the firm ground of all exact science. . . . We must therefore require a declaration of the cognitions, for example, whose source is space. The critical idealist must designate them with the same determinateness and clarity with which Kant could refer to the geometry and 'general doctrine of motion' that were alone known and recognized at his time."

166. Thus, for example, [Schlick, 1921, p. 101 (p. 326)] quotes from [Cassirer, 1921b, p. 101 (p. 433)], to the effect that "the 'a priori' of space . . . does not include . . . any assertion about a determinate particular structure of space, but is concerned only with the function of 'spatiality in general' . . . entirely without regard to its more particular determination," and concludes that this formulation is "hardly satisfactory[; f]or what complex of axioms is it that is supposed to be comprised in this assertion?"

out, however, that there is no way to determine the specific content of such "categories" in advance:

> The goal of critical analysis would be attained if it succeeded in establishing in this way what is ultimately common to all possible forms of scientific experience, that is, in conceptually fixing those elements that are preserved in the progress from theory to theory, because they are the conditions of each and every theory. This goal may never be completely attained at any given stage of knowledge; nevertheless, it remains as a *demand* and determines a fixed direction in the continual unfolding and development of the system of experience itself.
>
> The strictly limited objective meaning of the 'a priori' appears clearly from this point of view. We can only call those ultimate *logical invariants* a priori that lie at the basis of every determination of a lawlike interconnection of nature in general.[167]

Just as the object of natural scientific knowledge, for the Marburg School, is the never fully realized "X" towards which the entire historical development of science is converging, so the a priori form of scientific knowledge, for Cassirer, can only be determined as that stock of "categorial" principles which, viewed from the perspective of the *completed* developmental process, are seen (retrospectively, as it were) to hold at every stage. So we do not know, at any given stage, what the particular content of spatial geometry, for example, must be, but we can venture the very well-supported conjecture that one or another spatial-geometrical structure must be present.[168]

What is happening here is that Schlick is attempting to hold Cassirer to Kant's original conception of the synthetic a priori,

167. [Cassirer, 1910, p. 357 (p. 269)]; the quotations in the text above occur on the preceding page.

168. See [Cassirer, 1910, p. 358 (p. 270)]: "Space, but not color, is 'a priori' in the sense of the critical theory of knowledge because only it constitutes an invariant of every *physical construction*." The passage from [Cassirer, 1921b, p. 101 (p. 433)], cited in note 166 above, agrees completely with this point of view, for the entire passage runs as follows (my emphasis): "For the 'a priori' of space, *which* [physics] *asserts as the condition of every physical theory*, does not include, as has been shown, any assertion about a determinate particular structure of space, but is concerned only with the function of 'spatiality in general', which is already expressed in the general concept of the line-element *ds* as such—entirely without regard to its more particular determination." Cassirer is here taking the line-element or "metric tensor" employed in general relativity as our current best candidate for an ultimate geometrical invariant.

whereas Cassirer himself is articulating a quite different conception. For Kant, there are two distinct types of a priori principles in the realm of theoretical cognition: *constitutive* principles (principles of Euclidean geometry and Newtonian mechanics, for example) due to the faculties of understanding and sensibility, and *regulative* principles (principles of maximal simplicity and coherence, for example) due to the faculties of reason and judgment. The former must be realized in the phenomenal world of human sensible experience, for they are necessary conditions of its comprehensibility and intersubjective validity. The latter, by contrast, can never be fully realized in experience, but rather present us with ideal ends or goals for seeking the never fully attainable complete science of nature. And, by the same token, whereas the content of Kantian constitutive principles can be fully specified in advance, that of the *regulative* principles remains forever indeterminate (at least as far as theoretical cognition is concerned), because we can never know in advance what the content of the ideal complete science of nature might be. Now Cassirer's conception of the a priori, it is clear, is modelled on the Kantian conception of *regulative* principles. Indeed, precisely because Cassirer has self-consciously rejected the original Kantian distinction between the faculties of understanding and sensibility, there is also no room, on his view, for Kant's distinction between constitutive and regulative principles. Constitutive principles, for Kant, arise from applying the intellectual faculties (understanding and reason) to the distinct faculty of sensibility, whereas regulative principles arise from the intellectual faculties themselves independently of such application. By rejecting Kant's original account of the transcendental schematism of the understanding with respect to a distinct faculty of sensibility in favor of a teleologically oriented "genetic" conception of knowledge, Cassirer (and the Marburg School more generally) has thereby replaced Kant's constitutive a priori with a purely regulative ideal.

Cassirer [1927, § 3] discusses Schlick's *General Theory of Knowledge* in some detail. As one would expect, Cassirer applauds Schlick's rejection of the "copy" theory of knowledge in favor of purely logical "coordination," and he is especially pleased to see Schlick accordingly reject the naive concept of

substance on behalf of the concept of universal law.[169]
Nevertheless, as one would also expect, Cassirer [p. 76]
deplores Schlick's explicit rejection of the "critical" theory and
its commitment, more specifically, to "certain highest principles
that it views as conditions of the possibility of experience and as
conditions of the possibility of its 'objects'." Cassirer alludes [p.
76n] to the dispute with Schlick on the theory of relativity that
we have been discussing, but he concentrates instead on
Schlick's own use, in *General Theory of Knowledge,* of the prin-
ciple of causality, the requirement that nature be described by
genuinely universal mathematical laws. The gist of Cassirer's
argument is that Schlick himself must also assume the "a priori
validity" of the causal requirement—that is, as we have just
seen, its "a priori validity" as a *regulative* principle in Kant's
original sense. And Cassirer finds a tension here between the
clear need for such "a priori validity," on the one hand, and
Schlick's own association, on the other, of a purely formal or
"semiotic" conception of meaning with the notion of "conven-
tion":

> When Schlick emphasizes the merely designative "semiotic" character of
> all thinking and knowledge, and when he attempts to derive from this,
> not only the incorrectness of the metaphysical concept of the object, but
> also that of the critical concept, then he appears to emphasize only the
> negative moment in the function of "designation," only the arbitrariness
> of the sign and its "conventional" character. Something merely factual,
> like the sounds of a language, is never a "sign" considered solely in accor-
> dance with its "physical" existence, as noise or "tone"; rather, it first
> becomes such by our attributing a "sense [*Sinn*]" to it towards which it is
> directed and by which it becomes "significant [*bedeutsam*]." How it is

169. See [Cassirer, 1927, p. 75]: "Here Schlick adopts precisely the thesis that I
attempted to develop and establish almost two decades ago in my book,
Substanzbegriff und Funktionsbegriff. And I admit that it appears to me as an especially
valuable confirmation of this thesis that Schlick, one of the foremost experts on modern
physics and its development in these last two decades, finds that it is thoroughly cor-
roborated there. The replacement of the concept of substance by the concept of law
appears to him as the goal towards which recent physics strives ever more consciously—
and which it has almost attained in the foundations of the general theory of relativity."
As André Carus has pointed out to me, Cassirer is expressing a certain amount of gen-
tle irony here. For in a remark added to § 5, "Das Erkennen durch Begriffe," (which is
then left out in the second edition) [Schlick, 1918, pp. 23–26] sharply attacks
Substance and Function on behalf of traditional logic.

possible to accomplish such an attribution, how and on the basis of what principles and presuppositions a sensible thing can become a representative and bearer of a "sense"—this certainly constitutes one of the most difficult problems of the critique of knowledge, if not *the* problem of the critique of knowledge in general. The question of the objectivity of the "thing" becomes a part of this problem: precisely considered, it is nothing but a corollary of the systematically much more comprehensive question of the objectivity of "meaning [*Bedeutung*]." [Cassirer, 1927, pp. 78–79]

What is ultimately at issue between Schlick and Cassirer thus depends finally on the "objectivity of meaning"—a problem, in turn, that is central to the philosophy of symbolic forms.

Now, as we have seen, one of the basic epistemological motivations for Carnap's constitutional system of the *Aufbau* is precisely to provide an account of objective knowledge and objective meaning as found in empirical science:

> [*E*]*very scientific statement can in principle be so transformed that it is only a structural statement*. This transformation is not only possible, however, but required. For science wants to speak about the objective; however, everything that does not belong to structure but to the material, everything that is ostended concretely, is in the end subjective. . . . From the point of view of constitutional theory this state of affairs is to be expressed in the following way. The series of experiences is different for each subject. If we aim, in spite of this, at agreement in the names given for the objects [*Gebilde*] constituted on the basis of the experiences, then this cannot occur through reference to the completely diverging material but only through the formal indicators of the object-structures [*Gebildestrukturen*].[170]

Carnap's construction of purely structural definite descriptions is then supposed to show that all concepts of science (even those of introspective psychology) have truly objective meaning in precisely this sense.

There is a close analogy, as Carnap himself notes, between his conception of how purely structural definite descriptions avoid appeal to subjective ostension and Schlick's account [1918, § 7] of how Hilbert-style implicit definitions similarly

170. [Carnap, 1928a, § 16]. This passage was quoted in note 97 above.

escape the realm of subjective intuitive *Vorstellungen*. But, as Carnap also notes, there is a crucially important difference as well:

> In contrast to implicit definitions, *structural definite descriptions* characterize (or define) only a single object—and, in fact, an object of an empirical, extra-logical domain For the validity of such a description we do not only require the consistency of the characterizing structural statement, but, beyond this, also the empirical fact that one and only one object of the relevant kind is present in the domain in question. Further statements about the object are then not, as in the case of implicit definitions, all analytic (i.e., deducible from the defining statements), but in part synthetic—namely, empirical discoveries in the object-domain in question. [Carnap, 1928a, § 15]

For Schlick, concepts are defined (*implicitly*) by purely formal axiom systems having no intrinsic relation to any particular empirical domain. Concepts are then related to such a domain extrinsically, in the "method of coincidences," by invoking purely ostensive reference to intuitive subjective experience after all. For Carnap, by contrast, an empirical domain is included *within* his constitutional system via a single extra-logical basic relation. All other concepts are then defined (*explicitly*) from the given basic relation by developing a formal characterization containing this relation and stipulating that the defined concept in question is the unique concept satisfying the characterization. Thus the visual field, as we saw in chapter 5 above, is the unique sense modality (constructible from the given basic relation) having exactly five dimensions. It is in this way, in particular, that Carnap avoids all appeal to subjective ostensive reference, and how, unlike Schlick, he then has no problem at all of relating the formal system of signs constituting scientific knowledge to an extrinsic realm of "reality" lying wholly outside of this system.[171] And this is one important respect, as we also saw in chapter 5, in which Carnap's view is in fact closely analogous to that of the Marburg School.

171. For more on the contrast between Carnap and Schlick here see [Friedman, 1999, chapter 1, Postscript].

As we have also seen, however, Carnap's use of purely structural definite descriptions involves, at the same time, a fundamental disagreement with the "genetic" conception of knowledge. For, as is clearly indicated in the above quotation, purely structural definite descriptions suffice fully to define or "constitute" their objects at definite finite stages of Carnap's constitutional procedure. The object of empirical knowledge is by no means an incompleteable "X" for Carnap, and it is only the further empirical specification of an *already defined* such "X" that entails an incompleteable task. It is precisely on this basis, moreover, that Carnap himself rejects the Kantian synthetic a priori. Purely logical or analytic definitions allow us to "constitute" the object of science, and empirical investigation then allows us further to characterize this object without end.[172] But the objectivity of our scientific knowledge, and, in particular, the intersubjective meaning of the concepts we employ in articulating this knowledge, are already secured by the purely logical, purely structural definite descriptions by which we pick out relevant objects uniquely from the single empirical domain constructed on the basis of Carnap's single non-logical primitive. So it is pure formal logic, the logic of *Principia Mathematica,* that definitively solves the problem of the "objectivity of meaning" in the *Aufbau.*

Carnap's program for constructing explicit definitions for all concepts of empirical science using the logic of *Principia Mathematica* is far superior to Schlick's conception of implicit definition in this respect. For, in the first place, not only is Schlick completely unclear about the fundamental differences between modern mathematical logic and traditional syllogistic logic,[173] but he also extends the notion of implicit definition to logic itself. Logical truths, for Schlick, are themselves implicit definitions of logical concepts like negation and quantifica-

172. See the passages from [Carnap, 1928, § 179] cited above to which notes 106 and 109 are appended.

173. [Schlick, 1918, § 10] explicitly argues that modern mathematical logic represents no inferential advance beyond traditional Aristotelian syllogistic. This is connected with his criticism of Cassirer on behalf of traditional logic cited in note 169 above.

tion.[174] And, in the second place, whereas Carnap draws a clear and sharp distinction between conventional and factual, analytic and synthetic statements within the empirical domain, no such distinction is available to Schlick. For Carnap, pure formal logic, together with the empirical structure of the domain in question given by the single non-logical basic relation, are sufficient to determine, for example, that there is one and only one sense modality (constructible from the basic relation) having exactly five dimensions. Conventional stipulation enters in only in the trivial sense that we then decide to call this structure "the visual field." For Schlick, by contrast, there is no basis at all for distinguishing logical, empirical, and conventional statements in this way. The notion of implicit definition expands to include all the statements in a single axiomatic presentation of science (even those of pure formal logic itself), and the idea of conventional stipulation therefore infects all statements indifferently. It is in this sense that Schlick's epistemological viewpoint, unlike Carnap's, is indeed vulnerable to Cassirer's complaint regarding "objective validity" quoted above [Cassirer, 1927, pp. 78–79].[175]

Nevertheless, we here see Carnap and Cassirer moving in quite different directions. On Kant's original conception of objectivity, pure formal logic, as schematized in terms of pure

174. See [Schlick, 1918, pp. 286–87 (p. 337)]: "The principle of non-contradiction, as earlier emphasized (§ 10), signifies only the rule for the use of the words 'not', 'none', etc. in the designation of real (and of course also non-real) objects; in other words, it defines negation."

175. It must be admitted, however, that Carnap entertains a much wider scope for conventional stipulation in the *Aufbau*. In [Ibid., § 107], for example, it is suggested (but entirely without explanation or support) that "[*l*]*ogic (including mathematics) consists only of conventional stipulations* about the use of signs and *of tautologies* on the basis of these stipulations." In addition, we saw above that Carnap's claim to provide purely structural definite descriptions actually fails at the level of physical objects, and this leaves him with no adequate alternative to the synthetic a priori after all (notes 115–18). After reconsidering both the nature of logic and the character of empirical science in response to discussions within the Vienna Circle and the debates on the foundations of mathematics that raged throughout the 1920s, Carnap [1934] then develops a radically new conception of logic incorporating significant elements of "conventionalism" from a rather different point of view. But these matters lie beyond the scope of the present essay. For further discussion see [Friedman, 1999, Part Three], and see [Ibid., chapter 3] for the significant differences that remain between Carnap's conception of the analytic/synthetic distinction (and thus of the a priori) and Schlick's views.

sensibility, is the ultimate basis for the *constitutive* synthetic a priori grounding human objective knowledge and intersubjective communication. From Carnap's point of view, dropping pure sensibility from this picture then means that we retain the idea of constitutivity, but lodge it instead in pure formal logic alone (rather than in "transcendental logic"); the analytic, but still constitutive a priori replaces the synthetic constitutive a priori. For Cassirer, by contrast, dropping pure sensibility from the Kantian picture means that we turn, as an alternative, to "transcendental logic," which is now understood in terms of a *sui generis* intellectual faculty of "pure synthesis" no longer mediated by metaphysical and transcendental deductions connecting pure logical forms with pure sensibility. Formal logic in general becomes of decidedly secondary philosophical significance—and so, in fact, does the original Kantian conception of the constitutive a priori as such, which is now absorbed, according to the "genetic" conception of knowledge, into the *regulative* a priori. It follows that pure formal logic can no longer play a foundational role in accounting for the "objectivity of meaning," and this circumstance becomes even more important, in the philosophy of symbolic forms, when we deliberately emphasize more primitive types of symbolic meaning of an explicitly non-logical character.

Precisely this circumstance underlies the sole critical remarks on Carnap's philosophy that Cassirer ever published. These remarks, entitled "Thing perception and expressive perception," occur in [Cassirer, 1942, § 2]. Cassirer argues that expressive perception [*Ausdruckswahrnehmen*] (which is based, as we know, on the expressive function [*Ausdrucksfunktion*] of symbolic meaning) is just as fundamental as thing perception [*Dingwahrnehmung*] (which is based, as we know, on the representative function [*Darstellungsfunktion*] of symbolic meaning). Neither can be reduced to the other, both are "primary phenomena [*Urphänomene*]." Moreover, whereas the physical sciences take their evidential base from the sphere of thing perception, the cultural sciences take theirs from the sphere of expressive perception, and, more specifically, from the fundamental experience of other human beings as fellow selves sharing a common intersubjective world of "cultural meanings." And it is at this point that Cassirer explicitly challenges the

"physicalism" of the Vienna Circle, as articulated, in particular, in [Carnap, 1928b] and [Carnap, 1932b]. What Cassirer wants to oppose, of course, is the idea (originally developed in the *Aufbau*) that the domain of the "heteropsychological" must be constructed or constituted from the domain of the physical, from the purely physical phenomena of bodily motion, sign production, and the like.[176]

After citing a claim from Carnap's [1932b] to the effect that the language of physics is the only intersubjective language, Cassirer suggests [1942, pp. 47–49 (pp. 96-99)] that this conclusion, if strictly carried through, would entail the elimination of the genuinely cultural sciences. The only escape from this dilemma is to acknowledge, on the contrary, the independence and autonomy of *all* symbolic functions [Ibid., p. 48 (p. 97)]: "We must strive, without reservation or epistemological dogma, to understand each type of language in its own particular character—the language of science, the language of art, of religion, and so on; we must determine how much each contributes to the construction [*Aufbau*] of a 'common world'." Acknowledging the autonomy of the expressive function, in particular, then allows us to grant the cultural sciences their own authority and autonomy, while also recognizing their dependence on the physical realm:

> Like every other object, a cultural object has its place in space and time. It has its "here" and "now," it arises and perishes. And, to the extent that we describe this "here" and "now," this arising and perishing, we do not need to go beyond the circle of physically established facts. But, on the other side, the physical itself appears in the object in a new *function*. It not only "is" and "becomes," but in this being and becoming something new appears. This appearance of a "sense [*Sinn*]," which is not absorbed by the physical, but is rather embodied in it, is the common element of all those contents that we designate with the term "culture." [Cassirer, 1942, p. 48 (p. 98)]

176. Cassirer does not explicitly mention the *Aufbau* here. However, in [Krois, 1995, p. 121] ([Krois and Verene, 1996, p. 125]), Cassirer, in the course of a parallel criticism of [Carnap, 1928b] and [Carnap, 1932b], refers to a work by J. Cohn attacking the *Aufbau* itself on analogous grounds. Moreover, in manuscripts on expressive phenomena [*Ausdrucksphänomene*] Cassirer himself explicitly criticizes the *Aufbau* in the same vein [BRL, box 52, folders 1041–43]. I am indebted to John Michael Krois for providing me with transcripts of these materials.

When we see that "cultural meaning" is based, in the end, on the equally fundamental "primary phenomenon" of expression, there is no longer any reason to question the legitimacy of the cultural sciences from the point of view of the physical sciences, which are themselves based on the "primary phenomenon" of representation.

Now Carnap, in the *Aufbau*, has no intention of questioning the legitimacy of the cultural sciences. These sciences acquire their own, *relatively* autonomous domain immediately after the construction of the heteropsychological (see note 113). At the same time, however, Carnap does maintain the privileged position of the physical sciences, and he does say, in particular, that only the world of physics provides for the possibility of a "univocal, consistent intersubjectivization" (see note 95). In this sense, Carnap does indeed assert that the language of physics is the only intersubjective language. But Carnap does not base this claim on any "naive empiricist" prejudice privileging "thing perception" over "expressive perception." Carnap has no such philosophical views on the ultimate nature of perception at all. Rather, the language of physics is privileged, for Carnap, because the exactness and precision of the mathematical representations employed therein make it an exemplary vehicle for the kind of purely formal meaning Carnap hopes to capture in purely structural definite descriptions.[177] In other words, mathematical physics is privileged, for Carnap, because it provides the most highly developed example of what Cassirer calls the *significative* function [*Bedeutungsfunktion*] of symbolic meaning.

Cassirer himself of course agrees completely with this idea. He, too, holds that modern mathematical physics, as expressed especially within the language of modern mathematics and mathematical logic, presents us with the most highly developed

177. Thus, in the ellipses of the passage from [Carnap, 1928a, § 15] cited above (and in note 97), Carnap illustrates the purely formal objective meaning in question as follows: "In *physics* we easily recognize this desubjectivization, which has transformed almost all physical concepts into pure structure concepts." He then provides examples ("four-dimensional tensor and vector fields," "world-lines with their relations of coincidence and proper time") taken from the highly abstract mathematical representations employed in general relativity.

form of the significative function of symbolic meaning. But the whole point of the philosophy of symbolic forms is that objectivity as such, intersubjective validity and communicability, is by no means confined to the significative function. Physical science has its own characteristic type of objectivity, expressed in universally valid mathematical laws holding for all times and all places. In the cultural sciences, however, we have access to a different but analogous type of objectivity, expressed in our ability continually to interpret and reinterpret human products or "works" from our own particular perspective within the continual historical development of human culture:

> The constancy required for this purpose is not that of properties or laws, but rather that of meanings [*Bedeutungen*]. The more culture develops, the more particular domains [there are] in which it disperses itself, the more richly and variously this world of meanings forms itself. We live in the words of language, in the forms of poetry and plastic art, in the forms of music, in the structures of religious representation and religious belief. And only within these forms do we "know" one another. . . . The goal [of cultural science] is not the universality of laws, but neither is it the [mere] individuality of facts and phenomena. In contrast to both it establishes its own ideal of knowledge. What it wishes to know is the *totality of forms* in which human life is realized. These forms are infinitely differentiated, but they do not lack unified structure. For it is ultimately the "same" human being that we always continually encounter in the development of culture, in thousands of manifestations and in thousands of masks. [Cassirer, 1942, p. 84 (p. 143–44)]

In the philosophy of human culture we postulate that meanings remain constant in this continual historical process of interpretation and reinterpretation, just as in physics and astronomy we postulate a homogeneous distribution in space:

> We do not become conscious of this identity through observation, weighing, and measuring; nor do we infer it from psychological inductions. It can prove itself in no other way that through the act. A culture only becomes accessible to us in so far as we actively enter into it; and this entry is not bound to the immediate present. Here temporal distinctions, distinctions of earlier and later, are relativized, just as spatial distinctions, distinctions of here and there, are relativized in the viewpoint of physics and astronomy. [Ibid., pp. 84–85 (pp. 144–45)]

The philosophy of symbolic forms therefore takes the unity and objectivity of "cultural meaning" as, once again, an *ideal task*. It is a task which we must necessarily undertake if we are to appropriate the cultural products of the past for our own present cultural life.[178]

178. See [Cassirer, 1942, pp. 85–86 (p. 146)]: "What is actually preserved for us from the past are certain historical monuments: 'memorials' in words and writing, in images and bronze. This only becomes history for us in so far as we see symbols in these monuments, on the basis of which we can not only recognize certain forms of life but also revive them for ourselves." As we observed, Cassirer alludes to the general theory of cultural meaning aimed at in the philosophy of symbolic forms in his complaint against Schlick regarding "objective validity" quoted above [Cassirer, 1927, pp. 78–79] (and compare the text to which note 175 above is appended).

8

Before and After Davos:
Cassirer and Heidegger

As we indicated in chapter 6, Cassirer's phenomenological development (in the Hegelian sense) of the three fundamental forms of symbolic meaning (expressive, representative, and significative) is intended, among other things, to come to terms with recent work in the tradition of *Lebensphilosophie* by such authors as Bergson, Dilthey, Scheler, and Simmel. Tracing back the origins of all symbolic meaning to the primitive mythical "feeling [*Lebensgefühl*]" of "the community of all living things" is a particularly clear expression of this intention.[179] Heidegger's "existential analytic of Dasein" is also intended to bring to greater "ontological transparency" some of the basic philosophical impulses of *Lebensphilosophie*. Thus, in a preliminary methodological section of *Being and Time,* on "the delimitation of the analytic of Dasein with respect to anthropology, psychology, and biology" [1927, § 10, p. 46], Heidegger favorably contrasts *Lebensphilosophie* with traditional philosophical theories of the "soul" or "subject": "On the other hand, however, in the correctly understood tendency of all serious scientific '*Lebensphilosophie*'—the terms says as much as the botany of plants—there lies an unexpressed tendency towards an understanding of the being of Dasein." Heidegger

179. This is the subject of [Cassirer, 1925, Part Three, chapter 2, § 1]. See especially pp. 220–21 (p. 179): "For early stages of the mythical world-view there is not yet a sharp separation between human beings and the totality of living things, between human beings and the world of animals and plants. Thus the circle of *totemistic* representation, in particular, is characterized precisely by the circumstance that here the 'kinship' between humans and animals—and, specifically, the kinship between a certain clan and its totem-animal or totem-plant—does not hold merely in some metaphorical sense but rather in a strictly literal one."

then explains that he wants to advance on the work of Dilthey, Bergson, and Scheler, in particular, by reinterpreting the phenomenology of Husserl in accordance with his own novel "ontological" perspective.

Heidegger clearly found Cassirer's work on myth to be especially interesting in this regard, for the very next section is devoted to "the existential analytic and the interpretation of primitive Dasein." Heidegger begins by contrasting his notion of "everydayness [*Alltäglichkeit*]" with primitiveness:

> The interpretation of Dasein in its everydayness is not, however, identical with the describing of a primitive stage of Dasein, the knowledge of which can be empirically mediated by anthropology. *Everydayness does not coincide with primitiveness.* Everydayness is rather a mode of being of Dasein also and precisely when Dasein moves in a highly developed and differentiated culture. [Heidegger, 1927, § 11, pp. 50–51]

Anthropology and ethnology cannot help us with his peculiarly philosophical problem, according to Heidegger, because they, like all other empirical sciences of "human nature," already presuppose a more fundamental philosophical understanding of the being of Dasein. Heidegger concludes [p. 51] that "[s]ince the positive sciences neither 'can' nor should wait for the ontological work of philosophy, the progress of [philosophical] research will not be completed as an 'advance', but rather as a *repetition* and ontologically more transparent purification of what has been ontically [viz., empirically] discovered." And here Heidegger appends a footnote to Volume 2 of Cassirer's *Philosophy of Symbolic Forms*, applauding the "guiding thread" that has thereby been supplied to ethnology, but questioning, at the same time, the "transparency" of Cassirer's philosophical orientation.

Heidegger differentiates himself from Cassirer's enterprise even more sharply in the subsequent paragraph:

> In the task [of an existential analytic of Dasein] a desideratum is included, which has troubled philosophy for a long time, but which it has continually refused to fulfill: to work out the idea of a *"natural view of the world* [*natürlichen Weltbegriffes*]."* The rich store of knowledge now available of the most varied and distant cultures and forms of Dasein appears to be

well adapted for a fruitful initial attack on this problem. But this is only an appearance. In principle, such a profusion of knowledge is [rather] a temptation to miss the authentic problem. Syncretistic universal comparison and classification does not yet itself yield genuine knowledge of essence [*Wesenserkenntnis*]. Ordering the manifold [of information] in tabular form does not guarantee a real understanding of that which is ordered therein. The genuine principle of the ordering has its own objective content, which is never discovered by the ordering, but is rather already presupposed in it. Thus, the explicit idea of the world in general is required by the ordering of world-views [*Weltbildern*]. And if "world" is itself a constitutive [element] of Dasein, then the conceptual working out of the phenomenon of "world" [*Weltphänomens*] requires an insight into the fundamental structures of Dasein. [Heidegger, 1927, § 11, p. 52]

From Heidegger's point of view, Cassirer's enterprise thus appears, in the end, as merely "syncretistic" and lacking all proper philosophical foundations. It does not and cannot provide us with any philosophical insight into our "natural view of the world" represented in "Dasein's everydayness."

Heidegger reviewed Cassirer's Volume 2 in 1928, making essentially the same points he had made in *Being and Time*. After presenting a lucid summary of the main argument of Cassirer's book, Heidegger concludes that Cassirer has indeed provided a definite advance "for the foundations and guidance of the positive sciences of mythical Dasein (ethnology and the history of religion)." Once again, however, the philosophical orientation and foundation of Cassirer's work, and especially his explicit reliance on Kantian and neo-Kantian ideas, are seen as highly questionable. Heidegger accordingly asserts, not surprisingly, that "[t]he essential interpretation [*Wesensinterpretation*] of myth as a possibility of human Dasein remains accidental and without direction so long as it cannot be grounded on a radical ontology of Dasein in light of the problem of being in general."[180] This time, however, Heidegger sketches out an example of how such "ontological grounding" might go. Focussing specifically on the "mana-representation" of what is sacred or holy as opposed to ordinary or profane,

180. [Heidegger, 1928 (1991), pp. 264–65 (pp. 40–41)]. These points closely parallel the brief remarks in [Heidegger, 1927, p. 51n].

Heidegger suggests that, whereas the systematic place of this representation has been left wholly "indeterminate" by Cassirer, it can be incorporated relatively straightforwardly into the existential analytic of *Being and Time*. The idea of "thrownness [*Geworfenheit*]," in particular, can provide "the ontological structure of mythical Dasein [with] a grounded articulation."[181] Neo-Kantianism, Heidegger suggests, by remaining within the problematic of "consciousness," misses the centrality of being-in-the-world and thus misses this possible foundation.

Cassirer, in general, is acutely aware of the methodological problems Heidegger raises for the philosophy of symbolic forms. Cassirer is especially concerned to differentiate his distinctively philosophical approach to the historical and comparative study of human culture from all forms of empirical ethnology, anthropology, and psychology. The basis for such a differentiation is Cassirer's appeal to a generalization of Kant's "transcendental method." Just as Kant, on the reading of the Marburg School, began with the "fact of science," but then no longer remained at the merely factual level in inquiring into the conditions of the possibility of this fact, so Cassirer, in the philosophy of symbolic forms, aims to do something closely analogous for the "fact of culture" taken as a whole:

> For, just as in pure epistemology in particular, the philosophy of symbolic forms as a whole does not ask after the empirical origin of consciousness but after its pure content [*Bestand*]. Instead of investigating its temporal generating causes it is directed solely towards that which "lies in it"—towards apprehending and describing its structural forms. Language, myth, theoretical knowledge are all taken here as fundamental *forms* of "objective spirit," whose "being" must be able to be indicated and understood purely as such, independently of the question of its "becom-

181. [Heidegger, 1928 (1991), pp. 266–67 (pp. 42–43)]: "In 'thrownness' there is a being-delivered-up [*Ausgeliefertsein*] of Dasein to the world of a kind that such a being-in-the-world is overwhelmed by that to which it is delivered up. Overpoweringness can only manifest itself as such in general *for* something that is a being-delivered-up. . . . In such being-directed-to [*Angewiesenheit*] the overpowering, Dasein is captivated *by* it and may therefore only experience itself as belonging to and akin to this reality. In thrownness, therefore, any being that is in any way revealed has the being-character of overpoweringness (mana)."

ing [*Gewordensein*]." We stand here in the sphere of the universal "transcendental" question: in the sphere of that method which takes the *"quid facti"* of the individual forms of consciousness as its starting point, in order to inquire into their meaning [*Bedeutung*], into their *"quid juris."* [Cassirer, 1929a, p. 58 (p. 49)]

And it is precisely in thus beginning from the "fact of culture," of course, that Cassirer's "transcendental" method differs from Heidegger's "existential-phenomenological" method.

Cassirer holds, in particular, that we have no access at all to the "transcendental sources" of human culture independently of the products and "works" in which this culture expresses itself (in this case, the various systems of symbolic representation). Commenting on Bergson's quest for a wholly unmediated relation to the fundamental basis of life itself, Cassirer remarks [1929a, p. 47 (p. 39)]: "A self-*apprehension* of life is only possible if it does not simply *abide* in itself[; i]t must give form to itself, for precisely in this 'otherness' of form does it first obtain its 'visibility', if not its reality." Then, applauding Natorp's attempt to found a truly philosophical form of psychology, where "we are to seek a goal that lies behind, so to speak, all objective knowledge," Cassirer [p. 63 (p. 53)] similarly explains that "[w]e can never lay bare the immediate being and life of consciousness purely as such—but it is a meaningful task to attempt to obtain a new point of view and a new sense for the process of objectification, which, as such, can never be eliminated, by traversing it in a double direction: from *terminus a quo* to *terminus ad quem*, and from the latter back again to the former." It is only such an essentially "reconstructive" movement of thought, in fact, that can possibly answer the "transcendental" question:

We attempt to clarify the question [of the structure of various forms of consciousness], in so far as we do not abandon ourselves either to the methodology of natural scientific, causal-explanatory psychology or to the method of pure "description." We proceed rather from the problems of "objective spirit," from the forms in which it consists and exists; we do not remain with them as mere facts, however, but attempt, by a reconstructive analysis, to penetrate back to their elementary presuppositions, to the "conditions of their possibility." [Cassirer, 1929a, p. 67 (p. 57)]

For Cassirer, all attempts at "pure description," whether empirical, metaphysical, or phenomenological, rest, in the end, on the illusory dream of directly immediate knowledge.

But how is it possible to achieve truly philosophical knowledge, that is, "transcendental" or "a priori" knowledge, by means of this kind of reconstructive analysis? How, in particular, can we work up the staggering "profusion" of empirical information made available by comparative mythology, linguistics, and ethnology into a non-empirical philosophy of human culture? This problem is especially acute for the analysis of more primitive systems of symbolic representation, of course. For they, unlike the highly abstract and developed forms found in the exact sciences, appear to consist exclusively of "subjective" representations possessing neither logical structure nor intersubjective validity.[182]

Cassirer's solution to this problem, if I understand him correctly, is that all symbolic forms (including the more primitive ones) are necessary parts of a single phenomenological process of development (again in the Hegelian sense). Mythical consciousness evolves dialectically into language, and language evolves dialectically into science. Conversely, language necessarily has a prior origin in myth, exact science a prior origin in language.[183] Accordingly, each of the symbolic forms can be properly understood, from the point of view of Cassirer's general philosophy of culture, only by reference to its own particular position in the essentially unitary dialectical process:

182. This problem, as one would expect, arises most acutely in the case of mythical thought. See the Preface to [Cassirer, 1925, p. viii (p. xiv)]: "If logic, ethics, and aesthetics have been able to assert themselves in their own systematic independence against this kind of explanation and derivation [from an empirical theory of 'human nature'], no matter how many times this was attempted, this is because they all could call upon and support themselves upon an independent principle of 'objective' validity resisting every psychologistic dissolution. Myth, by contrast, for which every support of this kind seems to be lacking, seemed for precisely this reason to be forever handed over and given up, not only to psychology but also to psychologism."

183. See [Cassirer, 1929a, pp. 55–57 (pp. 47–49)]: "Are we permitted, where it is a question of an overview of the *whole* of knowledge, of the totality of its forms, to turn our attention only to this end [theoretical exact science] instead of equally to its beginning and its middle? All conceptual knowledge is based necessarily on intuitive knowledge, all intuitive knowledge on perceptual knowledge. . . . The image-world of myth, the phonetic structures of language, and the signs that serve exact knowledge, each determine their own *dimension* of representation [*Darstellung*], and only taken in their totality do all these dimensions constitute the whole of spiritual space." Compare notes 141 and 153 above.

Philosophical thought confronts all these directions [of symbolic representation], not simply with the purpose of following each of them separately or of surveying them all, but rather under the assumption that it must be possible to relate them to a unified common point, to an ideal center. But this center, considered critically, can never consist in a given being but only in a common task. The various products [*Erzeugnisse*] of spiritual culture—language, scientific cognition, myth, religion—thereby become, despite all their internal differences, members of a single great problem-complex—[they become] manifold efforts that are all directed towards the one goal of transforming the passive world of mere *impressions*, with which spirit is initially engrossed, into a world of pure spiritual *expression*. [Cassirer, 1923, p. 11–12 (p. 80)]

Moreover, the dialectical progression of symbolic forms can then be viewed from the perspective of a single, and as it were "highest" end:

Thus, the relations in myth, language, and art, no matter how much they immediately interpenetrate one another in their formations and in concrete historical phenomena, nevertheless present a determinate systematic sequence of stages, an ideal progression, the goal of which can be characterized by the idea that the spirit not only lives and exists in its own constructions [*Bildungen*], in its self-created symbols, but also grasps them as what they are. . . . In *this* respect the problems arising from a "philosophy of mythology" are immediately connected, once again, with those arising from the philosophy and logic of pure cognition. For science is also distinguished from the other stages of spiritual life, not by encountering the unveiled truth, the truth of the "thing in itself," without mediation through signs and symbols, but rather by the circumstance that it is able, otherwise and more deeply than in these other stages, to know and to grasp the symbols that it uses as such. [Cassirer, 1925, p. 35 (p. 26)]

A teleological development towards increasing philosophical self-consciousness,[184] a developmental process in which each symbolic form is progressively embedded, thus secures the ultimate unity of the entire system of symbolic forms, and also the

184. The reference to Hegel is made explicit in the ellipses of the above quotation: "Also in regard to this problem, that which Hegel has designated as the comprehensive theme of the 'phenomenology of spirit' is shown to be correct: the goal of the development is that spiritual being be conceived and expressed, not merely as substance but 'equally as subject'."

peculiarly philosophical perspective from which this system is surveyed.

Cassirer had originally intended to add a conclusion to the third volume of *The Philosophy of Symbolic Forms* situating that philosophy with respect to "the total effort of contemporary philosophy." This conclusion was not included because of lack of space, and Cassirer instead announced his intention to publish a separate work, under the title of "'Life' and 'Spirit': Towards a Critique of Contemporary Philosophy."[185] This work, too, never appeared in Cassirer's lifetime, but he did leave behind manuscripts for this project from 1928, now collected in [Krois, 1995], [Krois and Verene, 1996].[186] The main point of these manuscripts is to identify the fundamental tendency of "contemporary metaphysics" as *Lebensphilosophie* and to contrast this tendency with the "critical" or non-metaphysical philosophy of symbolic forms. Whereas *Lebensphilosophie,* in typically metaphysical fashion, sets up a dualistic opposition between "life" and "spirit," seeing in the latter a falling away from the pure immediacy of life into the mediacy of culture and thought, the philosophy of symbolic forms adheres rather to the central "critical" or "functional" insight that life can only know and realize itself in the continual dialectical process of creating ever more self-conscious levels of form. And, whereas traditional metaphysics was erected on the basis of dualistic oppositions between being and becoming, universal and particular, matter and form, soul and body, contemporary *Lebensphilosophie* has concentrated them all down into a single remaining opposition between "spirit" and "life."[187] In doing so, however, it has thus become, in the end, the metaphysical counterpart to the non-metaphysical philosophy of symbolic

185. See the Preface to [Cassirer, 1929a, pp. viii–ix (p. xvi)].

186. As Krois and Verene point out [1996, pp. ix–x], Cassirer's [1930a] cannot be considered to be the more comprehensive work Cassirer had planned on this topic.

187. See [Krois, 1995, pp. 7–8 (Krois and Verene, 1996, p. 8)]: "The opposition between 'life' and 'spirit' stands at the center of this metaphysics. It proves to be so determining and decisive that it gradually appears to absorb all other pairs of metaphysical concepts that have been coined in the course of the history of metaphysics and thereby to eliminate them. The oppositions between 'being' and 'becoming', between 'unity' and 'plurality', between 'matter' and 'form', between 'soul' and 'body'—they now appear as it were dissolved in this single, absolutely fundamental antithesis. . . . Here, in this unifying point, the philosophy of nature meets the philosophy of history;

forms, whose mission is precisely to replace this final dualistic opposition with a "functionally" oriented developmental process.[188]

As we observed in chapter 1, Cassirer added five footnotes referring to Heidegger's *Being and Time* before publication of the third volume of *The Philosophy of Symbolic Forms*. The basic idea advanced in these footnotes is that, whereas Heidegger has indeed given very illuminating analyses of the role such concepts as spatiality and temporality play in the more fundamental and primitive levels of human symbolic consciousness (primarily, for Cassirer, that of intuitive representation), the goal of the philosophy of symbolic forms is rather to show how these more primitive levels are successively transformed in the direction of the universally valid "timeless truths" characteristic of the "highest" domain of purely significative representation. Thus, in first considering Heidegger's treatment of spatiality, Cassirer begins by assigning it to the purely "pragmatic space" associated with our instrumental use of tools (see note 146 above)—

No real [handwritten margin note] Candidat here

here ethics and the theory of value interpenetrate epistemology and the general theory of science. Thinkers of such divergent spiritual character and spiritual background as Nietzsche and Bergson, Dilthey and Simmel, have [all] engaged in this movement of transforming metaphysical opposition[s]." Compare [Ibid., p. 11 (pp. 11–12)]: "If we proceed from these considerations [of Simmel's], in which one of the central problems of modern 'philosophy of life' is in fact identified with exemplary pregnance and clarity, we are surprised to realize that, although modern metaphysics does differ from the older metaphysics in its goal, it hardly differs at all in its path; it differs in its contentful presuppositions and tendencies, but hardly at all in its *method*. . . . Here, the modern concept of *life*, under the compulsion of the metaphysical *type of thinking* itself, must follow the same path that the *concept of God* has followed in the older metaphysics."

188. See [Ibid., p. 13 (pp. 13–14)]: "We here now arrive at precisely that point at which the modern metaphysics of life [*Lebens-Metaphysik*] is in direct contact with our own systematic fundamental problem. For what is here described as the 'rotation of the axis of life' [by Simmel] is nothing but that peculiar reversal, that spiritual peripetea, that life experiences as soon as it catches sight of itself in the medium of a 'symbolic form'. . . . If, however, we once bring the problem to *this* level, if we do not simply oppose the 'immediacy' of life with the 'mediacy' of thought and spiritual consciousness as such, as rigid opposites, but rather attend purely to the process of their *mediation*, as this process realizes itself in language, in myth, in cognition—then the problem at once acquires another form and another character. Not some or another absolute [found] beyond this mediation, but only [this mediation] itself, can provide us with an escape from the theoretical antinomies." Compare [Ibid., p. 16 (p. 17)]: "Life and form, continuity and individuality, diverge further and further from one another, as soon as one takes them both as absolutes, as soon as one sees metaphysical modes of being [*Seins-Weisen*] in them. But the gulf is closed if one places oneself instead in the midst of the concrete process of formation [*Formwerden*] and the dynamics of this process—if one takes the opposition of the two moments as an opposition of pure *functions* rather than of beings."

this, of course, is what Heidegger calls the ready-to-hand. Cassirer then continues:

> Our own investigation and task is distinguished from that of Heidegger, above all, by the circumstance that it does not remain at this level of the "ready-to-hand" and its spatiality, but that it raises questions that go beyond it (without in any way disputing it). It wishes to follow the path leading from space as an element of the ready-to-hand to space as the form of the present-at-hand; and it wishes further to show how this path leads through the realm of *symbolic* formation—in the twofold sense of "representation" and "significance" (cf. Part Three). [Cassirer, 1929a, p. 173n (p. 149n)]

(Part Three treats "the construction of scientific knowledge," where, as the next footnote makes clear, specifically mathematical space is constructed.) Similarly, in the case of Heidegger's treatment of temporality:

> The "philosophy of symbolic forms" does not in any way dispute this "temporality," as it is here supposed to be disclosed as the ultimate ground of the "existentiality of Dasein" and [thus] made transparent in its particular elements. But its question [that of the philosophy of symbolic forms] first begins beyond this: it begins at precisely that point where a transition from this "existential" time to the *form* of time is realized. It wishes to display the conditions of the possibility of this *form* as the condition for the positing of a "being" extending beyond the existentiality of Dasein. As in the case of space, so in the case of time, this transition, this μεταβασις from the meaning of being [*Seinssinn*] of *Dasein* to the "objective" meaning of the "logos," is its proper theme and its proper problem (cf. above p. 173n). [Cassirer, 1929a, p. 189n (p. 163n)]

As Cassirer explains in the following pages [pp. 191–92 (p. 165)], it is with the concept of "timeless being," as the correlate of "timeless truth," that "the tearing away of 'logos' from myth is accomplished." And the development of Newtonian "absolute time," at the height of the scientific revolution, is what first achieves this in a rigorous fashion. Thus, Cassirer's philosophy of symbolic forms here diverges from Heidegger's existential analytic of Dasein precisely in emphasizing a teleological development toward the genuinely "objective" and "universally valid" realm of scientific truth.

It is by no means surprising, therefore, that this same teleo-logical problematic constitutes the core of the Davos disputa-tion as well. Heidegger, as we know, questions the very notion of "universally valid" truth. And it is on this basis, in fact, that Heidegger [1991, p. 273 (p. 171)] states that his reading of Kant implies "the destruction of the previous foundation of Western metaphysics (spirit, logos, reason)." Cassirer, in the disputation, then challenges Heidegger's reading of Kant with the example of mathematics:

> And it now follows [from Heidegger's reading] that a finite being as such cannot possess eternal truths. There are no eternal and necessary truths for human beings. And here the entire problem arises once again. For Kant this was precisely the problem: How can there be—in spite of the finitude that Kant himself has indicated—how can there be, nevertheless, necessary and universal truths? How are synthetic a priori judgments pos-sible?—judgments that are not simply finite in their content but rather universally necessary. This is the problem for which Kant exemplifies mathematics: Finite cognition places itself in a relation to truth that does not again develop an "only." [Ibid., p. 278 (p. 173–74)]

Cassirer concludes by asking [Ibid., p. 278 (p. 174)]: "Does Heidegger want to renounce this entire objectivity, this form of absoluteness that Kant has represented in the ethical [sphere], the theoretical [sphere], and in the *Critique of Judgment*?"

Heidegger, in his reply, first disposes of the example of mathematics by arguing that Kant was not particularly inter-ested in giving a transcendental theory of the object of mathe-matical natural science [p. 278–79 (p. 174)]: "Kant seeks a theory of being in general, without assuming objects that would be given, without assuming a determinate region of beings (neither the psychological nor the physical)." Heidegger then challenges the idea that we find genuine transcendence of finitude in Kant's ethics, for the concept of an imperative as such already contains an essential reference to the finite crea-ture (God cannot experience an imperative). Finally, in turning to the question of "universal validity" in general, Heidegger's main point [p. 282 (p. 176)] is that "[t]he peculiar validity that is attributed to [a truth content] is badly interpreted if one says that over and above the flux of experience there is something

stable, the eternal, the meaning [*Sinn*] and concept[—rather, i]s this eternity not solely that which is possible on the basis of an inner transcendence of time itself?" In inquiring into this "inner transcendence," however, we inevitably encounter the phenomena of nothingness and human freedom:

> The question—How is freedom possible?—is meaningless [*widersinnig*]. But it does not follow that here a problem of the irrational somehow remains. Rather, because freedom is no object of theoretical comprehension, but an object of philosophizing, this can mean nothing else but that freedom only is and can be in the [act of] freeing. The only adequate relation to the freedom in human beings is the self-freeing of the freedom in human beings. [Ibid., p. 285 (p.178)]

Philosophy has no other task here, in the end, than precisely self-liberation [Ibid., p. 291 (pp. 182–83)]: "[The nothingness of human Dasein] is not the occasion for pessimism and melancholy, but rather for understanding that authentic activity only exists where there is resistance, and that philosophy has the task, as it were, of throwing the human being back, from the indolent posture of one who merely uses the works of the spirit, onto the hardness of his fate."[189]

Cassirer reviewed Heidegger's Kant interpretation in his 1931 study, "Kant and the Problem of Metaphysics," which concludes with an allusion to the disputation at Davos. Here Cassirer criticizes Heidegger's reading on architectonic grounds. In Heidegger's interpretation, Cassirer explains [p. 8 (pp. 138–39)], "the threefold division of knowledge into sensibility, understanding, and reason has simply a *preliminary* character," for all three ultimately coalesce in a "single 'radical-faculty'" that Heidegger identifies with the "transcendental imagination." Accordingly, Heidegger places the chapter

189. This sentence concludes a set of remarks that begin by considering Cassirer's use of the teleological expressions *terminus a quo* and *terminus ad quem*. Heidegger says that for Cassirer the *terminus ad quem* is clear but the *terminus a quo* is completely problematic. Heidegger's own position is precisely the reverse—that is, his *terminus a quo* is the analytic of Dasein, but what is the corresponding *terminus ad quem*? The context as a whole suggests that the desired *terminus ad quem*, for Heidegger, is the wholly non-theoretical, peculiarly philosophical task, in Heidegger's sense, of self-liberation.

on schematism from the transcendental analytic of the *Critique of Pure Reason* at the center of his interpretation. But this, according to Cassirer, is to misconstrue the place of the analytic of the first *Critique* within the wider system of all three *Critiques*—where, in particular, we see that the idea of the "intelligible substrate of humanity," an entirely *non-sensible* idea, occupies the central position:

> Schematism and the theory of the "transcendental imagination" indeed stand at the center of the Kantian *analytic*, but not in the focus of the Kantian *system*. This system is determined and completed first in the transcendental dialectic—and further in the *Critique of Practical Reason* and the *Critique of Judgment*. Here, and not in the schematism, we first encounter Kant's own "fundamental ontology." The theme of "Kant and metaphysics," therefore, can only be treated *sub specie* the Kantian *theory of ideas* and, in particular, *sub specie* the Kantian theory of freedom and his theory of the beautiful, not exclusively *sub specie* the chapter on schematism. The *Critique of Practical Reason* and the *Critique of Aesthetic Judgment* also certainly belong to Kant's *"theory of man"*—but they develop this theory in such a way that they place human beings from the outset under the "idea of humanity" and consider them from the viewpoint of this idea. Not the *Dasein* of men, but the "intelligible substrate of humanity" is its essential goal. [Cassirer, 1931, pp. 18–19 (p. 149)]

In the transcendental dialectic we see that reason can attain to the idea of the unconditioned and the idea of freedom entirely independently of sensibility. Then, in the *Critique of Practical Reason,* we see how these ideas are given positive content by the moral law, which, in turn, itself gives positive content to the central Kantian distinction between noumena and phenomena.

And precisely here lies "the real and essential objection" that Cassirer wishes to raise against Heidegger:

> In so far as Heidegger attempts to relate, and indeed to reduce, all "faculties" of knowledge to the "transcendental imagination," only a *single* plane of reference, the plane of temporal *Dasein*, remains for him. The distinction between "phenomena" and "noumena" vanishes and is levelled; for *all* being now belongs to the dimension of time and thus of finitude. Thereby, however, one of the foundation stones of Kant's entire structure of thought is set aside—one without which this structure must collapse. Kant never represents this kind of "monism" of the imagination; he rather persists in a decisive and radical dualism, a dualism of the sensi-

ble and intelligible worlds. For *his* problem is not the problem of "being" and "time," but the problem of "being" and "ought," of "experience" and "idea." [Cassirer, 1931, p. 16 (pp. 147–48)]

This dualism, for Cassirer, does not involve a metaphysical opposition between two different "realms of being," of course, but rather an opposition between two different points of view, that of the "is" and that of the "ought," from which we can variously consider the single unitary realm of empirical (phenomenal) reality.[190]

Unlike in his remarks at the Davos disputation, then, Cassirer in his 1931 study places very little emphasis on specifically mathematical truth as a vehicle for the transcendence of Dasein's finitude.[191] There are obvious strategic reasons for this. Mathematics, for Kant, intimately involves the transcendental imagination and the schematism, and Cassirer is perfectly correct, accordingly, in emphasizing morality in particular when he wants to leave the transcendental imagination behind. But there are also much deeper problems and tensions at work here. For, at precisely the point where Cassirer (correctly) finds a fundamental systematic problem for Heidegger's interpretation of Kant, a parallel (and, as it were, inverse) problem arises for Cassirer himself.

For Kant, it is the very same conceptual or intellectual faculty that expresses itself in both mathematical theoretical science and in morality. This intellectual faculty, applied to pure sensibility, yields pure mathematics and what Kant calls pure natural science by the schematic activity of the transcendental imagination. The same intellectual faculty, acting entirely inde-

190. See [Cassirer, 1931, p. 14 (p. 145)]: "The separation of the *'mundus intelligibilis'* from the *'mundus sensibilis'* ultimately means, for Kant, nothing other than the indication of two completely different modes of orientation and evaluation. It says that all human *Dasein* and all human actions are to be considered from two in principle opposed standpoints and measured by two fundamentally different scales. The concept of the intelligible world [*Verstandeswelt*] is only a standpoint that reason finds it necessary to take outside the appearances in order to think itself as practical, which would not be possible if the influence of sensibility were determining for men, but which is absolutely necessary if man is to think of himself as intelligence, as free personality in a 'realm of ends'."

191. [Cassirer, 1931, pp. 10–11 (pp. 141–42)] touches on the spontaneity of the understanding exhibited in mathematical construction, but quickly moves on to a

pendently of sensibility, then yields the moral law by its own activity (as pure *practical* reason). For Kant himself, therefore, the difference between reason and the understanding is that the latter can give content to pure conceptual thought only by reference to an independent, non-conceptual faculty of sensibility, whereas the former can give content to pure conceptual thought (in the form of practical ideals and principles) wholly without reference to sensibility. Kant's entire architectonic thus rests, in the end, on his original sharp distinction between sensible and intellectual faculties.

Yet, as we saw in chapter 6, not only does Cassirer's own interpretation of Kant take its basis and starting point from an explicit denial of this distinction, but the philosophy of symbolic forms also undermines its systematic value and significance from a different point of view. Here a differentiation of sensible and intellectual faculties reappears in the distinction between intuitive or representative and purely significative meaning. The former embraces the world of ordinary perception generated and described by natural language, the latter embraces the purely formal and abstract world described by modern theoretical science. Thus mathematical theoretical science, in the philosophy of symbolic forms, exemplifies that type of symbolic meaning which exists at the furthest remove, as it were, from sensible and intuitive meaning—it is the very paradigm of purely intellectual, purely formal and abstract significative meaning.[192] Therefore, whereas Kant himself grounds the unity of practical and theoretical reason on the idea that it is the very same reason at work in both cases (in the latter dependent, the former independent of sensibility), *this* form of systematic unity is completely closed to Cassirer. So it is profoundly unclear, in particular, how the philosophy of symbolic

much more substantial consideration of the faculty of reason. In drafts prepared in 1928 under the heading "'Geist' und 'Leben' (Heidegger)" Cassirer gives rather more weight to the example of mathematics [Krois, 1995, p. 221 ([Krois and Verene, 1996, p. 203])]: "But for us meaning [*Sinn*] is by no means exhausted in Dasein—rather, 'there is' 'trans-personal' meaning, which is certainly only experienceable for an existing [*daseinendes*] subject. (Cf. 'mathematical' meaning, there is objective *significative*-meaning [*Bedeutungs-Sinn*] (= 'Geist');) there is finally a tearing away from the merely ontological, without the band to it being *broken*."

192. See especially notes 156 and 157 above, together with the (entire) paragraph to which they are appended.

forms can then unify both practical and theoretical principles under a common principle. Indeed, since "objective validity" in general here finds its "highest" expression in the purely formal significative meaning characteristic of modern abstract mathematics, it is radically unclear how practical, as opposed to theoretical principles can share in such "objective validity" at all.[193]

193. A discussion of Cassirer's views on morality and law lies beyond the scope of this essay. For a preliminary treatment see [Krois, 1987, chapter 4]. As we saw at the end of chapter 7 above, it is central to Cassirer's entire approach to maintain that the cultural sciences have their own distinctive form of "objectivity" and "intersubjective validity." But it remains fundamentally unclear, from a systematic point of view, how this form of "objectivity" can be unified or integrated with that characteristic of mathematical theoretical science or, by the same token, how either can be integrated with that characteristic of morality and law. (I will return to the issues broached here in chapter 9 below: see especially notes 209 and 215, together with the text to which they are appended.)

9

Analytic and Continental Traditions in Perspective

The Kantian system, at the height of the Enlightenment, had achieved a remarkable synthesis of virtually the whole of human thought. Mathematics and natural science, morality and law, culture and art, history and religion, all found their places within Kant's intricate architectonic, based on the three fundamental faculties of sensibility, understanding, and reason. These three faculties, in turn, depicted a universal normative structure common to all human beings as such, at all times and in all places, and thus underwrote a common claim to objectivity and intersubjective validity in all areas of human life. This claim was expressed constitutively, and as it were absolutely, in both mathematical natural science and morality (in the one case in virtue of a "schematization" or application of our intellectual faculty to our sensible faculty, in the other wholly independently of such schematization). It was expressed regulatively, and merely teleologically, in history, the development of culture, and religion. Here objectivity and intersubjective validity could only be striven for or set as a task, on the basis of a demand for realizing the "highest good" that itself flows constitutively from the moral law.

The rise of post-Kantian idealism ushered in the downfall of Kant's own architectonic, and thus a pervasive transformation and reconfiguration of the Kantian system. The sharp distinction between sensible and intellectual faculties was challenged, the dualistic opposition between phenomena and noumena (the sensible realm and the intelligible realm) was overthrown. In its place came a new emphasis on the regulative and teleological dimensions of Kant's thought, and on the priority of pure *practical* reason. Here the human personality could

constitute itself, as it were, with no external hindrances from a possibly recalcitrant sensory input supposedly due to an affection by noumenal objects. Then, by fundamentally reinterpreting the idea of "external" nature, human reason (or perhaps an "absolute" reason) could legislate autonomously both for nature and for itself. A new systematic unity of nature and spirit, reason and culture, would result—a unity in which Kant's own dualistic opposition between constitutive and regulative expressions of rationality is replaced by a common teleological development of both nature and human history towards the single ultimate goal of the full and active self-consciousness of reason as such.[194]

This extraordinarily ambitious post-Kantian program inevitably provoked severe philosophical reactions, from the "personalistic" or "proto-existentialist" challenges of a Nietzsche or a Kierkegaard, to the sober anti-metaphysical protests of more scientifically-oriented philosophers anxious to preserve an independent access to nature for the mathematical natural sciences. Here, in the work of thinkers like Herbart, Helmholtz, and Fries, arose the initial impulses for neo-Kantianism, a movement dedicated to a "return" to the mathematical and natural scientific preoccupations of Kant himself, aiming to replace the idealistic "metaphysics" of the post-Kantians with the new discipline of "epistemology" or "theory of knowledge [*Erkenntnistheorie*]."[195] And, whereas the neo-Kantians agreed with the post-Kantian idealists in rejecting Kant's original opposition between sensible and intellectual faculties, they turned away from the attempt to forge an ultimate metaphysical unity of nature and spirit. In its place they put a reinterpreted version of Kant's "transcendental logic" intended to articulate and illuminate the philosophical and methodological presuppositions of the positive sciences of their time, both the *Naturwissenschaften* and the *Geisteswissenschaften*.

194. The third volume of *Das Erkenntnisproblem* [Cassirer, 1920] presents a very clear and extensive discussion of the systems of post-Kantian idealism along these general lines.
195. See the fourth volume of *Das Erkenntnisproblem*, first published posthumously in English translation as *The Problem of Knowledge* [Cassirer, 1950], and then appearing in the original German as [Cassirer, 1957]. See also [Köhnke, 1986].

In their development of "transcendental logic" the neo-Kantians came into close proximity with a somewhat less familiar theme in nineteenth-century philosophical thought—the idea of a "pure logic [*reine Logik*]" originally identified with the names of Bolzano, Herbart, Lotze, and Meinong. Thinkers preoccupied with this idea were concerned with recent developments in the foundations of mathematics, and they opposed psychologistic and naturalistic trends of thought, as well as historicism, in maintaining the philosophical importance and centrality of the idea of "timelessly valid truth" as exemplified especially in logic and pure mathematics. This trend of thought then found its culmination, at the end of the nineteenth and beginning of the twentieth century, in two quite different thinkers, Gottlob Frege and Edmund Husserl.[196] Common to all these thinkers, however, was the idea that pure mathematics (at least in the form of pure arithmetic and analysis)[197] has no need of the Kantian faculty of sensible intuition but can rather be developed by the pure understanding alone. So pure logic, in this sense, is in no way dependent on either space or time, and philosophy finally has secure possession of a domain of truly timeless objective truth.

We have now arrived at the beginning of our own particular story, and also at a fundamental intellectual crossroads. For Frege implements the idea of pure logic in a basically technical direction. His project is to show, within a broadly Kantian epistemological framework, how Kant was nevertheless wrong about the particular status of arithmetic. Arithmetic can be fully developed on the basis of logic alone, and is thus purely intellectual, not sensible. To show this, however, we need self-con-

196. For a discussion of this trend of thought in its nineteenth-century philosophical context see [Sluga, 1980]; a discussion of the relationship between Frege and Husserl occurs on [pp. 39–41]. Frege was of course himself a mathematician, and Husserl began his career as a student of Weierstrass. Bolzano was one of the early contributors to the "rigorization of analysis" that Weierstrass completed. Herbart exerted philosophical influence on Riemann, the great inventor of the analytic theory of geometrical "manifolds" which in turn constitutes the essential mathematical framework for Einstein's general theory of relativity.

197. It is well known that Frege continued to maintain that geometry, as opposed to arithmetic and analysis, has its source in pure spatial intuition and is thus synthetic a priori. In this view, as we have seen, he was followed by both Husserl and the early Carnap (see notes 79–82 above, together with the text to which they are appended).

sciously to engage in a technical mathematical project. We need explicitly to articulate a new formulation of logic (what we now call symbolic or mathematical logic) adequate to this task, and we then need actually to construct a sequence of formal definitions of arithmetical concepts within this new logic so as to realize it.[198] It is sometimes said that in order to logicize mathematics Frege first had to mathematize logic. In the context of Bertrand's Russell idea of "logic as the essence of philosophy," Frege's work could thereby lead to the conception of philosophy, too, as an essentially technical and mathematical subject.

It is precisely this conception of philosophy, as we have seen, that finds its fullest expression in the work of Carnap.[199] Carnap aims, in the *Aufbau*, to do for epistemology what Frege had done for the philosophy of arithmetic. In particular, by actually carrying out a "rational [i.e., logical] reconstruction" of the fundamental process of cognition, by actually writing down the definitions of all concepts of science from a single basic relation between "given" elementary experiences in the language of *Principia Mathematica*, we rigorously carry out the ambitions of the Marburg School of neo-Kantianism in depicting the underlying logical forms responsible for the objectivity of natural scientific knowledge.[200] And, at the same time, we also reveal what Carnap calls the "neutral basis" common to *all* epistemological schools.[201] At a single stroke we have diffused

198. Frege [1879] first rigorously develops a system of what we now call mathematical logic. He then [Frege, 1884] and [Frege, 1893–1903] develops arithmetic on the basis of this system. As is well known, however, Frege's development of arithmetic depends on an additional principle (Basic Law V) which turns out to be inconsistent. Russell's discovery of this inconsistency in 1902 (together with related contradictions and "paradoxes") then precipitated the so-called foundations crisis in modern mathematics (for which the type-theory of *Principia Mathematica* is one possible solution). Carnap's *Logische Syntax der Sprache* [1934] is a detailed and original response to this situation, based on Carnap's assimilation of Gödel's celebrated incompleteness theorems (1931). For discussion see [Friedman, 1999, Part Three]. Cassirer [1929a, Part Three, chapter 4, § 2] also discusses this foundations crisis in some detail, but he of course was not able to respond there to Gödel's work.

199. See especially note 114 above—"Logic as the Essence of Philosophy" is the title of the second chapter of Russell's *Our Knowledge of the External World* [1914].

200. See again the passage from § 177 of the *Aufbau* to which note 99 is appended. There, in particular, Carnap explicitly agrees with the Marburg School that even the "given" elementary experiences must be "constituted" as "logical forms constructed in a determinate way" to count as genuine objects of knowledge.

201. See again the passage from § 178 of the *Aufbau* to which note 113 is appended.

all possibility of conflict and competition between mutually opposing philosophical tendencies, and we have given philosophy (that is, epistemology) a serious positive task of its own. Philosophy is itself a branch of mathematical science, a branch of what Carnap, in his *Logische Syntax der Sprache* [1934] will call *Wissenschaftslogik*.

Husserl, for his part, is interested above all in explaining the relationship between the realm of pure logic and the human mind. He is interested, as we have seen, in an "epistemology of the logical" which then becomes what he will call phenomenology. Our focus is no longer on the abstract mathematical systems (primarily in arithmetic and analysis) that inspired the idea of pure logic in the first place, but rather on the intentional structures of consciousness by which we human beings are able to gain access to such mathematical "essences." In particular, by "bracketing" all questions of spatio-temporal existence in the phenomenological and "eidetic" reductions, the phenomenological method allows us to have an equally a priori apprehension of the "essential" structures of human conscious life itself. Here we encounter an intrinsically non-mathematical and peculiarly philosophical type of knowledge, which, as such, can therefore constitute a philosophical foundation for both the mathematical natural sciences and the essentially non-mathematical cultural sciences.[202] Philosophy, for Husserl, is definitely not a branch of mathematics; and, for precisely this reason, it is still characteristically philosophical.

Just as Carnap begins his philosophical career by attempting to realize the philosophical ambitions of the Marburg School of neo-Kantianism using the new mathematical logic created by Frege, Heidegger begins his career by attempting to resolve the outstanding problems of the Southwest School using the new phenomenological method due to Husserl. But, as we have seen, Heidegger here encounters a rather more difficult situation. By rejecting the distinction between pure sensibility and pure understanding (and, accordingly, Kant's own particular role for the transcendental schematism of the understanding),

202. See notes 51–55 above, together with the text to which they are appended, and compare note 98.

both schools of neo-Kantianism had rendered Kant's original metaphysical and transcendental deductions of the categories otiose. Pure logical forms, conceived in the tradition of pure logic, could no longer succeed in constituting the "real" concrete object of experience. However, whereas the Marburg School cheerfully embraced this situation in their "genetic" conception of the "real"—now essentially incomplete—empirical object (their "logical idealism"), this strategy, as we have seen, could not possibly work from the perspective of the Southwest School. Heidegger therefore follows the example of Emil Lask in turning the entire neo-Kantian problematic on its head. Far from being an essential constitutive element of the "real" concrete object of experience, the notion of logical form is nothing but an artificial and derivative abstraction from the truly concrete empirical situation. Logical forms of thought, in this context, can have no philosophical explanatory value whatsoever.[203]

Heidegger, from this initial starting point, is then led in increasingly radical directions. He appropriates the insights of Dilthey's historically oriented *Lebensphilosophie* and, in particular, its emphasis on the concrete living subject of historical life and action. Although Husserl himself had explicitly rejected Dilthey's historicism on behalf of a "rigorously scientific" investigation of timeless, ahistorical "essences" (see note 57), Heidegger now formulates the paradoxical-sounding project of giving a phenomenological "essential analysis" of concrete historical existence itself. This project is carried out by rotating the axis of phenomenological investigation from a theoretical to a fundamentally practical point of view and, more specifically, by approaching the essential finitude of human life through an existential analysis of "being-towards-death." Here, in Dasein's own free choice between authentic and inauthentic existence, the peculiar character of man as an entity whose "essence" is "existence" is thereby finally fully disclosed.[204] And the way is also now cleared for philosophy as a discipline to rec-

203. See notes 42–45 and 59 above, together with the texts to which they are appended.
204. See notes 64–66 above, together with the text to which they are appended.

ognize as its true task nothing more nor less than "the self-free-ing of the freedom in human beings."[205] Beginning from the epistemological problematic of neo-Kantianism and the *reine Logik* tradition, the "personalistic" impulses of Nietzsche and Kierkegaard have been rigorously integrated with the "scientific" phenomenology of Husserl, and both have been integrated with historicism and *Lebensphilosophie*. The result is a breathtakingly original exploration of the spiritual and philosophical predicament of the early twentieth century.

Yet there are crucially important strands of early twentieth-century intellectual life that find no secure place in Heidegger's thought. To be sure, *Being and Time* exhibits a sensitive awareness of the great revolutions in the foundations of mathematics and mathematical physics that were so important in this period.[206] Nevertheless, under pressure from, among other things, his encounters with both Carnap and Cassirer, Heidegger comes increasingly to adopt a severely dismissive attitude towards these developments, which are now seen as totally devoid of genuine philosophical significance.[207] This weakness in Heidegger's thinking is highlighted by comparison with Carnap and, especially, with Cassirer. For, aside from the early efforts of Husserl himself, Cassirer is the only significant twentieth-century philosopher to make a serious effort to comprehend both these developments within the exact sciences and the contemporary turmoil

205. See note 189 above, together with the text to which it is appended.

206. Thus Heidegger [1927, § 3, pp. 9–10] comments sympathetically on both the foundations crisis in modern mathematics (see note 198 above) and relativity theory. Compare note 71 above.

207. See especially the passage from the 1943 postscript (apparently directed to Carnap's criticisms) to [Heidegger, 1929b] quoted in chapter 2 above where Heidegger speaks of the "degeneration" of thought in modern mathematical logic and concludes that "[e]xact thinking ties itself down solely in calculation with what is and serves this [end] exclusively." Compare also the passage explicitly devoted to Carnap's criticisms to which note 28 is appended (together with note 29). Characterizing the early-twentieth-century advances in mathematics, mathematical logic, and mathematical physics in terms of mere "calculation" is of course a quite hopeless distortion. We should note, however, that the mathematician Oskar Becker, who was a student of both Husserl and Heidegger, published a lengthy monograph on the foundations crisis in modern mathematics from a Heideggerian point of view in the very same issue of Husserl's *Jahrbuch* in which *Being and Time* first appeared. Cassirer remarks on this work in a pre-publication footnote in [Cassirer, 1929b, p. 469n (p. 404n)].

taking place in the foundations of the historical and cultural sciences.[208] And it is in this respect, in particular, that Cassirer here emerges as a quite central twentieth-century figure. For he alone attempts to do justice, once again, to both sides of Kant's original philosophical synthesis. And he alone is thus in a position to mediate the increasing intellectual tension between the now notorious "two cultures"—between the *naturwissenschaftliche* and *geisteswissenschaftliche* intellectual orientations.

Cassirer's philosophy of symbolic forms is truly remarkable in its conception and scope. Nevertheless, as we have seen, there are deep systematic difficulties standing in the way of its successful execution. Cassirer's most general philosophical aim is to show how all the different symbolic forms (from mathematical natural science to the history of human culture, from natural language to morality, religion, and art) possess their own distinctive types of "universal validity." They are all expressions of the ultimately unitary human spirit, as it strives unceasingly to "objectify" its surrounding world. But the clearest and best example of such "universal validity" continues, in good Marburg style, to be given by the language of mathematical exact science:

> And with this transition [to pure significative meaning] the realm of proper or rigorous "science" first opens up. In *its* symbolic signs and concepts everything that possesses mere expressive value is extinguished. Here there is to be no longer any individual subject, but only the thing itself is to "speak." . . . However, what the formula [of this language] lacks in closeness to life and in individual fullness—this is now made up, on the other side, by its universality, by its scope and its universal validity. In this universality not only individual but also national differences are

208. As we noted several times above (e.g., note 113), Carnap, in the *Aufbau*, intends to represent the rightful claims of the *Geisteswissenschaften* as well. These brief remarks hardly amount to very helpful or insightful contributions, however, and in later works he simply lets the matter drop. It is also interesting to note that Carnap was by no means entirely blind to the attractions of *Lebensphilosophie*. Indeed, the concluding section of [Carnap, 1932a], entitled "Metaphysik als Ausdruck des Lebensgefühls," includes favorable references to both Dilthey and Nietzsche. Carnap even speculates that metaphysics may have originated in *mythology*, which also gave birth to art. He concludes that art is the adequate expression of the same fundamental *Lebensgefühl* for which metaphysics (following theology) is an inadequate expression. Here I am indebted to discussions with Gottfried Gabriel.

overcome. The plural concept of "languages" no longer holds sway: it is pushed aside and replaced by the thought of the *characteristica univer-salis*, which now enters the scene as [a] *"lingua universalis."*

And now we hereby first stand at the birthplace of mathematical and mathematical natural scientific knowledge. From the standpoint of our general problem we can say that this knowledge begins at the point where thought breaks through the veil of language—not, however, in order to appear entirely unveiled, to appear devoid of all symbolic clothing, but rather in order to enter into an in principle different symbolic form. [Cassirer, 1929b, p. 394 (p. 339)][209]

This commitment to the originally Leibnizean ideal of a truly universal, trans-national, and trans-historical system of communication, exemplified by the logical-mathematical language of exact scientific thought, is enthusiastically embraced by Carnap as well. It constitutes, in fact, the very core and basis of Carnap's whole philosophical orientation.[210] As we have seen in chapter 7, however, whereas Carnap's ideal of truly universal intersubjective communicability is precisely that which is expressible in rigorous logical notation, Cassirer wants to extend it (also as a regulative ideal) to all the other symbolic forms as well.[211]

The deep systematic difficulties standing in the way of this

209. It appears that it is due precisely to this greater tendency towards objectivity and universality that the language of theoretical science (in the words of the passage to which note 184 above is appended) "is able, otherwise and more deeply than in [the] other stages [of symbolic meaning], to know and to grasp the symbols that it uses as such."

210. See especially [Carnap, 1963a, § 11], which explains the relationship between Carnap's two life-long interests in what he calls "language planning"—designing new symbolic systems of mathematical logic, on the one hand, and working on universal languages for international communication, on the other. He notes several times the original inspiration for both of these projects in Leibniz and the *characteristica univer-salis*, and he explains how the motivations for the second project embody "the humanitarian ideal of improving understanding between nations." (Carnap's motivations for the first project, we might add, embody the parallel ideal of improving and facilitating understanding between apparently irreconcilable philosophical positions and schools.) Perhaps most characteristic is Carnap's account of attending a performance of Goethe's *Iphigenie* in Esperanto translation [Ibid., p. 69]: "It was a stirring and uplifting experience for me to hear this drama, inspired by the ideal of one humanity, expressed in the new medium which made it possible for thousands of spectators from many countries to understand it, and to become united in one spirit." (One hesitates to imagine what Heidegger would have made of this!)

211. See again the passages from *Zur Logik der Kulturwissenschaften* quoted in the paragraph to which note 177 is appended. Here Cassirer is concerned with the com-

ambition became clear at the end of chapter 8. In the original
Kantian architectonic, what Kant calls pure general logic (tradi-
tional Aristotelian formal logic) constitutively frames the entire
system at the highest level. The traditional logical theory of
concepts, judgments, and inferences supplies the formal sys-
tematic scaffolding on which Kant's comprehensive synthesis is
constructed. The logical forms of concepts and judgments,
when schematized by the faculty of sensibility, generate both
the table of categories and the system of principles, which in
turn underlie Kant's constitutive theory of human sensible
experience of the phenomenal world, as made possible in pure
mathematics and pure natural science. These same logical
forms, considered independently of the faculty of sensibility,
then generate the concept of the noumenon, which remains
merely "problematic," however, from a theoretical point of
view. Further, the basic logical forms of (syllogistic) inference,
again considered independently of sensibility, generate the idea
of the unconditioned in general and the idea of freedom in par-
ticular. And both of these ideas also remain "indeterminate"
from a theoretical point of view, although they nonetheless
possess positive guiding force in the regulative use of reason.
This same faculty of reason, finally, when applied to the deter-
mination of the will, also generates the moral law as a product
of pure *practical* reason.[212] Here the ideas of freedom and the
unconditioned receive positive constitutive content, which can
then set a definite teleological goal (the ideal of the highest
good) as the highest guiding principle of *all* regulative activity,
both practical and theoretical.

For Kant himself, therefore, the systematic unity of all forms

mon "cultural meanings" that ensure that "it is ultimately the 'same' human being that
we always continually encounter in the development of culture, in thousands of mani-
festations and in thousands of masks," so that all of human culture—at all stages of
development and in all places—is in principle accessible to us.

212. This process involves the forms of concepts and judgments expressing the
essential nature of the faculty of understanding as well. For, as Kant explains in the
chapter of the *Critique of Practical Reason* entitled "On the Typic of Pure Practical
Judgment," practical reason here applies itself not to the faculty of sensibility but to the
general form of the understanding itself. The latter yields the general idea of a law-gov-
erned system of nature as such, which then underlies the so-called "law of nature" for-
mulation of the categorical imperative.

of thought—theoretical, practical, aesthetic, and religious—is grounded on the idea that it is ultimately the very same reason at work in all cases. Moreover, the objectivity of thought *begins* with the theoretical reason exerted most clearly and uncontroversially in pure and empirical natural science, which is then extended to all other forms of thought by a teleological procedure guided by the regulative use of reason. Aesthetic judgments, for example, acquire their own distinctive type of objectivity in virtue of the circumstance that it is the "free play of the cognitive faculties"—the very same cognitive faculties governing theoretical natural science—which is responsible for the distinctive type of pleasure expressed in aesthetic judgments.[213] For Cassirer, by contrast, theoretical science rather represents the end-point of his dialectical development of the various symbolic forms, which acquire their systematic unity, as we noted, from their "centrifugal" arrangement around a common origin and center. But this common center is situated in mythical thought, governed by the most primitive and least logical (and therefore apparently least objective) symbolic function of expressive meaning. And it is precisely this idea, as we also noted, that binds Cassirer most closely with the "irrationalist" tendencies of contemporary *Lebensphilosophie*, as expressed in the thought of Bergson, Scheler, and Simmel.[214]

The most fundamental problem created by the post-Kantian rejection of the central Kantian distinction between sensible and intellectual faculties, then, lies in the destruction of Kant's intricate architectonic. It is no longer possible, in particular, to view pure formal logic, as the most clearly and uncontroversially universal form of human thinking, also as the framework for a comprehensive philosophy of the whole of our intellectual and cultural life. Cassirer's herculean efforts to construct a similarly comprehensive philosophy of symbolic forms make this problem especially clear. For, whereas Cassirer perseveres in the

213. This is the crux of Kant's explanation of the universal communicability of aesthetic judgments in the First Part of the *Critique of Judgment*.

214. Cassirer is of course fully aware of the delicate and precarious nature of the route he is attempting to traverse here. Compare note 182 in chapter 8 above. As I try to show in the remainder of chapter 8, however, it does not appear that the philosophy of symbolic forms has the systematic resources to negotiate this route successfully.

idea that pure formal logic (in its modern, post-Kantian guise as a sufficient and adequate language for all of mathematics and exact science) provides us with the paradigm of truly universal intersubjective communicability as well, he also wants to maintain a complementary but still universal intersubjective validity in the essentially non-mathematical cultural sciences. He never satisfactorily explains, however, how these two characteristically different types of validity are related—even if both, in the end, are conceived as purely regulative ideals.[215] And, if Cassirer cannot thus make good on the idea of an underlying unity for the totality of symbolic forms, it appears that we are finally left (in the present space of intellectual possibilities, of course) with the fundamental philosophical dilemma presented by Carnap and Heidegger after all. We can either, with Carnap, hold fast to formal logic as the ideal of universal validity and confine ourselves, accordingly, to the philosophy of the mathematical exact sciences, or we can, with Heidegger, cut ourselves off from logic and "exact thinking" generally, with the result that we ultimately renounce the ideal of truly universal validity itself.

If I am not mistaken, it is precisely this dilemma that lies at the heart of the twentieth-century opposition between "analytic" and "continental" philosophical traditions, which thus rests, from a purely philosophical point of view, on the systematic cracks which had meanwhile appeared in the original Kantian architectonic. But the thoroughgoing intellectual estrangement of these two traditions, their almost total lack of mutual comprehension, is a product of the National Socialist seizure of power in 1933 and the resulting intellectual migration. Before this, as we have seen, logical positivism, as represented by Carnap, was very actively engaged with the other vocal movements in the German-speaking philosophical scene— with neo-Kantianism, with Husserlian phenomenology, and even with the "existential-hermeneutic" variant of phenomenology then being developed by Heidegger. The period of National Socialism, however, saw the death of Husserl and the

215. See notes 192 and 193 above, together with the paragraph to which they are appended.

emigration of both Carnap and Cassirer. "Scientific philosophy" as such had left the German-speaking world entirely, whereupon it resettled eventually in the United States. Here it merged with other major trends within English-language philosophical thought (particularly from Britain) to create what we now call the analytic tradition.[216] In Europe, by contrast, the only truly major philosopher left was Heidegger himself, and it is no wonder, then, that what we now call the continental tradition invariably takes its starting point from him. And it was only at this particular point that the two traditions first became thoroughly estranged, to the point of almost total mutual incomprehension, linguistically, geographically, and conceptually.

It would be foolish to identify the split between "scientific" and "humanistic" philosophy embodied most starkly in the opposition between Carnap and Heidegger with the equally stark social and political differences between them. Some "scientific" philosophers were and are conservative and even reactionary in their politics; not a few followers of Heidegger number among the leading "progressive" thinkers of the time.[217] At the same time, however, it cannot be denied that both Carnap and Heidegger viewed their own philosophical efforts as intimately connected with their wider social and political views and projects, and as closely intertwined, in particular, with precisely those social and political struggles of the Weimar period that eventuated in the triumph of National Socialism. Thus, by precisely representing some of the central ideas comprising the "logical idealism" of the Marburg School within the new mathematical logic of *Principia Mathematica*, Carnap

216. Because of his rather early death in 1945, Cassirer never became part of what we now call the analytic tradition. He continued to think, in style and in substance, as what we would now call a continental philosopher.

217. An important example of the former type of philosopher is Gottlob Frege, who espoused strongly anti-democratic, and even anti-Semitic, political views in the period of the Weimar Republic. He shared some of these opinions with his friend Bruno Bauch, who became a leader of "Nazi philosophy" during the National Socialist period (next to Bauch, Heidegger's own involvement with Nazism somewhat pales). For discussion of both Frege and Bauch see [Sluga, 1993] (see also [Krois, 2000] for Bauch's earlier anti-Semitic attack on Hermann Cohen's Kant interepretation, which prefigured the 1929 attack by Orthmar Spann: compare note 7 above). Important examples of "progressive" (or at least left-wing) students and followers of Heidegger, of course, are Herbert Marcuse, Hannah Arendt, and Jean-Paul Sartre.

viewed himself as having injected the ideology of the *neue Sachlichkeit* into philosophy itself. Philosophy, that is, had now become a genuinely "objective" discipline capable (like the exact sciences) of cooperative progress and, in principle, of universal agreement as well. Indeed, philosophy had now become a branch of mathematical logic, the most "objective" and universal discipline of all, and Carnap had thereby arrived at a conception of philosophy which, in his eyes, best served the socialist, internationalist, and anti-individualistic aims of that cultural and political movement with which he most closely identified.[218] Moreover, this "objectivist" and universalist conception of philosophy (based on the new mathematical logic) of course stands in the most extreme contrast with the particularist, existential-historical conception of philosophy we have seen Heidegger develop (based on an explicit rejection of the centrality of logic), and it is clear that the latter philosophical conception, in Heidegger's eyes, best served the neo-conservative and avowedly German-nationalist cultural and political stance he himself favored.[219]

Cassirer, as we know, was a staunch supporter of the Weimar Republic. Perhaps precisely because of this, however, he was never attracted to the more radical social and political orientations adopted by Carnap and Heidegger respectively. Just as, in the philosophical sphere, Cassirer viewed himself as a contemporary representative of the great classical tradition of what he called "modern philosophical idealism," so, in the practical sphere, he similarly viewed himself as a representative of the

218. In this respect, Carnap's identification with the *neue Sachlichkeit* is far more radical than Neurath's. For Neurath, unlike Carnap, made no attempt to turn philosophy itself into an "objective" (purely technical) discipline. See the remarks on Neurath cited in note 20 above (together with the text to which it is appended) and compare [Carnap, 1963a, pp. 51–52]. For Neurath's own views see again the references cited in note 19 above. This significant difference between Carnap and Neurath seems to be missed in the otherwise quite useful discussion of the relationship between the Vienna Circle and the *neue Sachlichkeit* [Galison, 1990], which generally ignores the important areas of disagreement between the two philosophers.

219. Heidegger is perfectly explicit about this connection between his political engagement and his philosophical conception of the necessary "historicality of Dasein" in a well-known conversation (in 1936) reported by Karl Löwith [Wolin, 1991, p. 142]. Curiously, this crucial connection seems to be missed in the otherwise very interesting study of the relationship between Heidegger's philosophy and German neo-conservatism [Bourdieu, 1988].

great classical tradition of liberal republican political thought.[220] Just as his approach to philosophical questions was fundamentally synthetic and conciliatory, so his approach to political matters was similarly non-confrontational. As we have seen, Cassirer maintained very friendly personal relations with Heidegger almost until Heidegger's assumption of the rectorate in 1933, and, even afterwards, he never publicly referred to Heidegger's political involvement in print.[221] It must certainly be admitted, therefore, that his synthetic and conciliatory approach to both philosophical and political questions make Cassirer a much less striking and dramatic figure than either Carnap or Heidegger. Those interested in finally beginning a reconciliation of the analytic and continental traditions, however, can find no better starting point than the rich treasure of ideas, ambitions, and analyses stored in his astonishingly comprehensive body of philosophical work.

220. Here see again [Krois, 1987, chapter 4].

221. As we pointed out in note 10 above, the closest Cassirer came to this was in his posthumously published *The Myth of the State*. This work, despite its flaws, contains a very penetrating and still pertinent diagnosis of the power of modern political fascism, which, according to Cassirer, lies in its deliberate manipulation, by the tools of modern technology (the mass media), of more primitive mythical forms of thought. For a balanced discussion of both the strengths and the weaknesses of this work see [Krois, 1987, chapter 5].

Bibliography

ASP (Archives for Scientific Philosophy). University of Pittsburgh Libraries. References are to file folder numbers. Quoted by permission of University of Pittsburgh Libraries. All rights reserved.

Aubenque, P., L. Ferry, E. Rudolf, J.-F. Courtine, F. Capeillières (1992) "Philosophie und Politik: Die Davoser Disputation zwischen Ernst Cassirer und Martin Heidegger in der Retrospektive." *Internationale Zeitschrift für Philosophie* 2, 290–312.

Ayer, A., ed. (1959) *Logical Positivism*. New York: Free Press.

Bauch, B. (1911) *Studien zur Philosophie der exakten Wissenschaften*. Heidelberg: Winter.

———. (1914) "Über den Begriff des Naturgesetzes." *Kant-Studien* 19, 303–337.

———. (1923) *Wahrheit, Wert und Wirklichkeit*. Leipzig: Meiner.

Bourdieu, P. (1988) *l'Ontologie politique de Martin Heidegger*. Paris: Editions de Minuit. Translated as *The Political Ontology of Martin Heidegger*. Stanford: Stanford University Press, 1991.

BRL (Beinecke Rare Book and Manuscript Library). Yale University. All rights reserved.

Carnap, R. (1922) *Der Raum. Ein Beitrag zur Wissenschaftslehre*. Berlin: Reuther and Reichard.

———. (1923) "Über die Aufgabe der Physik und die Anwendung des Grundsatzes der Einfachstheit." *Kant-Studien* 28, 90–107.

———. (1924) "Dreidimensionalität des Raumes und Kausalität." *Annalen der Philosophie und philosophischen Kritik* 4, 105–130.

———. (1928a) *Der logische Aufbau der Welt*. Berlin: Weltkreis. Second edition, Hamburg: Meiner, 1961. Translated from the second edition as *The Logical Structure of the World*. Berkeley: University of California Press, 1967.

———. (1928b) *Scheinprobleme in der Philosophie*. Berlin: Weltkreis. Translated as *Pseudoproblems in Philosophy*. Berkeley: University of California Press, 1967.

———. (1932a) "Überwindung der Metaphysik durch logische Analyse der Sprache." *Erkenntnis* 2, 219–241. Translated as "The Elimination of Metaphysics through Logical Analysis of Language." In [Ayer, 1959].

———. (1932b) "Die physikalische Sprache als Universalsprache der Wissenschaft," *Erkenntnis* 2, 432–465. Translated as *The Unity of Science*. London: Kegan Paul, 1934.

———. (1934) *Logische Syntax der Sprache*. Wien: Springer. Translated as *The Logical Syntax of Language*. London: Kegan Paul, 1937.

———. (1963a) "Intellectual Autobiography." In [Schilpp, 1963].

———. (1963b) "Replies and Systematic Expositions." In [Schilpp, 1963].

Carnap, R., H. Hahn, O. Neurath (1929) *Wissenschaftliche Weltauffassung: Der Wiener Kreis*. Vienna: Wolf. Translated as "The Scientific Conception of the World:The Vienna Circle." In [Neurath, 1973].

Cartwright, N., J. Cat, L. Fleck, T. Uebel (1996) *Otto Neurath: Philosophy Between Science and Politics*. Cambridge: Cambridge University Press.

Cassirer, E. (1902) *Leibniz' System in seinen wissenschaftlichen Grundlagen*. Marburg: Elwert.

———. (1906) *Das Erkenntnisproblem in der Philosophie und Wissenschaft der neueren Zeit. Erster Band*. Berlin: Bruno Cassirer. Third edition, 1922.

———. (1907a) *Das Erkenntnisproblem in der Philosophie und Wissenschaft der neueren Zeit. Zweiter Band*. Berlin: Bruno Cassirer. Third edition, 1922.

———. (1907b) "Kant und die moderne Mathematik." *Kant-Studien* 12, 1–40.

———. (1910) *Substanzbegriff und Funktionsbegriff: Untersuchungen über die Grundfragen der Erkenntniskritik*. Berlin: Bruno Cassirer. Translated as *Substance and Function*. Chicago: Open Court, 1923.

———. (1913) "Erkenntnistheorie nebst den Grenzfragen der Logik." *Jahrbücher der Philosophie* 1, 1–59.

———. (1920) *Das Erkenntnisproblem in der Philosophie und Wissenschaft der neueren Zeit. Dritter Band: Die nachkantischen Systeme*. Berlin: Bruno Cassirer. Second edition, 1922.

———. (1921a) "Goethe und die mathematische Physik. Eine erkenntnistheoretische Betrachtung." In *Idee und Gestalt*. Berlin: Bruno Cassirer.

———. (1921b) *Zur Einsteinschen Relativitätstheorie. Erkenntnistheoretische Betrachtungen*. Berlin: Bruno Cassirer. Translated as *Einstein's Theory of Relativity*. Chicago: Open Court, 1923.

———. (1923) *Philosophie der symbolischen Formen. Erster Teil: Die Sprache*. Berlin: Bruno Cassirer. Translated as *The Philosophy of Symbolic Forms. Volume One: Language*. New Haven: Yale University Press, 1955.

———. (1925) *Philosophie der symbolischen Formen. Zweiter Teil: Das mythische Denken*. Berlin: Bruno Cassirer. Translated as *The Philosophy of Symbolic Forms. Volume Two: Mythical Thought*. New Haven: Yale University Press, 1955.

———. (1927) "Erkenntnistheorie nebst den Grenzfragen der Logik und Denkpsychologie." *Jahrbücher der Philosophie* 3, 31–92.

———. (1929a) *Die Idee der Republikanischen Verfassung*. Hamburg: Friedrichsen.

———. (1929b) *Philosophie der symbolischen Formen. Dritter Teil: Phänomenologie der Erkenntnis*. Berlin: Bruno Cassirer. Translated as *The*

Philosophy of Symbolic Forms. Volume Three: The Phenomenology of Knowledge. New Haven: Yale University Press, 1957.

————. (1930a) "'Geist' und 'Leben' in der Philosophie der Gegenwart." *Die neue Rundschau* 41, 244–264. Translated as "'Spirit' and 'Life' in Contemporary Philosophy." In [Schilpp, 1949].

————. (1930b) "Form und Technik." In *Kunst und Technik* (ed. L. Kestenberg). Berlin: Wegweiser. Reprinted in *Symbol, Technik, Sprache* (ed. E. Orth and J. Krois). Hamburg: Meiner, 1985.

————. (1931) "Kant und das Problem der Metaphysik. Bemerkungen zu Martin Heideggers Kantinterpretation." *Kant-Studien* 36, 1–16. Translated as "Kant and the Problem of Metaphysics." In M. Gram, ed. *Kant: Disputed Questions.* Chicago: Quadrangle, 1967.

————. (1936) *Determinismus und Indeterminismus in der modernen Physik.* Göteborg. Högskolas Arsskrift 42. Translated as *Determinism and Indeterminism in Modern Physics.* New Haven: Yale University Press, 1956.

————. (1942) *Zur Logik der Kulturwissenschaften.* Göteborg. Högskolas Arsskrift 47. Translated as *The Logic of the Humanities.* New Haven: Yale University Press, 1961.

————. (1943) "Hermann Cohen, 1842–1918." *Social Research* 10, 219–232.

————. (1946) *The Myth of the State.* New Haven: Yale University Press.

————. (1950) *The Problem of Knowledge: Philosophy, Science, and History since Hegel.* New Haven: Yale University Press.

————. (1957) *Das Erkenntnisproblem in der Philosophie und Wissenschaft der neueren Zeit. Vierter Band: von Hegels Tod bis zur Gegenwart (1832–1932).* Stuttgart: Kohlhammer.

Cassirer, T. (1981) *Mein Leben mit Ernst Cassirer.* Hildesheim: Gerstenberg.

Coffa, J. (1991) *The Semantic Tradition from Kant to Carnap: To the Vienna Station.* Cambridge: Cambridge University Press.

Cohen, H. (1871) *Kants Theorie der Erfahrung.* Berlin: Dümmler.

————. (1902) *Logik der reinen Erkenntnis.* Berlin: Bruno Cassirer.

Cohen, H. F. (1994) *The Scientific Revolution: A Historiographical Inquiry.* Chicago: University of Chicago Press.

De Pierris, G. (1993) "The Constitutive A Priori." *Canadian Journal of Philosophy,* Supplementary Volume 18, 179–214.

Dedekind, R. (1883) *Was sind was sollen die Zahlen?* Braunschweig: Vieweg. Translated as "The Nature and Meaning of Numbers." In *Essays on the Theory of Numbers.* Chicago: Open Court, 1901.

Dilthey, W. (1914–36) *Gesammelte Schriften.* 12 vols. Leipzig: Teubner.

Farias, V. (1987) *Heidegger et le nazisme.* Paris: Verdier. Translated as *Heidegger and Nazism.* Philadelphia: Temple University Press, 1989.

Feigl, H. (1969) "The Wiener Kreis in America." In [Fleming and Bailyn, 1969].

Fleming, D. and B. Bailyn, eds. (1969) *The Intellectual Migration: Europe and America, 1930–1960.* Cambridge, Mass.: Harvard University Press.

Frege, G. (1879) *Begriffsschrift, eine der arithmetischen nachgebildete Formelsprache des reinen Denkens.* Halle a/S. Translated as "Begriffsschrift, a formula language, modeled upon that of arithmetic, for pure thought." In J. van Heijenoort, ed. *From Frege to Gödel: A Source Book in Mathematical Logic, 1879–1931.* Cambridge, Mass.: Harvard University Press, 1967.

——. (1882) *Die Grundlagen der Arithmetik. Eine logisch-mathematische Untersuchung über den Begriff der Zahl.* Breslau: Koebner. Translated as *The Foundations of Arithmetic: A Logico-mathematical Enquiry Into the Concept of Number.* Oxford: Blackwell, 1950.

——. (1893–1903) *Grundgesetze der Arithmetik, begriffsschriftlich abgeleitet.* 2 vols. Jena: Pohle. First Part of Vol. I translated as *The Basic Laws of Arithmetic: An Exposition of the System.* Berkeley: University of California Press, 1965.

Friedman, M. (1992) *Kant and the Exact Sciences.* Cambridge, Mass.: Harvard University Press.

——. (1996) "Overcoming Metaphysics: Carnap and Heidegger." In [Giere and Richardson, 1996].

——. (1997) "Helmholtz's *Zeichentheorie* and Schlick's *Allgemeine Erkenntnislehre:* Early Logical Empiricism and Its Nineteenth-Century Background." *Philosophical Topics* 25, 19–50.

——. (1999) *Reconsidering Logical Positivism.* Cambridge: Cambridge University Press.

——. (2000) "Geometry, Construction, and Intuition in Kant and His Successors." In G. Scher and R. Tieszen, eds. *Between Logic and Intuition: Essays in Honor of Charles Parsons.* Cambridge: Cambridge University Press.

Galison, P. (1990) "Aufbau/Bauhaus: Logical Positivism and Architectural Modernism." *Critical Inquiry* 16, 709–752.

Gawronsky, D. (1949) "Ernst Cassirer: His Life and His Work." In [Schilpp, 1949].

Giere, R. and A. Richardson, eds. (1996) *Origins of Logical Empiricism.* Minneapolis: University of Minnesota Press.

Goodman, N. (1963) "The Significance of *Der logische Aufbau der Welt.*" In [Schilpp, 1963].

Haack, S. (1977) "Carnap's *Aufbau*: Some Kantian Reflexions." *Ratio* 19, 170–75.

Heidegger, M. (1927) *Sein und Zeit.* Tübingen: Max Niemeyer. Translated as *Being and Time.* New York: Harper and Row, 1962.

——. (1928) "Ernst Cassirer: Philosophie der symbolischen Formen. 2. Teil: Das mythische Denken." *Deutsche Literaturzeitung* 21, 1000–1012. Reprinted in [Heidegger, 1991]. Translated as "Book Review of Ernst Cassirer's *Mythical Thought.*" In *The Piety of Thinking* (ed. J. Hart and J. Maraldo). Bloomington: Indiana University Press.

——. (1929a) *Kant und das Problem der Metaphysik.* Bonn: Friedrich Cohen. Third edition, 1965. Fourth edition, 1973.

————. (1929b) *Was ist Metaphysik?* Bonn: Friedrich Cohen. Translated as "What is Metaphysics?" In *Basic Writings* (ed. D. Krell). New York: Harper and Row, 1977.

————. (1933) *Die Selbstbehauptung der deutschen Universität*. Breslau: Korn. Translated as "The Self-Assertion of the German University." In [Wolin, 1991].

————. (1943) "Nachwort" to *Was ist Metaphysik?* (fourth edition). Frankfurt: Klostermann. Translated as "Postscript" to "What is Metaphysics?" In *Existence and Being* (ed. W. Brock). Chicago: Henry Regnery, 1949.

————. (1953) *Einführung in die Metaphysik*. Tübingen: Niemeyer. Translated as *Introduction to Metaphysics*. New York: Doubleday, 1961.

————. (1954) "Überwindung der Metaphysik." In *Vorträge und Aufsätze*. Pfullingen: Neske. Translated as "Overcoming Metaphysics." In *The End of Philosophy* (ed. J. Stambaugh). New York: Harper and Row, 1973. Reprinted in [Wolin, 1991].

————. (1976) *Logik: Die Frage nach der Wahrheit*. *Gesamtausgabe*. Vol. 21. Frankfurt: Klostermann.

————. (1978) *Frühe Schriften*. *Gesamtausgabe*. Vol. 1. Frankfurt: Klostermann.

————. (1979) *Prolegomena zur Geschichte des Zeitbegriffs*. *Gesamtausgabe*. Vol. 20. Frankfurt: Klostermann. Translated as *History of the Concept of Time: Prolegomena*. Bloomington: Indiana University Press, 1985.

————. (1983) *Einführung in die Metaphysik*. *Gesamtausgabe*. Vol. 40. Frankfurt: Klostermann.

————. (1990) *Kant and the Problem of Metaphysics*. Bloomington: Indiana University Press.

————. (1991) *Kant und das Problem der Metaphysik*. *Gesamtausgabe*. Vol. 3. Frankfurt: Klostermann.

Hilbert, D. (1899) *Grundlagen der Geometrie*. Leipzig: Teubner. Translated from the tenth (1968) edition as *Foundations of Geometry*. La Salle: Open Court, 1971.

Husserl, E. (1900) *Logische Untersuchungen. Erster Teil: Prolegomena zur reinen Logik*. Hall: Max Niemeyer. Second edition, 1913. Translated from second edition as *Logical Investigations*. London: Routledge, 1973.

————. (1901) *Logische Untersuchungen. Zweiter Teil: Untersuchungen zur Phänomenologie und Theorie der Erkenntnis*. Halle: Max Niemeyer. Second edition, 1913. Translated from the second edition as *Logical Investigations*. London: Routledge, 1973.

————. (1911) "Philosophie als strenge Wissenschaft." Logos 1, 289–341. Translated as "Philosophy as Rigorous Science." In *Phenomenology and the Crisis of Philosophy* (ed. Q. Lauer). New York: Harper and Row, 1965.

————. (1913) *Ideen zu einer reinen Phänomenologie und phänomenologischen Philosophie*. Halle: Max Niemeyer. Translated as *Ideas Pertaining to a Pure Phenomenology and to a Phenomenological Philosophy. First Book: General Introduction to Pure Phenomenology*. Dordrecht: Kluwer, 1980.

————. (1928) *Vorlesungen zur Phänomenologie des inneren Zeitbewusstseins* (ed. M. Heidegger). Halle: Max Neimeyer. Translated as *On the Phenomenology of the Consciousness of Internal Time* (1893–1917). Dordrecht: Kluwer, 1990.

Kaegi, D. and E. Rudolph, eds. (2000) *70 Jarhre Davoser Disputation*. Hamburg: Meiner.

Kisiel, T. (1993) *The Genesis of Heidegger's Being and Time*. Berkeley: University of California Press.

Köhnke, K. (1986) *Entstehung und Aufstieg des Neukantianismus: die deutsche Universitätsphilosophie zwischen Idealismus und Positivismus*. Frankfurt: Surhkamp. Translated (partially) as *The Rise of Neo-Kantianism*. Cambridge: Cambridge University Press, 1991.

Kraft, V. (1950) *Der Wiener Kreis*. Wien: Springer. Translated as *The Vienna Circle*. New York: Philosophical Library, 1953.

Krois, J. (1983) "Cassirer's Unpublished Critique of Heidegger." *Philosophy and Rhetoric* 16, 147–166.

————. (1987) *Cassirer: Symbolic Forms and History*. New Haven: Yale University Press.

————. (1992) "Aufklärung und Metaphysik. Zur Philosophie Cassirers und der Davoser Debatte mit Heidegger." *Internationale Zeitschrift für Philosophie* 2, 273–289.

————., ed. (1995) *Ernst Cassirer: Zur Metaphysik der symbolischen Formen*. Hamburg: Meiner.

————. (2000) "Warum fand keine Davoser Debatte zwischen Cassirer und Heidegger statt?" In [Kaegi and Rudolph, 2000].

Krois, J. and D. Verene, eds. (1996) *The Philosophy of Symbolic Forms. Volume Four: The Metaphysics of Symbolic Forms*. New Haven: Yale University Press.

Lask, E. (1912) *Die Lehre vom Urteil*. Tübingen: Mohr.

Lotze, H. (1874) *Logik*. Leipzig: Hirzel. Translated as *Logic*. Oxford: Oxford University Press, 1884.

Makkreel, R. (1969) "Wilhelm Dithey and the Neo-Kantians: The Distinction between the *Geisteswissenschaften* and the *Kulturwissenschaften*." *Journal of the History of Philosophy* 7, 423–440.

Moulines, C. (1985) "Hintergrunde der Erkenntnistheorie des frühen Carnap." *Grazer philosophische Studien* 23, 1–18.

Natorp, P. (1910) *Die logischen Grundlagen der exakten Wissenschaften*. Leipzig: Tuebner.

————. (1912) "Kant und die Marburger Schule." *Kant-Studien* 17, 193–221.

Neurath, O. (1932) "Die 'Philosophie' im Kampf gegen den Fortschritt der Wissenschaft." *Der Kampf* 25, 385–389. Reprinted in [Neurath, 1981].

————. (1973) *Empiricism and Sociology* (ed. M. Neurath and R. Cohen). Dordrecht: Reidel.

————. (1981) *Gesammelte philosophische und methodologische Schriften* (ed. R. Haller and H. Rutte). Vienna: Hölder-Pichler-Tempsky.

————. (1983) *Philosophical Papers: 1913–1946* (ed. R. Cohen and M. Neurath). Dordrecht: Reidel.

Ott, H. (1988) *Martin Heidegger: Unterwegs zu seiner Biographie.* Frankfurt, Campus. Translated as *Martin Heidegger: A Political Life.* London: Harper Collins, 1993.

Paetzold, H. (1995) *Ernst Cassirer—Von Marburg nach New York: eine philosophische Biographie.* Darmstadt: Wissenschaftliche Buchgesellschaft.

Pöggeler, O. (1991) "Heidegger's Political Self-Understanding." In [Wolin, 1991]

Pos, H. (1949) "Recollections of Ernst Cassirer." In [Schilpp, 1949].

Quine, W. (1951) "Two Dogmas of Empiricism." *Philosophical Review* 60, 20-43. Reprinted in *From a Logical Point of View.* New York: Harper, 1963.

————. (1969) "Epistemology Naturalized." In *Ontological Relativity and Other Essays.* New York: Columbia University Press.

Richardson, A. (1992) "Logical Idealism and Carnap's Construction of the World." *Synthese* 93, 59–92.

————. (1998) *Carnap's Construction of the World: The Aufbau and the Emergence of Logical Empiricism.* Cambridge: Cambridge University Press.

Rickert, H. (1882) *Der Gegenstand der Erkenntnis.* Tübingen: Mohr. Third edition, 1915.

————. (1902) *Die Grenzen der naturwissenschaftlichen Begriffsbildung.* Tübingen: Mohr. Third edition, 1921. Translated (partially) from the third edition as *The Limits of Concept Formation in Natural Science.* Cambridge: Cambridge University Press, 1986.

————. (1909) "Zwei Wege der Erkenntnistheorie." *Kant-Studien* 14, 169–228.

————. (1911) "Das Eine, die Einheit und die Eins." *Logos* 2, 26–78.

Russell, B. (1903) *The Principles of Mathematics.* London: Allen and Unwin.

————. (1914) *Our Knowledge of the External World as a Field for Scientific Method in Philosophy.* London: Allen and Unwin.

Ryckman, T. (1991) "*Conditio Sine Qua Non? Zuordnung* in the Early Epistemologies of Cassirer and Schlick." *Synthese* 88, 57–95.

Safranski, R. (1994) *Ein Meister aus Deutschland: Heidegger und seine Zeit.* München: Hanser. Translated as *Martin Heidegger: Between Good and Evil.* Cambridge, Mass.: Harvard University Press. 1998.

Sauer, W. (1985) "Carnaps *Aufbau* in kantianischer Sicht." *Grazer philosophische Studien* 23, 19–35.

————. (1989) "On the Kantian Background of Neopositivism." *Topoi* 8, 111–119.

Schilpp, P., ed. (1949) *The Philosophy of Ernst Cassirer.* La Salle: Open Court.

————., ed. (1963) *The Philosophy of Rudolf Carnap.* La Salle: Open Court.

Schlick, M. (1917) *Raum und Zeit in der gegenwärtigen Physik.* Berlin: Springer. Third edition, 1920. Translated from the third edition as *Space and Time in Contemporary Physics.* Oxford: Oxford University Press, 1920.

———. (1918) *Allgemeine Erkenntnislehre*. Berlin: Springer. Second edition, 1925. Translated from the second edition as *General Theory of Knowlege*. La Salle: Open Court, 1985.

———. (1921) "Kritizistische oder empiristische Deutung der neuen Physik?" *Kant-Studien* 26, 96–111. Translated as "Critical or Empiricist Interpretation of Modern Physics?" In *Moritz Schlick: Philosophical Papers*. Vol. 2 (ed. H. Mulder and B. van de Velde-Schlick). Dordrecht: Reidel, 1979.

Schneeberger, G. (1962) *Nachlese zu Heidegger*. Bern: Suhr.

Schwemmer, O. (1997) *Ernst Cassirer. Ein Philosoph der europäischen Moderne*. Berlin: Akademie.

Sluga, H. (1980) *Gottlob Frege*. London: Routledge.

———. (1993) *Heidegger's Crisis: Philosophy and Politics in Nazi Germany*. Cambridge, Mass.: Harvard University Press.

Uebel, T. (1996) "The Enlightenment Ambitions of Epistemic Utopianism: Otto Neurath's Theory of Science in Historical Perspective." In [Giere and Richardson, 1996].

Waismann, F. (1967) *Wittgenstein und der Wiener Kreis* (ed. D. McGuiness). Frankfurt: Suhrkamp. Translated as *Wittgenstein and the Vienna Circle*. London: Blackwell, 1979.

Webb, J. (1992) "Reconstruction from Recollection and the Refutation of Idealism: A Kantian Theme in the *Aufbau*." *Synthese* 93, 93–106.

Whitehead, A. and B. Russell (1910–13) *Principia Mathematica*. 3 vols. Cambridge: Cambridge University Press.

Willett, J. (1978) *The New Sobriety: Art and Politics in the Weimar Period, 1917–1933*. London: Thames and Hudson.

Wittgenstein, L. (1922) *Tractatus Logico-Philosophicus*. London: Routledge.

WKS (Wiener Kreis Stiftung). Rijksarchief in Noord-Holland, Haarlem. All rights reserved.

Wolin, R., ed. (1991) *The Heidegger Controversy: A Critical Reader*. New York: Columbia University Press.

Index

Arendt, H., 157n
Ayer, A.J., 13

Bauch, B., 26, 63–64, 71, 157n; *see also* neo-Kantianism, Southwest School
Becker, O., 151n
being and validity, 34–35, 39–41, 56–60, 76n, 81, 126, 139
Bergson, H., 13, 101, 129–130, 133, 136n, 155; *see also Lebensphilosophie*
Bollnow, O., 2n
Bolzano, B., 28, 29n, 36n, 55n, 147
Bourdieu, P., 158n
Bühler, K., 8

Carnap, R.
 Aufbau, 8, 16, 17n, 18, 26n, 63n, 70–72, 73n, 74, 81–83, 111, 119, 121, 122n, 125, 148, 152n
 on concept of nothing, 11–12, 25
 on construction of reality, 70, 72–85, 120
 Der Raum, 63–64, 68n, 93n
 on logic, 12, 15, 18–19, 22, 66–67, 72–73, 85, 120–123, 148, 158
 on idealism, 14, 80, 82
 on intersubjective communicability, 74–75, 121, 124–125, 153

and *Lebensphilosophie*, 152n
 Logical Syntax of Language, 19n, 85
 on natural science, 22, 72, 80, 119, 121, 124–127, 148–149
 and neo-Kantianism, 26n, 66, 69–71, 74–85, 120–121, 123, 148–149
 on objectivity, 74, 119–121, 148, 158
 on phenomenalism, 70–71, 74, 82n
 on philosophy and politics, 16–22, 157–158
 on philosophy as a science, 82–83, 148–149, 157–158
 on pure intuition, 65–67
 rejection of "metaphysics", 12–15, 19, 82–83, 152n
 on relativity, 64–65, 125n
 on space and geometry, 64–69, 93n, 147n
 on structural definite descriptions, 74–76, 119–122, 125
 on synthetic a priori, 13–14, 65, 67, 70, 80, 83–85, 121–123, 147n
 See also Vienna Circle; intersubjectivity; logical positivism
Cartwright, N., 15n
Carus, A., 100n, 118n
Cassirer, E.
 on "copy" theory of knowledge, 94, 97n, 102–104, 117

LaVergne, TN USA
16 November 2010
205203LV00003B/9/A